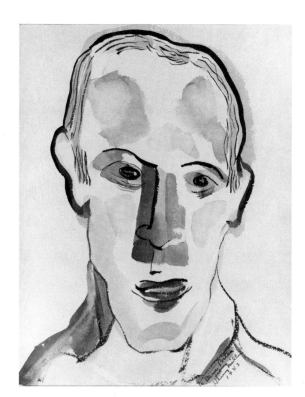

Every artist worth his salt has his "violin d'Ingres."
HENRY MILLER

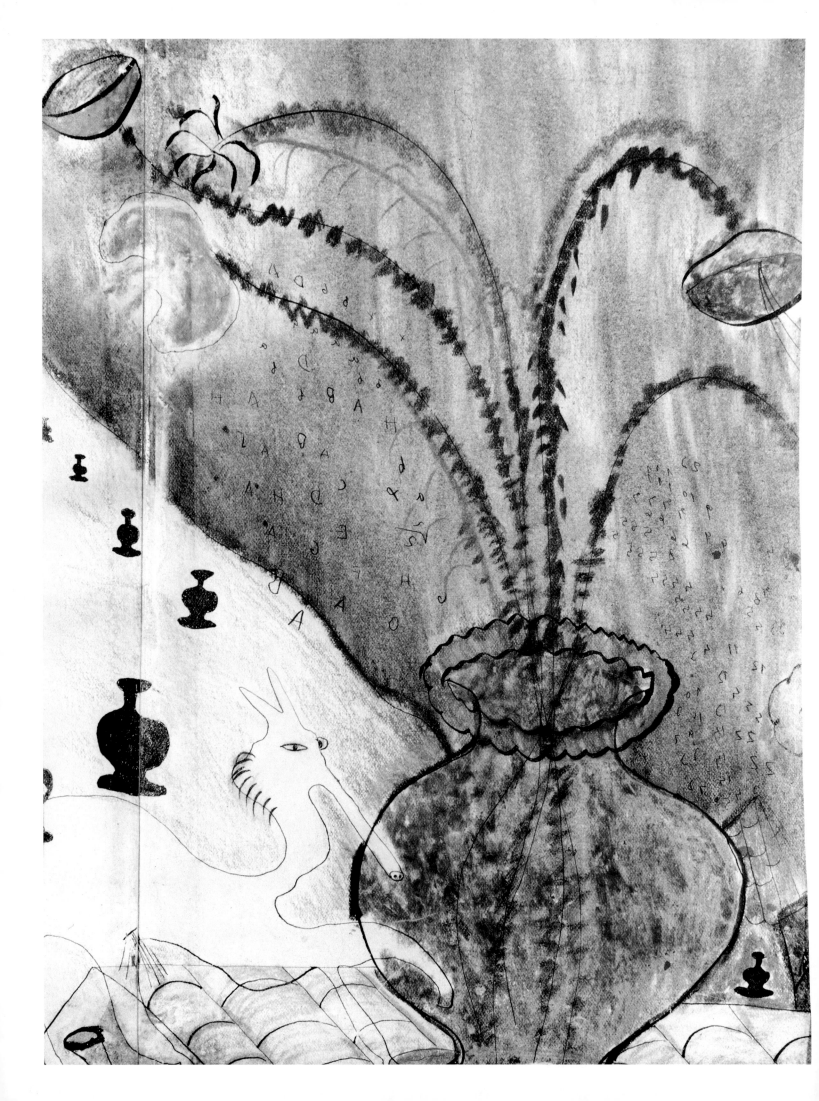

DOUBLY GIFTED
The AUTHOR *as* VISUAL ARTIST

Kathleen G. Hjerter *Foreword by John Updike*

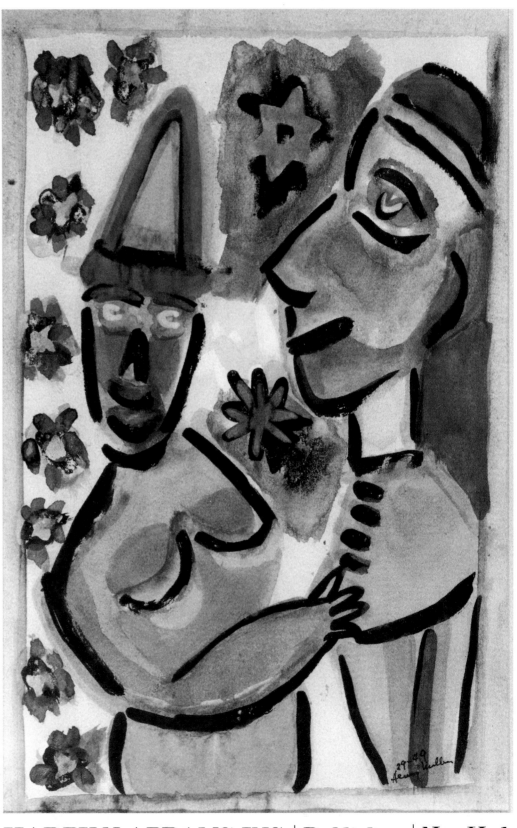

HARRY N. ABRAMS, INC. | *Publishers* | *New York*

FOR MY WONDERFUL CHILDREN
Jennifer, Christopher, Mary Cecile, Josiah, Elizabeth, Madeleine, Hans and Noah, Christopher II

EDITOR: *Lory Frankel*
DESIGNER: *Judith Michael*

LIBRARY OF CONGRESS CATALOGING-IN-PUBLICATION DATA
Hjerter, Kathleen G.
Doubly gifted.

1. Authors as artists. 2. Authors—Biography.
I. Title.
N8356.A9H5 1986 704′.8 85–23024
ISBN 0-8109-1842-0

Printed and bound in Japan

ENDPAPERS:
William Faulkner. *Design for Endpapers.* Affixed to inside covers of
Royal Street New Orleans, holograph book, text and artwork by
William Faulkner, 1926. Ink and watercolor, 7 × 5″. Harry Ransom
Humanities Research Center Manuscripts Collection, The
University of Texas at Austin

PAGE ONE:
Henry Miller. *Self-portrait.* 1943. Watercolor, 9½ × 7½″. Inscribed
to Bern Porter. Harry Ransom Humanities Research Center Art
Collection, The University of Texas at Austin
Citation:
Henry Miller, *To Paint Is to Love Again: Including Semblance of a Devoted Past* (New
York: Grossman Publishers, 1968), p. 21.

PAGE TWO:
Federico García Lorca. *Vase of Flowers.* Pastel and ink, 8½ × 6½″.
Collection Carmen del Rio de Piniés

PAGE THREE:
Henry Miller. *Two Clowns.* 1949. Watercolor, 15½ × 10⅛″. Harry
Ransom Humanities Research Center Art Collection, The
University of Texas at Austin

LEFT:
Djuna Barnes. Cover design, back, for *Ladies Almanack showing
their Signs and their tides . . . written & illustrated by a lady of
fashion.* 1928. Watercolor and ink on parchment, image 5½ × 4″.
Private collection, New York

PAGE SIX:
John Ruskin. *Beach Procession.* 1879. Pencil on envelope flap,
2½ × 1″. Harry Ransom Humanities Research Center Art
Collection, The University of Texas at Austin
 The envelope is addressed to Miss Edith Gall, ᶜ/o Professor
Ruskin, Brantwood, Coniston, Lancashire, postmarked 2 April
1879.
Citations:
e. e. cummings, Introduction to *New Poems* (from *Collected Poems*), 1938, in *Poems
1923–1954* (New York: Harcourt Brace & World, 1954), p. 332.
Hermann Hesse, "Artists and Psychoanalysis," 1918, *My Belief: Essays on Life and Art*,
trans. Denver Lindley, ed. Theodore Ziolkowski (New York: Farrar, Straus & Giroux,
1974), p. 50.

PAGE SEVEN:
John Updike. *Untitled.* 1953. Pen and ink, 3¾ × 2½″.
Whereabouts unknown

PAGE EIGHT:
John Updike. *"Miss Gridley."* 1951. Pen and brush and ink, 7 × 6″.
Whereabouts unknown

PAGE FOURTEEN:
Günter Grass. *Nun.* Graphite pencil, 44 × 30″. Collection the artist

PAGE FIFTEEN:
Jean Cocteau. *Man with Heart.* Ink, 11 × 8⅜″. Harry Ransom
Humanities Research Center Art Collection, The University of
Texas at Austin. Carlton Lake Collection
Citation:
Leonardo da Vinci, *The Unknown Leonardo,* ed. Ladislao Reti (Maidenhead, Eng.:
McGraw-Hill Bros., 1974), p. 80.

CONTENTS

Miracles are to come. With you I leave a remembrance of miracles: they are by somebody who can love and who shall be continually reborn, a human being; somebody who said to those near him, when his fingers would not hold a brush "tie it to my hand."
e. e. cummings

Now no one is likely to find this stimulating, educative, goading power of analysis more beneficial than the artist. For his concern is not with the most comfortable adjustment to the world and its ways but rather with what is unique, what he himself means.
HERMAN HESSE

FOREWORD

THE ITCH to make dark marks on white paper is shared by writers and artists. Before the advent of the typewriter and now the word processor, pen and ink were what one drew pictures and word-pictures with; James Joyce, who let others do his typing, said he liked to feel the words flow through his wrist.

There is a graphic beauty to old manuscripts, and to the signatures whose flourishes and curlicues were meant to discourage forgery. The manuscripts of Ouida, dashed off with, it seems, an ostrich quill, and the strenuously hatched and interlineated manuscripts of Pope and Boswell are as much pictorial events as a diploma by Steinberg. An old-fashioned gentleman's skills often included the ability to limn a likeness or a landscape, much as middle-class men now can all operate a camera; such writers as Pushkin and Goethe startle us with the competence of their sketches.

Thackeray, of course, was a professional illustrator, as were Beerbohm and Evelyn Waugh. Edward Lear was a serious painter and a frivolous writer, and he might be surprised to know that the writing has won him posterity's ticket. On the other hand, Wyndham Lewis now seems to be valued more for his edgy portraits of his fellow-modernists than for his once much-admired prose. Thurber was thought of as a writer who, comically and touchingly (since he was half-blind), could not draw but did anyway, whereas Ludwig Bemelmans is remembered, if he is remembered at all, as an artist who could write; in truth, both men were bold minimalists in an era when cartoons were executed in sometimes suffocating detail. A number of writers began as cartoonists: of S. J. Perelman we might have suspected this, and even of Gabriel García Márquez; but Flannery O'Connor? Yes, when we think back to her vivid outrageousness, the definiteness of her every stroke.

Alphabets begin as pictographs, and, though words are spoken things, to write and read we must see. The line between picture and symbol is a fine one. In the days of mass illiteracy, imagery—hung on cathedral walls, scattered in woodcuts—was the chief non-oral narrative means. Most paintings "tell a story," and even departures from representation carry a literary residue, e.g., the labels and bits of newspaper worked into Cubist collages, and the effect of monumental calligraphy in the canvases of Pollock and Kline. The art of the comic strip exists as if to show how small the bridge need be between the two forms of showing, of telling. Music, perhaps the most ancient of the fine arts, is simultaneously more visceral and abstract, and though some musicians become writers (John Barth, Anthony Burgess) the leap is rarer. Music is a world of its own; writing and drawing are relatively parasitic upon the world that is in place.

As those who have both drawn and written know, the problems of definition differ radically. A table or a person becomes in graphic representation a maze of angles, of half-hidden bulges, of second and third and fourth looks adding up to an illusion of thereness. When color is added to line, the decisions and discriminations freighted into each square inch approach the infinite; one's eyes begin to hurt, to water, and the colors on the palette converge toward gray mud. Whereas the writer has only to say "table" to put it there, on the page. Everything in the way of adjectival adjustment doesn't so much add as carve away at the big vague shape the word, all by itself, has conjured up. To make the table convincing, a specified color, wood, or number of legs might be helpful; or it might be too much, an overparticularized clot in the flow of the prose. The reader, encountering the word "table," has, hastily and hazily, supplied one from his experience, and particularization risks diminishing,

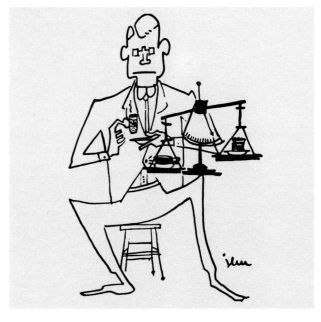

rather than adding to, the reality of the table in his mind. Further, the table takes meaning and mass from its context of moral adventure, from what it tells us about the human being who owns it, his or her financial or social or moral condition; otherwise this piece of furniture exists outside the movement of the story and is merely "painterly."

The painter's media are palpable. The more he tells us, the more we know. What he tells us, goes: his strokes are here and not there, this and not that. Although I rarely have cause in my adult life to open the India ink bottle, when I do, and take the feather-light nib and holder again in hand, and begin to trace wet marks over my pencil sketch on the pristine Bristol board, the old excitement returns—the glistening quick precision, the possibility of smudging, the tremor and swoop that impart life to the lines. Drawing, we dip directly into physical reality. The child discovers that a few dots and a curved line will do for a face, which smiles back out at him. Something has been generated from nothing. Or the pose of a moment has been set down forever; back in my mother's attic, old sketchpads of mine hold pets long dead, infants now grown to adulthood, grandparents whose voices I will not hear again.

Years before words become pliant and expressive, creative magic can be grasped through pen and ink, brush and paint. The subtleties of form and color, the distinctions of texture, the balances of volume, the principles of perspective and composition—all these are good for a future writer to experience and will help him to visualize his scenes, even to construct his personalities and to shape the invisible contentions and branchings of plot. A novel, like a cartoon, arranges stylized versions of people within a certain space; the graphic artist learns to organize and emphasize, and this knowledge serves the writer. The volumes, cloven by line and patched by color, which confront the outer eye—the most vulnerable of body parts, where our brain interfaces with the world—are imitated by those dramatic spaces the inner eye creates, as theaters for thoughts and fantasies. Unconscious, we dream within vivid spaces; when we read a book, we dream in a slightly different way, again slightly different from the way in which the writer dreamed.

Joseph Conrad, introducing his third novel, the novel that committed him to the writer's vocation, made the visual component central: "Art itself may be defined as a single-minded attempt to render the highest kind of justice to the visible universe. . . . It is an attempt to find in its forms, in its colors, in its light, in its shadows, in the aspects of matter and in the facts of life, what of each is fundamental, what is enduring and essential. . . . My task which I am trying to achieve is, by the power of the written word, to make you hear, to make you feel—it is, before all, to make you *see*."

"The highest kind of justice to the visible world"— the phrase, expanded to include "psychological" and "social" along with "visible," nobly sums up what the writer hopes to render. As training to render such justice, no better school exists than graphic representation, with its striving for vivacity, accuracy, and economy. No wonder writers, so many of them, have drawn and painted; the tools are allied, the impulse is one.

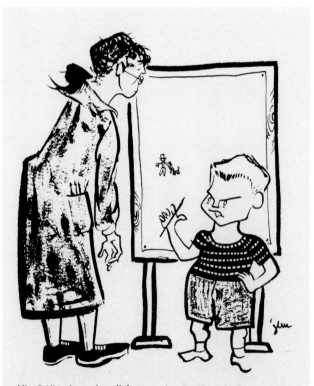

Miss Gridley, I may have little to say, but I'm determined to say it well

For, verily, "art" is embedded in nature;
he who can extract it has it.[1]
ALBRECHT DÜRER

A "UNIQUE" OBJECT, by definition, can be
produced only once. Any artwork produced
by any person is unique. An artwork has a one-time
quality, an intrinsic style that cannot be perfectly
duplicated, even by the person who created it. An
artwork produced just for the joy of it is a reminder of
joy, as well as a spontaneous imprint of the mind that
conceived it.

Artworks created by minds that excel in literature
sometimes hold more of the excess of their creators'
energies than do their words. Freed from the stringent
restraints of traditional art training and demands of the
current artistic schools, authors who eschew the limits
of the language of their trade for a brief moment
have discovered a weightlessness when wielding a
paintbrush that they found intoxicating.

D. H. Lawrence discovered the delight of painting
the day Mrs. Aldous Huxley arrived at his villa in Italy
with four discarded canvases:

I sat on the floor with the canvas propped against a
chair—and with my housepaint brushes and colours in
little casseroles, I disappeared into that canvas.[2]

In his novel *Tarr*, Wyndham Lewis was more explicit
and more caustic as he explained the exhilaration of a
painter painting:

He flung a man or a woman on to nine feet of canvas
and pummeled them on it for a couple of hours, until
they were incapable of moving. . . . He had never been
able to treat people like this in any other way of life, and
he was grateful to painting for the experience.[3]

Goethe and Hesse, the great idealists, often wrote
despairingly of the limitations of writing and of their
yearnings for the freedom of expression to be found in
the visual arts.

The style of any drawing gives obvious insights into
the personality of its creator. The hand that writes
precisely usually draws precisely. Gerard Manley
Hopkins, who in his poetry sought the essence of things
in nature, drew with a thrifty sense of selection.

Stylistically, all caricature is pure analysis. The
artist simplifies and juxtaposes the physical
characteristics of the subject to reveal an exaggerated
picture of the person's complexities of mind—as did
Max Beerbohm. The master caricaturist, Beerbohm
intuitively dissected his victims with the delicacy of a
brain surgeon and reassembled their parts sparingly,
emphasizing one key physical characteristic that he
made into the trademark of the man: the droopy
moustache, the swayback, the elongated head, or the
paunch over tiny feet. For Beerbohm's caricature of
himself, he selected those features that explained his
keen abilities—an oversize intelligent head with large
penetrating eyes.

When I draw a man, I am concerned simply and solely
with the physical aspect of him. I don't bother for one
moment about his soul. I see all his salient points
exaggerated (points of face, figure, port, gesture and
vesture), and all his insignificant points proportionately
diminished. . . . In the salient points a man's soul does
reveal itself, more or less faintly. . . . Thus if one
underline these points, and let the others vanish, one is
bound to lay bare the soul.[4]

Robert Louis Stevenson sketched his island paradise
with an adventurous flair and good humor, whereas
Victor Hugo sketched a beach house on stilts as if it
were a lost soul. James Michener's ingenious ability to
organize mammoth quantities of material into a
workable literary vehicle is evident in the tight, well-
organized composition of his painting *Biography*, laid
out like a checkerboard, each square representing a
significant event in his life.

Writers who give free rein to the abstract and dip
lavishly into their own streams of consciousness, as did

[1] In Erwin Panofsky, *The Life and Art of Albrecht Dürer* (Princeton, N.J.: Princeton University Press, 1955), p. 279.

[2] In Keith Sagar, *The Life of D. H. Lawrence* (New York: Pantheon Books, 1980), p. 212.

[3] Wyndham Lewis, *Tarr* (London: Chatto and Windus, 1918, 1928), p. 74.

[4] In "One of the Family," W. H. Auden, *Forewords & Afterwords*, ed. Edward Mendelson (New York: Random House, 1973), p. 376.

Cocteau and Miller, produce abstract, colorful, open-faced works of art.

Günter Grass gives his visual images, especially his amazing fish, a reality so blunt that they set themselves into the mind of the spectator like concrete, as much fantastic as hard, like his unforgettable literary passages.

William Blake combined his visions with religious fervor to write his descriptions of allegorical kingdoms where good never quite conquers evil. In his artworks, he used symbolic humans and animals, reminiscent of, but not bound to, the conventional physical forms. He transformed natural shapes by manipulating them into inspirational attitudes, arranging them in compositions never used before—which gave them their quality of mysticism. Blake's originality of thought produced unfettered interpretations of heaven and hell that became a concept of ideal majesty and beauty for many succeeding generations of artists and authors alike. There is in his meld of genius and eternal innocence a totally unique impression of humanity transcended.

An artwork by a nonprofessional, however gifted, is not like an art piece by the professional. The professional artist, intent on achieving a particular effect, hones his skills and reworks his compositions toward perfection—much as a professional writer works through reams of paper before he is satisfied with the result. An artwork by an "amateur" is not usually drawn to be exhibited or shown to art critics, nor is it expected to be perfect. The amateur draws an image—just once—just for the pleasure of it, or—for the despair of it.

Spontaneous artworks present a panoply of indelible dreams. It is not possible to judge any of them by standards of artistic merit. Most are not artworks worthy to stand alone: these are fingerprints; self-explorations; portraits of soul; caricatures; random ideas and designs; carefully drawn representations of places seen and loved; or just lazy impressions of nothing. But each one contains a hidden statement—the artist's comment on a particular moment in the mind.

Artworks by authors are important components of the researcher's ongoing quest for more and more detailed historical truth. Unfortunately, visual artwork executed by famous authors is artwork that is born into limbo, belonging neither to the world of art nor to the world of literature.

When an author's drawing is "found"—scribbled on an envelope, tucked into a well-fingered volume, or laboriously drawn out in a forgotten sketching pad—the work becomes a valuable "discovery," but the artwork remains a treasure without classification.

Relegated to the isolated realm of "literary memorabilia," the author's artworks are quite often simply "thrown in" with large collections of manuscripts and correspondence sold or given to institutions by dealers or by the author's family. The "box-under-the-bed" collectors have saved for us most of these prizes, such as the childhood drawings of Tennessee Williams put aside by his mother—or the cartoons drawn for *The Harvard Lampoon* by John Updike, tucked away in an attic. Occasionally, the "middleman" in these transactions prefers to remain anonymous: sometimes it is a worshiping admirer, or a money-hungry friend of the author, or a secret lover, who has collected the most revealing—and most interesting—material.

Some artworks by authors show a high degree of polish, executed by those who planned initially to become professional painters. G. K. Chesterton received formal training at an art academy:

An art school is a place where about three people work with feverish energy and everybody else idles to a degree that I should have conceived unattainable by human nature.[5]

To test his own skills, T. S. Eliot took a special course under a professional artist. The parents of Charlotte and Emily Brontë beggared themselves to provide a formal art education in London for their only son, Branwell, who, they were convinced, was the only offspring likely to succeed in the artistic world. Charlotte stayed home and studied art with a private tutor. Determined to become a great painter, she worked with such intensity, copying intricate engravings, that by the time she was sixteen her

[5] G. K. Chesterton, *The Autobiography of G. K. Chesterton* (New York: Sheed & Ward, 1936), p. 86.

eyesight was almost ruined. Forced to wear thick glasses for the rest of her life, she never dared draw again.

Edwin Estlin Cummings was not satisfied to be simply a famous writer, but drove himself to the disciplined study of art, seriously intending to become even more famous as a painter. On a daily basis, whenever possible, he practiced: producing anatomical studies of animals and people, color charts, muscle charts, cartoons, line drawings of circus performers—and his beloved elephants—oil portraits of his wife and of himself, watercolors of the family farm. He stationed himself, as often as he could, on a bench in New York's Washington Square, within walking distance of his apartment, to sketch in specially designed drawing pads the exciting city life around him. When the square's ancient apple tree was chopped down by "progress," cummings and his wife moved to their farm in New Hampshire. In 1931, he exhibited his artworks with other artists in the Painters & Sculptors Gallery in New York. The catalogue, *CIOPW* (crayon, ink, oil, pastel, watercolor), is considered today to be an artwork in itself. In it, cummings deemed himself "an author of pictures, a draughtsman of words." In 1945, the Rochester Memorial Art Gallery honored him with his first one-man show. Cummings's artworks fully demonstrate the diversity of his talents—with a concentration on optimism—but the ingenuity they exposed would, nevertheless, be forever eclipsed by the genius of his poetry.

Another author absorbed by the passion to paint was the editor of a Dublin periodical, George Russell "AE," friend of William Butler Yeats. He painted hundreds of oils, many of them wistful landscapes of his beloved Ireland, peopled with dreamlike mothers and children at play. When, in later life, he moved to Bournemouth, England, he nostalgically decorated the walls of his office with murals of woodland greenery where ethereal humans and wood nymphs cavorted.

Famous people have often used art as a crutch, sometimes secretly, their thinking tainted perhaps by Plato's assertion that painting was the "lesser" of the arts. Using painting and drawing as a release for emotional tensions is now an accepted practice of twentieth-century psychotherapy. Before the age of

analysis, dabbling in paint was considered just another "hobby."

When Henry Miller discovered that his wife had deserted him, to exorcise his pain he frenziedly painted the walls of their basement apartment with hideous portraits of her and of her lover, whom he depicted as a skull being consumed by serpents, surrounded by mandalas.

But compulsive violence does not necessarily produce artworks of merit; they can, however, be achieved by serious application, as Miller was to learn. Following his distraught exodus to Paris in 1929, he suffered from writer's block while trying to finish *Dion Moloch*. He was encouraged by his friend John Nicholas to work out his frustrations and overpowering emotional surges on paper, with paint. As Nicholas described it: ". . . he wielded the brush and sponge with reckless abandon—but abandon was now his byword in everything and he felt that by increasing his speed and destroying premeditation he made a leap forward in painterly technique."[6]

While turning out hundreds of sketches and watercolors, Miller documented his self-torments and his observations of the creative process in letters to a friend in New York. These wise and witty messages were published thirty-nine years later in a little volume about life and art worthy to be any artist's first guidebook. The same year, Miller was made to realize that his overflow of enthusiasms had produced something with monetary as well as artistic value. When a friend found Miller living in near poverty in California, he arranged for the author's first showing and the sale of his watercolors, now highly prized.

What's important about drawing is drawing, the doing it right or wrong, good or bad, finished or unfinished. The effort, in other words. Them as wants perfect horses, perfect nudes, perfect architecture, let them go to those as makes 'em.[7]

While waiting apprehensively for the première of

[6] In Jay Martin, *Always Merry and Bright* (Santa Barbara, Calif.: Capra Press, 1978), p. 221.

[7] Henry Miller, *To Paint Is to Love Again: Including Semblance of a Devoted Past* (New York: Grossman Publishers, 1968), pp. 5,7.

Summer and Smoke, Tennessee Williams spent many restless nights in New Orleans working out ideas for a new play to be entitled *The Poker Night* and painting portraits on cheap canvasboard. Watching the lusty street life at night from his window, he changed the name of the new play to *A Streetcar Named Desire*, for which he won the Pulitzer Prize in 1948.

In 1938, T. H. White had completed the first part of his Arthurian quartet, *The Once and Future King*, and was agonizing over his decision to expatriate himself to Ireland just before the outbreak of World War II. From Doolistown, he wrote to David Garnett in London in 1944: "There is no one to talk to: there is no sense in Ireland: there are no fish in the Boyne, there are no books in the telephone booths."[8] In the bleak silence of the moors, his only friends falcons and dogs, White attempted to expiate his guilt about the war and about not joining the Catholic Church by painting "grotesqueries" in oil. A chance guest described them: ". . . his fantastic (and I think almost totally worthless) paintings, with glass eyes tucked into the oil paint, bits of silver paper and so on. These I think were therapy, as I don't remember being asked to admire them more than perfunctorily."[9]

Somewhere between the obsessive artist and the carefree dabbler is the author who understood how to enjoy his second talent. William Makepeace Thackeray, Johann Wolfgang Goethe, and John Ruskin belong to this category. Ruskin, who never left home without a sketchbook, had astounded the critics at an early age with his knowledge of art and had written of his ambitions with youthful verve:

I rather want good wishes just now, for I am tormented by what I cannot get said, nor done. I want to get all the Titians, Tintorets, Paul Veroneses, Turners and Sir Joshuas in the world into one great fireproof Gothic gallery of marble and serpentine. I want to get them all perfectly engraved. I want to go and draw all the subjects of Turner's nineteen thousand sketches in Switzerland and Italy, elaborated by myself. I want to get everybody a dinner who hasn't got one.[10]

The need for funds is another very potent reason for picking up a paintbrush. To secure money enough to leave her family and go to Paris to write, Aurore Dupin Dudevant tried several trades:

I'd tried translations: they were too time-consuming, and caused me too much trouble and too many pangs of conscience; quick portrait sketches in chalk or watercolors: I caught the likeness cleverly, and passably drew my little heads, but they were unoriginal: dressmaking: I was fast, but did not sew nicely enough, and learned that what I made could bring in less than a franc a day. . . . For four years I groped about and toiled and moiled over nothing worth a straw, to discover in myself a talent for . . . anything.[11]

When Aurore found that the ladies' fans and snuff boxes she had painted sold for a good price, she took her profits and went to Paris, publishing her first novel there under the name of George Sand. *Indiana* was a great success and made her famous overnight, although her work would never obtain the lasting prominence achieved by that of her famous lovers, Prosper Mérimée, Alfred de Musset, and Frédéric Chopin.

Knowing only that he wished to make his career in the world of art, Evelyn Waugh explored some of its glamorous potential by helping his brother's fiancée paint a mural on the wall of her bedroom and by performing in an amateur film with the young Elsa Lanchester. At sixteen, Evelyn was apprenticed to an illuminist—an illustrator of fine manuscripts—whose task was to prepare the boy to make a living as an artist. However, the following year, Waugh entered the enlightened environs of Oxford, where the intellectual life, literature, and other ambitions overtook his plans for a career in art.

Artworks produced for relaxation, discipline, or therapy often hide many interesting stories, and unearthing the facts behind the images enhances their value. The lives of famous people are intriguing puzzles that no historian can resist until all the pieces have

[8] Sylvia Townsend Warner, *T. H. White* (London: Jonathan Cape with Chatto and Windus, 1967), pp. 204–5.

[9] Ibid., pp. 205–6.

[10] In E. T. Cook, *The Life of John Ruskin*, vol. 1 (London: George Allen & Company, 1912), p. 471.

[11] In André Maurois, *Lélia: The Life of George Sand*, trans. Gerard Hopkins (New York: Harper & Bros., 1953), p. 199.

been gathered together. These pieces of the literary puzzle explain a great deal about the artist's life and the impetus behind the writing, including some things never fully explained before, as in the youthful odyssey of William Faulkner.

Little is ever said about Faulkner's artworks, yet they are remarkably sophisticated. Malcolm Cowley recalled, in his biography of Faulkner, that Faulkner had said that his mother wished him to become a painter and that he had learned to paint in their kitchen on his mother's easel.

In 1914, Faulkner was not attending school, but reading Swinburne, Keats, Conrad Aiken, and Sherwood Anderson—and painting. Fascinated by airplanes, he drew pictures of them inside his textbook covers, then played hookey from school to build his own plane, which he crashed on takeoff. This passion led him later to join the Royal Air Force in Canada during World War I, where he obtained another airplane and flew it through the roof of a hangar. Mementos of this escapade were: his Flight Manuals covered with sketches of his fellow cadets and a distinguished lifelong limp in one leg.

After the war, Faulkner produced illustrations for the University of Mississippi magazine and the *Ole Miss.* yearbook (1920). He also wrote, illustrated, and planned to produce a play, but *Marionettes* was never performed and the script never published commercially.

When Faulkner lost his job as postmaster of Oxford, Mississippi, for playing cards in the back room of the post office, he moved to New Orleans to seek work. There he produced holograph books, hand-printed text with original ink illustrations, but success did not follow. Of his best, *Royal Street, New Orleans*, there is only one copy.

Faulkner's collaboration with William Spratling and Sherwood Anderson on a slim volume of caricatures entitled *Sherwood Anderson and Other Creoles* (privately printed in 1926) made no money. Faulkner returned to Oxford and joined the staff of an embryo literary magazine—as the art editor. He christened the publication *The Scream*, in respectful remembrance of eagles that had harassed the boy scout camp where he had been scoutmaster, and drew some cartoons for it.

The magazine soon expired.

These tantalizing drawings mark the zigzag trail Faulkner left behind during his early attempt to earn his place in the continuum. They reveal personality traits that made him one of America's greatest writers: perseverance in the face of adverse circumstances, a tender attention to detail, and the subtle sense of humor that endeared him to his readers.

We have one priceless universal trait, we Americans. That trait is our humor. What a pity it is that it is not more prevalent in our art. . . . One trouble with us American artists is that we take our art and ourselves too seriously. And perhaps seeing ourselves in the eyes of our fellow artists, will enable those who have strayed to establish anew a sound contact with the fountainhead of our American life.[12]

Faulkner's is only one of many trails left in ink, watercolor, oil, and other mediums that we may follow, tracking the famous to their inspired destinations. Maps of the mind, fascinating yet informational scraps to spur the curious romantic and the amateur analyst, these are the little jewels of the literati. Serious scholars call them visual aids. But whatever honorable title we finally decide to award to them, these works should be shown and appreciated for the candid contribution they make toward completing definitive biographical portraits of their masters.

The clues left by these colorful testimonials to *joie de vivre* can provide the scholar, the humanist, and especially the psychiatrist—amateur or professional— with some intriguing glimpses into the creative forces churning within us all, and—perhaps—impel them to explore further.

KATHLEEN G. HJERTER

[12] Introduction to *Sherwood Anderson & Other Famous Creoles*, 1926, in *Essays, Speeches and Public Lectures by William Faulkner*, ed. James B. Meriwether (New York: Random House, 1965), p. 174.

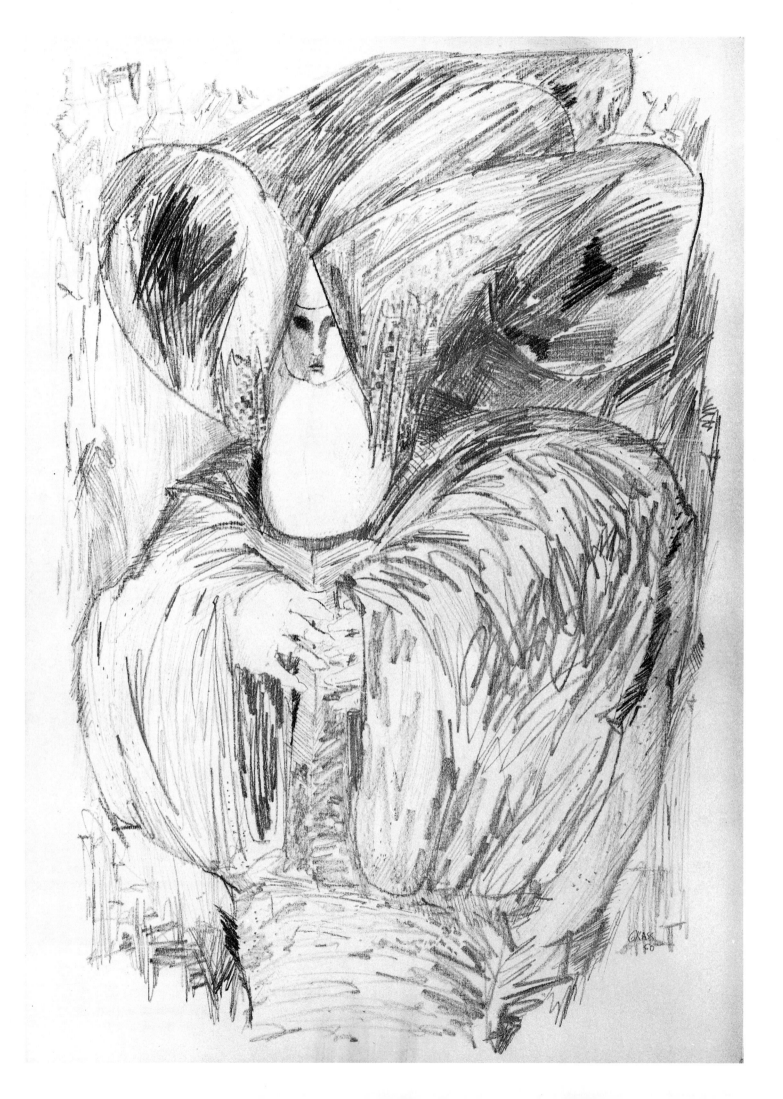

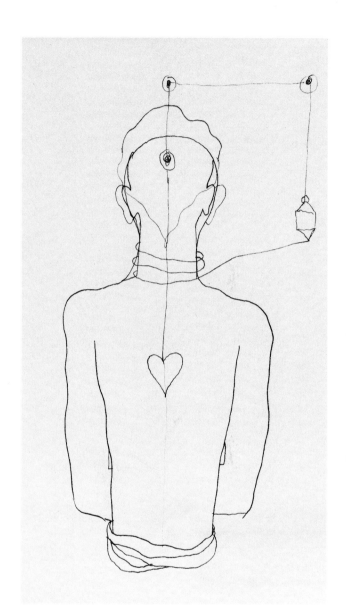

Silence, oh poet, you do not know
what you are saying; this picture serves
a nobler sense than your work.
LEONARDO DA VINCI

JOHANN WOLFGANG GOETHE

GERMAN | 1749–1832

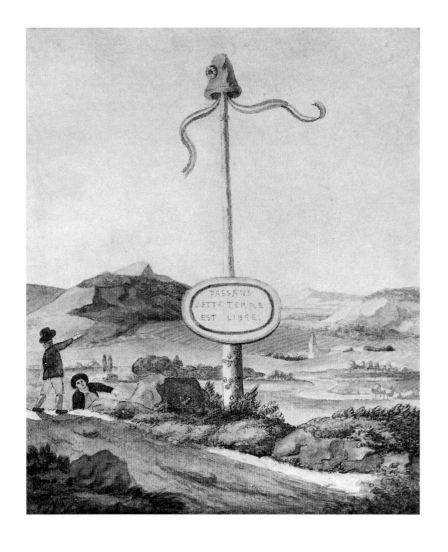

*We ought to talk less and draw more.
I, personally, should like to renounce speech
altogether and, like organic nature,
communicate everything I have to say
in sketches.*

"My Italian Journey," 1787, in W. H. Auden, *Forewords & Afterwords*, ed. Edward
Mendelson (New York: Random House, 1973), p. 133.

Landscape with the Freedom Tree. 1792. Ink with watercolor wash,
14 × 10½″. Goethe-Museums, Anton-und-Katharina-Kippenberg-
Stiftung, Düsseldorf

Goethe was an eyewitness to the Battle of Valmy, 20 September
1792, in which mobs of French citizens defeated a highly trained
army of German regulars.

OPPOSITE, ABOVE:
Karlsbad Landscape with the Andreas Chapel. 1812. Ink with sepia
wash, 4 × 7¾″. Goethe-Museums, Anton-und-Katharina-
Kippenberg-Stiftung, Düsseldorf

OPPOSITE, BELOW:
The Chapel of St. Lawrence in Karlsbad. 1808. Ink with sepia wash,
4¼ × 5¾″. Goethe-Museums, Anton-und-Katharina-Kippenberg-
Stiftung, Düsseldorf

*My poor little bit of sketching is priceless to me; it helped my
conception of material things; one's mind rises more quickly to
general ideas, if one looks at objects more precisely and keenly.*

Letter to Frau Von Stein from Rome, 1787, *Letters from Goethe*, trans. Dr. M. von
Herzfeld and C. Melvil Sym (Edinburgh: The Edinburgh University Press, 1957),
p. 188.

WILLIAM BLAKE

BRITISH | 1757–1827

Chaucer's Canterbury Pilgrims. 1810. Engraving, third state,
11⅝ × 38″. Harry Ransom Humanities Research Center Art
Collection, The University of Texas at Austin

Blake's engraving illustrates the pilgrimage to the cathedral in
Canterbury where St. Thomas à Becket was murdered, so aptly
described by Geoffrey Chaucer in 1389. Engraved in the plate are
the names of Chaucer's characters.

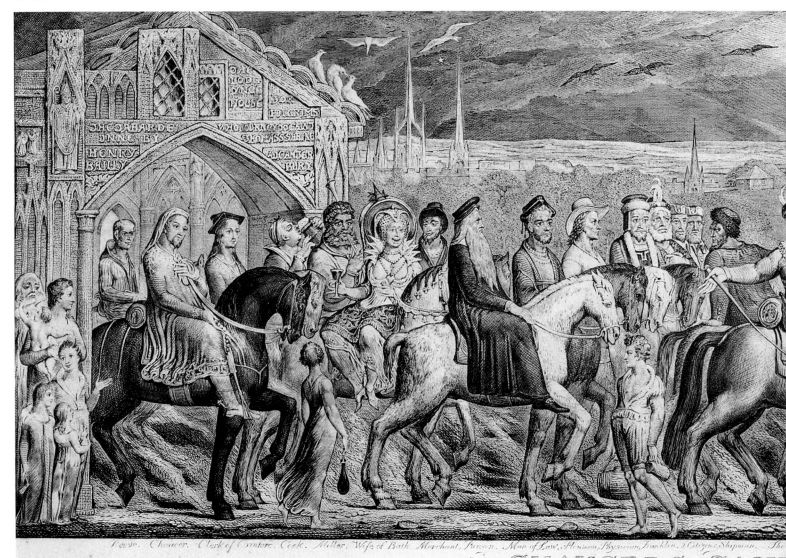

...*I know that This World Is a World of imagination & Vision. I see Every thing I paint In This World, but Every body does not see alike....Some See Nature all Ridicule & Deformity, & by these I shall not regulate my proportions; & Some Scarce see Nature at all. But to the Eyes of the Man of Imagination, Nature is Imagination itself. As a man is, So he Sees. As the Eye is formed, such are its Powers. You certainly Mistake, when you say that the Visions of Fancy are not to be found in This World.*

Letter to Dr. Trusler, 1799, *The Letters of William Blake*, ed. Geoffrey Keynes (London: Rupert Hart-Davis, 1956), pp. 34–35.

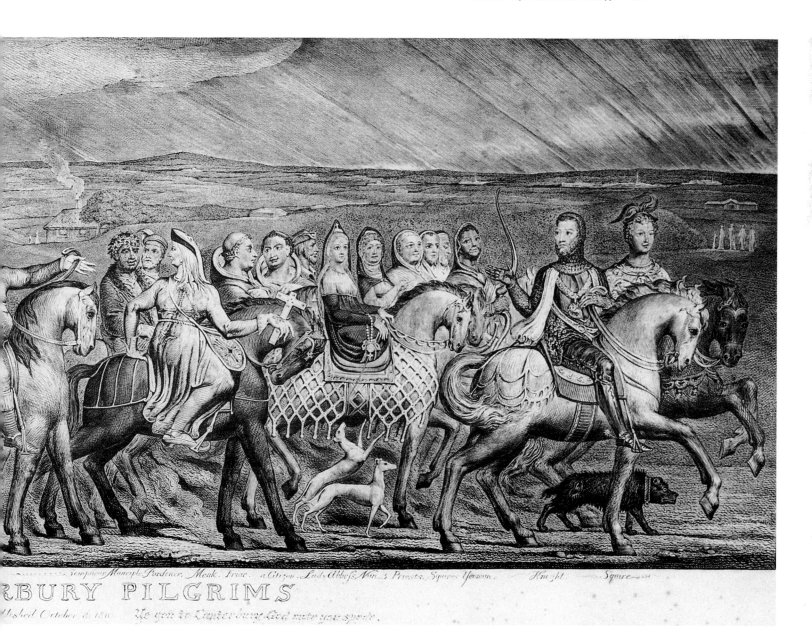

RBURY PILGRIMS

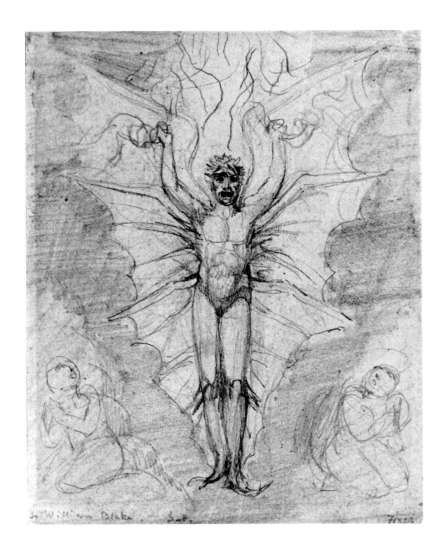

Satan Calling Up His Legions. c. 1780. Pencil on paper, 5⅝ × 4⅝″. Signed lower left in pencil: "William Blake." Harry Ransom Humanities Research Center Art Collection, The University of Texas at Austin. T. E. Hanley Collection

Truly, my Satan, thou art but a dunce,
 And dost not know the garment from the man;
Every harlot was a virgin once,
 Nor canst thou ever change Kate into Nan.

Tho' thou art worshiped by the names divine
 Of Jesus and Jehovah, thou art still
The son of Morn in weary Night's decline,
 The lost traveller's dream under the hill.

"To the Accuser Who Is the God of This World," 1793, Epilogue to *For the Sexes: The Gates of Paradise*, *The Complete Poetry and Prose of William Blake*, ed. David V. Erdman (Berkeley: University of California Press, 1982), p. 269.

OPPOSITE:

The Shepherd. 1789. Color engraving, hand-tinted, 4½ × 3″. Harry Ransom Humanities Research Center Manuscripts Collection, The University of Texas at Austin

The Shepherd is one of the plates produced by William Blake and his wife for the original edition of *Songs of Innocence*, a volume of verse designed, executed, colored, and printed by the author/artist.

How sweet is the Shepherd's sweet lot!
From the morn to the evening he strays;
He shall follow his sheep all the day,
And his tongue shall be filled with praise.

"The Shepherd," 1789, *Songs of Innocence* (Garden City, N.Y.: Doubleday & Co., 1966), p. 27.

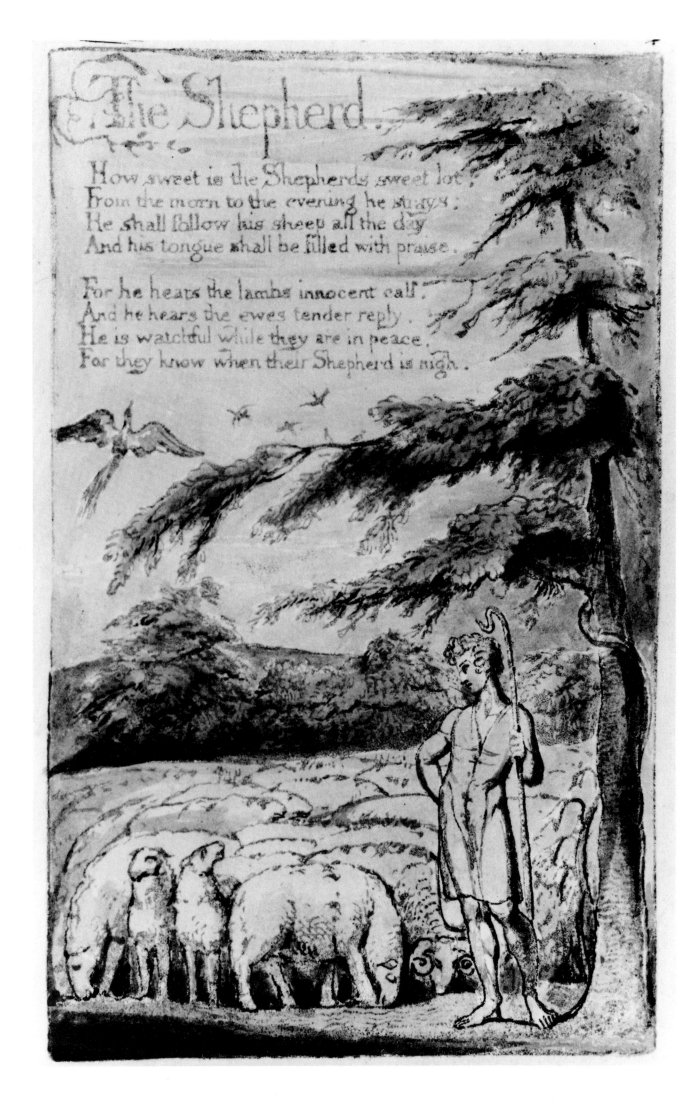

The Shepherd.

How sweet is the Shepherds sweet lot,
From the morn to the evening he strays;
He shall follow his sheep all the day
And his tongue shall be filled with praise.

For he hears the lambs innocent call.
And he hears the ewes tender reply.
He is watchful while they are in peace,
For they know when their Shepherd is nigh.

VICTOR HUGO

FRENCH | 1802–1885

L'Eclair. Published in *Sonnets et Eaux-fortes*, Paris, 1869. Etching, 8¾ × 6¼″. The New York Public Library, Astor, Lenox and Tilden Foundations, New York. Print Collection

...as a means of contrast with the sublime, the grotesque is, in our view, the richest source that nature can offer art.... Sublime upon sublime scarcely presents a contrast, and we need a little rest from everything, even the beautiful. On the other hand, the grotesque seems to be a halting-place, a mean term, a starting-point whence one rises toward the beautiful with a fresher and keener perception.

Preface to "Cromwell," 1827, in Charles W. Eliot, ed., *The Harvard Classics*, vol. 39 (New York: P. F. Collier & Son, 1938), pp. 348–49.

Elegant Group on Stairs. c. 1837? Pen, brown ink, and wash,
9⅜ × 7¼″. Nelson-Atkins Museum of Art, Kansas City, Missouri.
Gift of Kate Schaeffer

Victor Hugo enjoyed sketching his performers in rehearsal as well
as costumed society. He papered his apartment with drawings of the
romantic wedding of his patroness, Princess Hélène de
Mecklenburg, to the Duc d'Orléans, son and heir of King Louis-
Philippe, at the Château de Fontainebleau, where Hugo was one of
1,500 guests.

Low Tide. 1842. Ink, 18 × 24″. The Beinecke Rare Book and
Manuscript Library, Yale University, New Haven, Conn. Norman
Holmes Pearson Collection

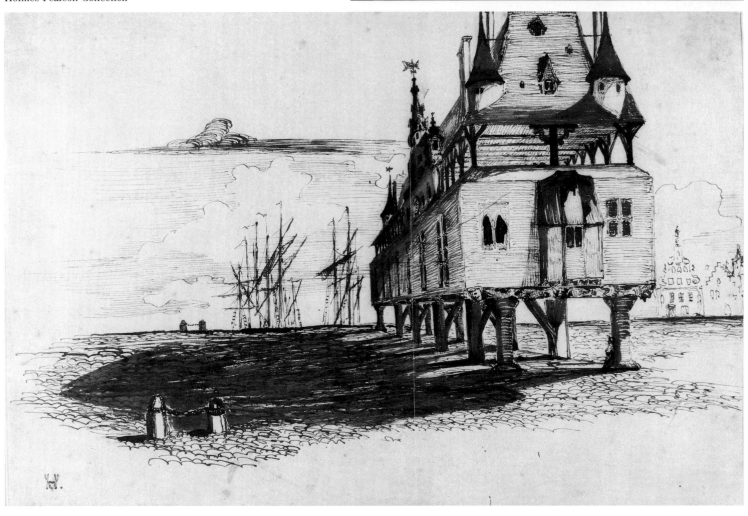

PROSPER MÉRIMÉE

FRENCH | 1803–1870

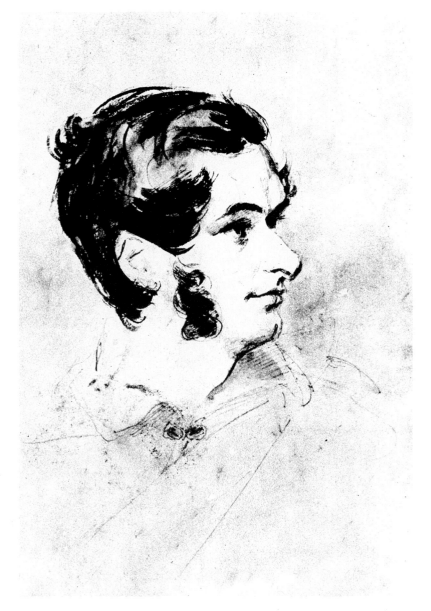

LEFT, ABOVE:
Self-portrait. 1833. Ink, 7¾ × 5″. Private collection. Courtesy Éditions Gallimard, Paris

LEFT, BELOW:
Alexandre Dumas, père, with Jeanne de Tourbey. c. 1860. Iron-gall ink on paper, 6⅞ × 9″. Harry Ransom Humanities Research Center Art Collection, The University of Texas at Austin. Artine Artinian Collection

Dumas, author of *The Three Musketeers*, was often heard to say, "My minutes are as precious as gold. When I put on my shoes, it costs me 500 francs." Jeanne de Tourbey, "The Lady of the Violets," was the mistress of Ernest Baroche, son of the Minister of Justice.

In Alexandre Dumas *fils*, *The Road to Monte Cristo, Condensation from the Memoirs of A. Dumas* (père), ed. Jules Eckert Goodman (New York: Charles Scribner's Sons, 1956), p. 267.

OPPOSITE:
George Sand. 1833. Iron-gall ink on paper, 6⅜ × 5¼″. Harry Ransom Humanities Research Art Collection, The University of Texas at Austin. Artine Artinian Collection

Mérimée pictured his mistress of eight days in Spanish dress, posed in the attitude of Goya's portrait of the Duchess of Alba, her hand pointing to the name of her lover in the sand.

I see her everywhere...her great black eyes, like the eyes of a young cat...gentle and wicked at once.

"Une femme est un diable," *Les Espagnols en Danemarck*, 1824, in G. H. Johnstone, *Prosper Mérimée: A Mask and a Face*, p. 30.

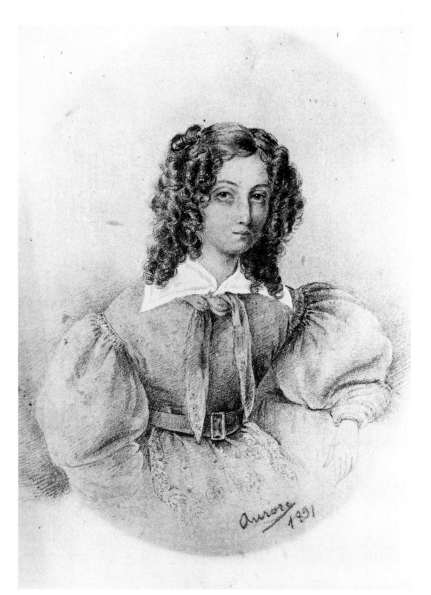

GEORGE SAND

FRENCH | 1804–1876

LEFT, ABOVE:

Self-portrait. 1831. Ink, watercolor wash with Chinese white, 7⅛ × 6¼″. Signed: "Aurore." Bibliothèque de la Ville de Paris

Phooey on that old grace which consists in artfully pinching snuff, affectedly wearing an embroidered jacket or a train, rattling a sword or plying a fan.

In André Maurois, *Lélia: The Life of George Sand*, p. 106.

LEFT, BELOW:

Frédéric Chopin. c. 1838, Italy. Pencil, 7 × 6″. Bibliothèque de la Ville de Paris

I'm beginning to believe that there are angels disguised as men who pass themselves off as such and who inhabit the earth for a while to console and lift up with them toward heaven the poor, exhausted and saddened souls who were ready to perish here below.

Letter to Eugène Delacroix about Chopin, in Curtis Cate, *George Sand: A Biography* (Boston: Houghton Mifflin Company, 1975), p. 456.

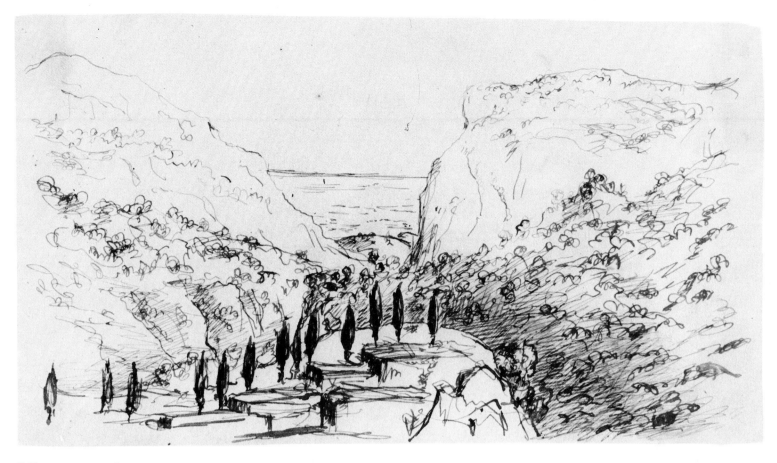

Valdemosa. c. 1859. Sepia with watercolor wash.
Courtesy French Cultural Services, New York

So much lunatic and ingenious scribbling—charming drawings or mad caricatures, painting in water-colour or tempera, the making of models of all kinds, flower studies from nature by lamplight, sketches dashed off from imagination or impressions of the morning walk, the preparation of entomological specimens, building of cardboard models, copying of music, somebody writing letters, somebody else writing comic verses, piles of wool or silk for embroidery, construction of scenes for the· puppets, costume making for the same, games of chess or piquet—a hundred and one things. Everything that people do in a family party in the country, with talking going on all round, during the long autumn and winter evenings....

In André Maurois, *Lélia: The Life of George Sand*, trans. Gerard Hopkins (New York: Harper & Brothers, 1953), p. 371.

ALFRED DE MUSSET

FRENCH | 1810–1857

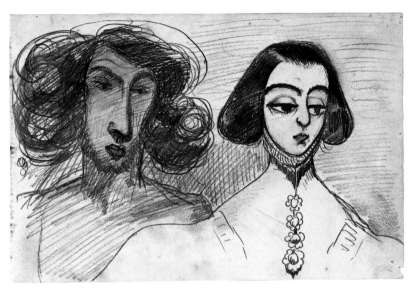

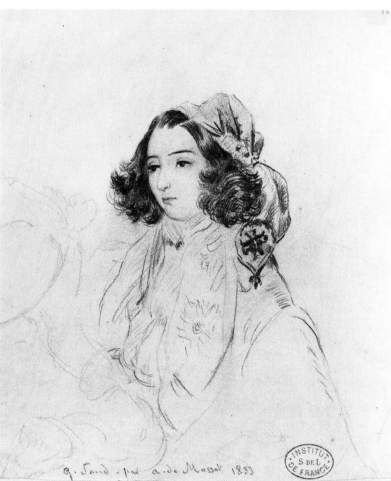

q. Sand par a. de Musset 1833

I studied painting. There, doubtless, in that plastic art, which is concerned only with lines and colors, the truth would have to appear to me.

Confession d'un Enfant du Siècle, in Geraldine Pelles, *Art, Artists and Society* (Englewood Cliffs, N.J.: Prentice-Hall, 1963), p. 66.

LEFT, ABOVE:
Caricature of Musset and George Sand. c. 1834. Pencil, 5 × 8″. Private collection

Alfred de Musset was twenty-three, a successful author and a dandy, derisively referred to by the sculptor Préault as "Mademoiselle Byron," when he met Sand. Sand, twenty-nine, received "my urchin Alfred" in her dressing gown of yellow silk, Turkish slippers, and a Spanish mantilla.

Posterity shall speak our names as it does those of the immortal lovers who are for ever linked—Romeo and Juliet, Héloise and Abélard. Never shall one be spoken without the other.

Letter to George Sand, 1833, in *The Intimate Journal of George Sand*, trans. Marie J. Howe (Chicago: Academy Chicago Publishers, 1978), p. 186.

LEFT, BELOW:
George Sand. 1834. Pen and ink, 6 × 4″. Bibliothèque de la Ville de Paris

When Sand realized that the affair was really over, in despair she cut off her hair and sent it to Musset. Delacroix painted her in this manner, with cropped hair, and the portrait was exhibited in the Louvre. Alfred de Musset wrote:

I had a kind of brooding desire to possess her once again, to drink all those bitter tears on that magnificent body, and then to kill both of us!

In Curtis Cate, *George Sand: A Biography* (Boston: Houghton Mifflin Company, 1975), p. 263.

OPPOSITE:
George Sand. 1833. Pen and ink, 9 × 7″. Bibliothèque de la Ville de Paris

In 1833 Sand and Musset went to Venice together, where their flaming love affair cooled and burned out. According to her journal, George Sand was told by Alfred de Musset, "George, I was wrong about my feelings: I ask you to forgive me, but the fact is I do not love you." In Paris, 1834, George Sand wrote in her journal, "Phantom of my burning nights, angel of death, fatal love, my destiny! How I still love you, assassin! Let your kisses burn me! Let me be utterly consumed by you! Then throw my ashes to the winds of heaven."

George Sand, *The Intimate Journal of George Sand*, pp. 175 and 40.

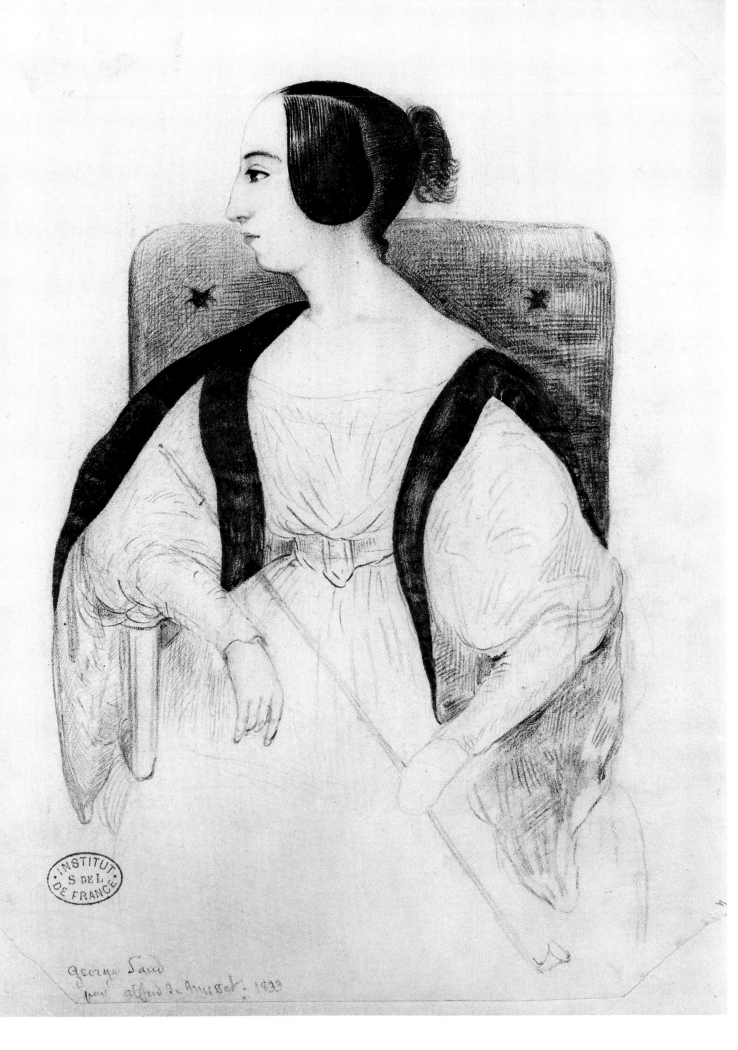

George Sand
par alfred de Musset. 1833

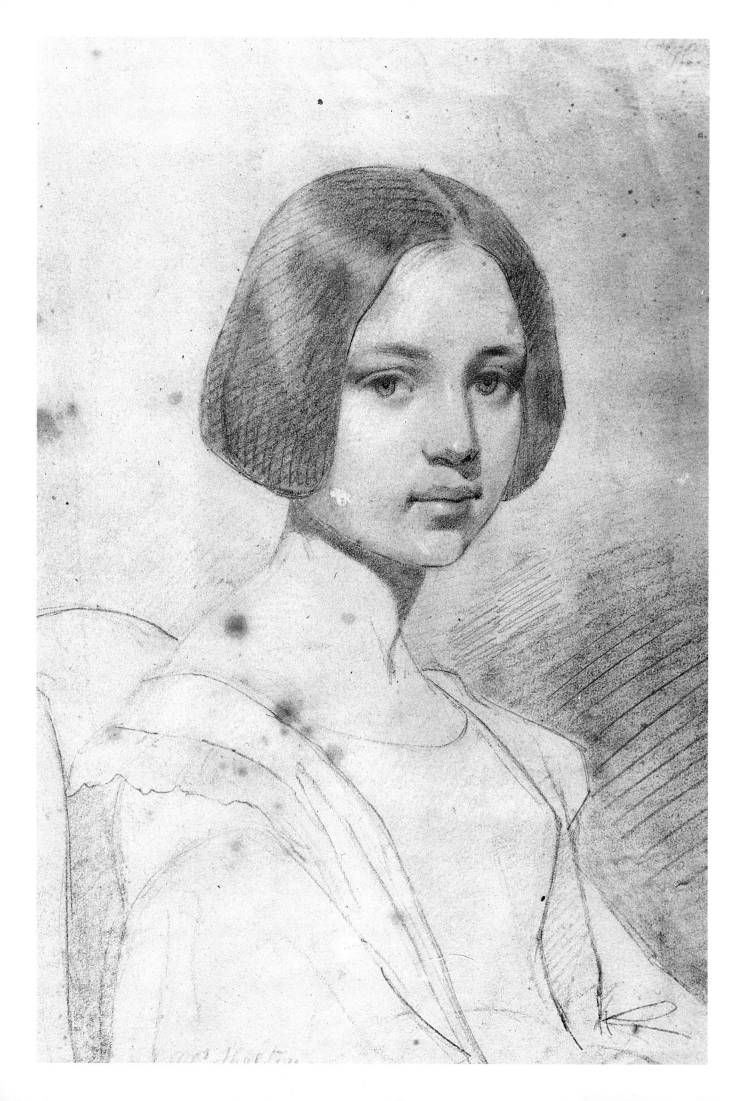

EDGAR ALLAN POE

AMERICAN | 1809–1849

Were I called on to define, very briefly, the term "Art," I should call it "the reproduction of what the Senses perceive in Nature through the veil of the soul."

"Marginalia," *The Centenary Poe*, ed. and intro. Montagu Slater (London: The Bodley Head, 1949), p. 539.

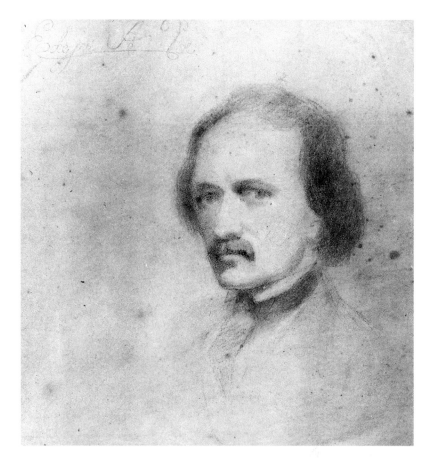

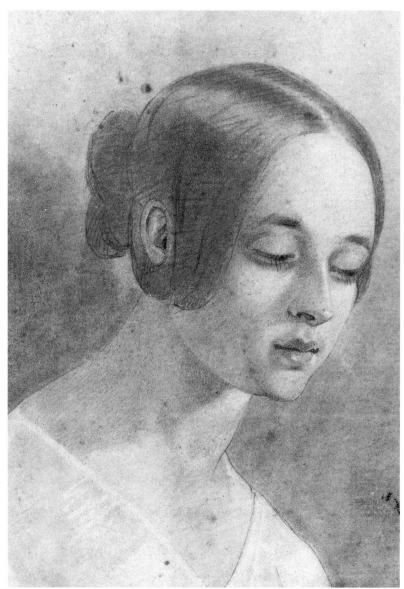

OPPOSITE:
Portrait of Elmira Royster Shelton. 1845. Crayon, 11 × 8¾". Lilly Library, Indiana University, Bloomington, Ind.

Mrs. Shelton and Poe planned to wed the year he mysteriously disappeared and died.

RIGHT, ABOVE:
Self-portrait. 1845. Crayon, 5⅞ × 6⅝". Lilly Library, Indiana University, Bloomington, Ind.

RIGHT, BELOW:
Portrait of Virginia Clemm Poe. 1845. Crayon, 6½ × 5¾". Lilly Library, Indiana University, Bloomington, Ind.

Virginia Clemm was very young when she married Edgar Allan Poe and very young when she died in winter at their small cottage in Fordham, New York, her only cover her impoverished husband's overcoat.

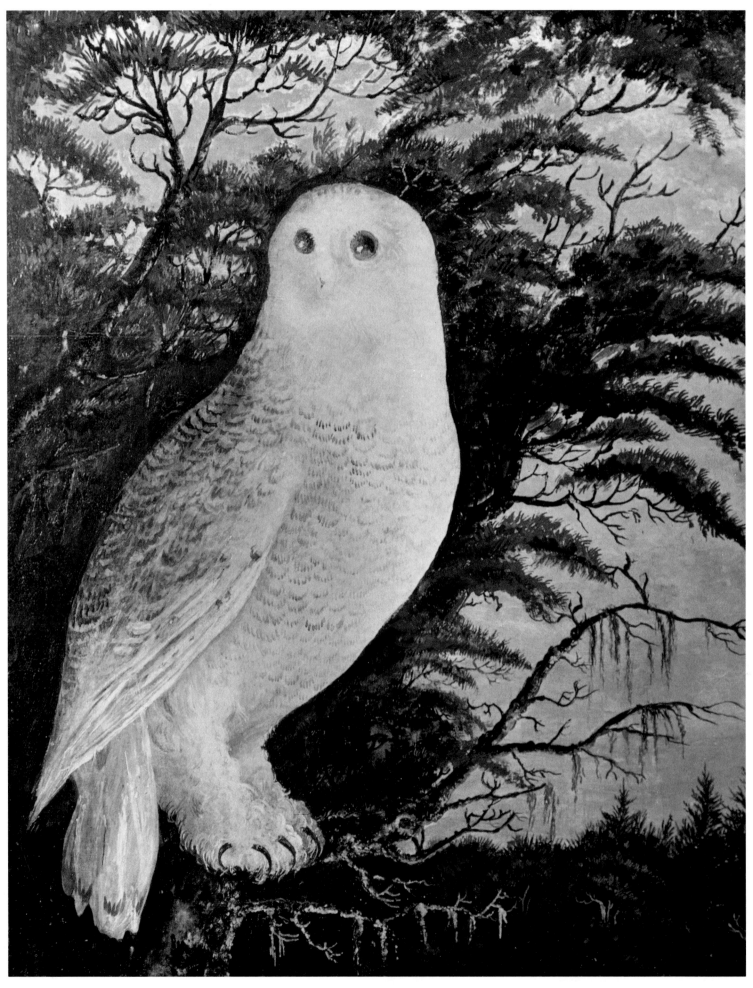

HARRIET BEECHER STOWE

AMERICAN | 1811–1896

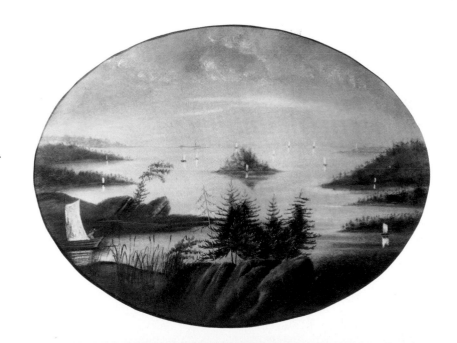

I propose, my dear grandmamma, to send you by the first opportunity a dish of fruit of my own painting. Pray do not now devour it in anticipation, for I cannot promise that you will not find it sadly tasteless in reality. If so, please excuse it for the sake of the poor young artist.

Letter to Stowe's grandmother, 1827, *Life and Letters of Harriet Beecher Stowe*, ed. Annie Fields (Boston: Houghton, Mifflin & Co., 1897), p. 65.

OPPOSITE:
Snowy Owl. Oil on canvas, 26 × 20″. The Stowe-Day Foundation, Hartford, Conn.

This is the only study of an animal known to have been painted by Mrs. Stowe.

RIGHT, ABOVE:
Casco Bay (Maine). Gouache, 14½ × 15″. The Stowe-Day Foundation, Hartford, Conn.

This seascape probably dates from 1851–53, the period when the family lived in Brunswick, Maine, at the north end of the bay.

RIGHT, BELOW:
White Magnolias (Magnolia Grandiflora). After 1867. Watercolor, 18 × 15″. The Stowe-Day Foundation, Hartford, Conn.

A flower is commonly thought the emblem of a woman; and a woman is generally thought of as something sweet, clinging, tender, and perishable. But there are women flowers that correspond to the forest magnolia,—high and strong, with a great hold of root and a great spread of branches; and whose pulsations of heart and emotion come forth like these silver lilies that illuminate the green shadows of the magnolia forests.

Palmetto Leaves, 1873, facsimile reproduction by Mary B. Graff and Edith Cowls (Gainesville: University of Florida Press, 1968), p. 165.

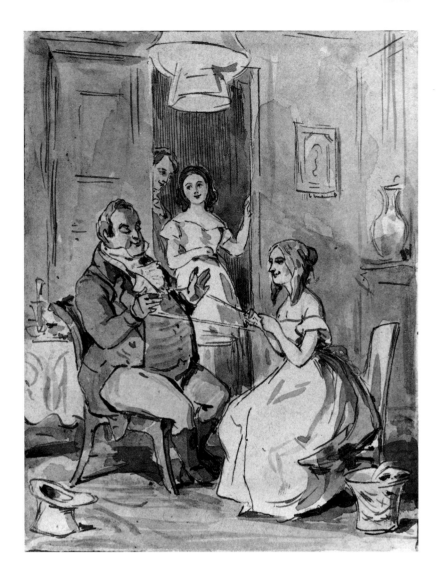

WILLIAM MAKEPEACE THACKERAY

BRITISH | 1811–1863

Miss, very few pictures or statties are worth a pin. After dangling for hours about the Exposition at Paris I came to that conclusion irrevocably. So and so, this portrait or that landscape is very nice; but apres? Bon Dieu what's the use of doing them? Say you can copy trees or human faces skilfully, well? Say you can black boots, or make puddings, or turn guncracks at a lathe, why not? Nothing is so overrated as the Fine Arts. . . ."

Letter to Mrs. Theresa Hatch, 15 May 1859, *The Letters and Private Papers of William Makepeace Thackeray*, ed. Gordon N. Ray, vol. 4 (Cambridge, Mass.: Harvard University Press, 1946), p. 141.

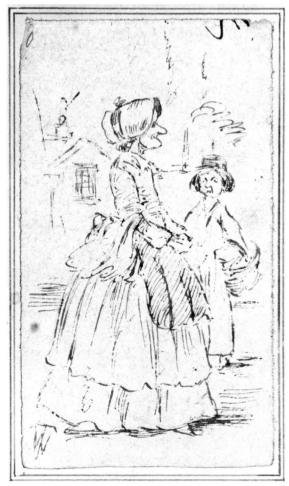

LEFT, ABOVE:
Mr. Joseph Entangled. Illustration for *Vanity Fair*. 1847. Pencil and watercolor, 5⅛ × 3⅞". Harry Ransom Humanities Research Center Art Collection, The University of Texas at Austin

And before he had time to ask how, Mr. Joseph Sedley, of the East Indian Company's service, was actually seated tete-a-tete with a young lady, looking at her with a most killing expression, his arms stretched out before her in an imploring attitude, and his hands bound in a web of green silk, which she was unwinding.

Vanity Fair (New York: The Modern Library, 1950), p. 37.

LEFT, BELOW:
Miss Crawley. Illustration for *Vanity Fair*. 1847. Pencil and watercolor wash, 4⅜ × 2½". Harry Ransom Humanities Research Center Art Collection, The University of Texas at Austin

As the only endowments with which Nature had gifted Lady Crawley were those of pink cheeks and a white skin, and as she had no sort of character, nor talents, nor opinions, nor occupation, nor amusements, nor that vigour of soul and ferocity of temper which often falls to the lot of entirely foolish women, her hold upon Mr. Pitt's affections was not very great.

Vanity Fair, p. 80.

OPPOSITE:
Stratford Church. c. 1823. Pencil and watercolor on paper, 8¾ × 6⅞". Harry Ransom Humanities Research Center Art Collection, The University of Texas at Austin

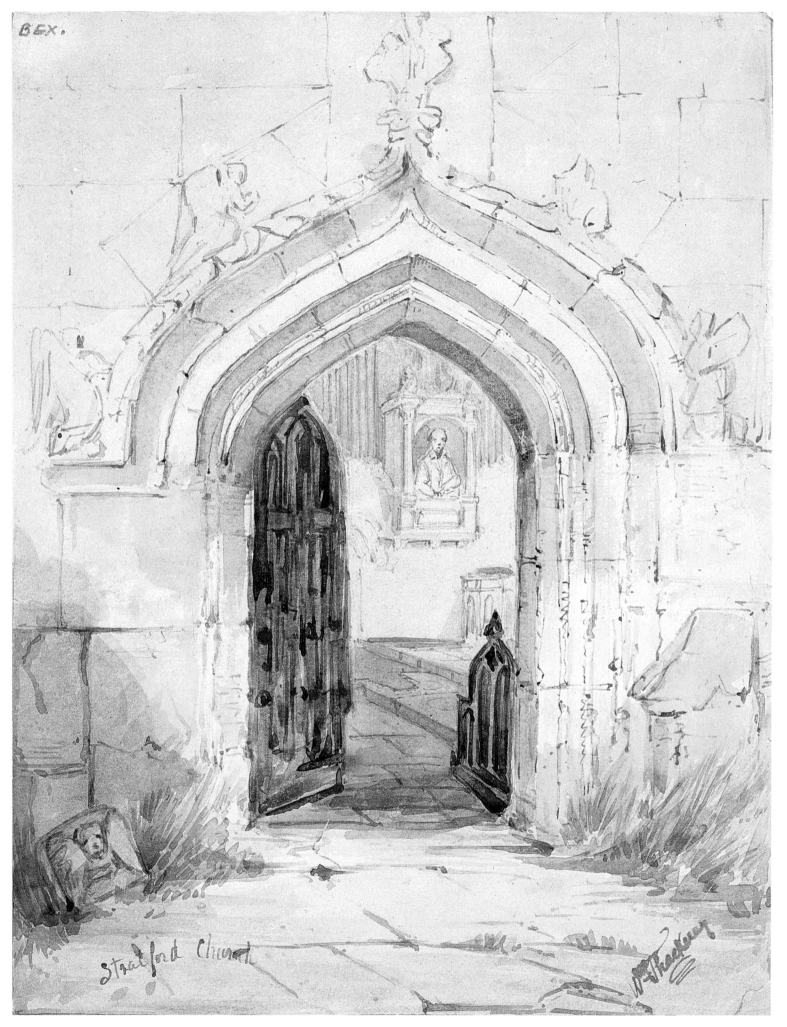

BEX.

Stratford Church

W. Thackeray

35

JOHN RUSKIN

BRITISH | 1819–1900

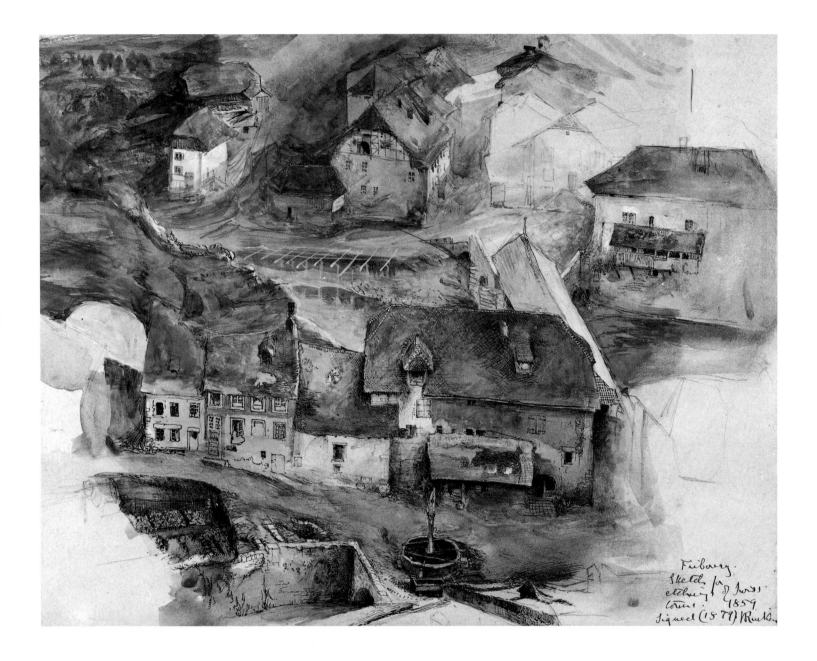

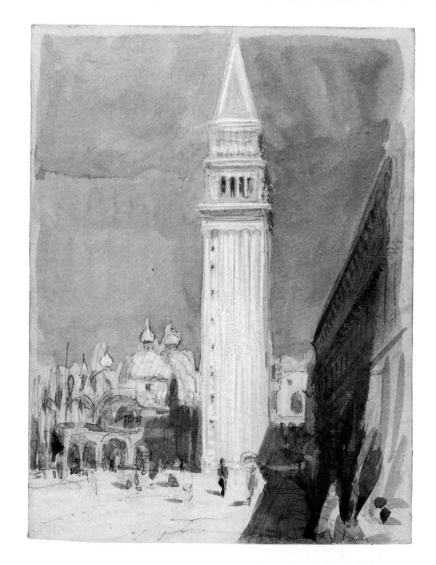

Truth *That is: I found that truth*
Refinement *was an absolute measure of*
Confusion *the goodness of art, that the*
greatest men were always those who gave
most truth. Secondly, that refinement was
also an absolute measure, all the greatest
men being, according to their scale,
exquisitely tender and refined and subtle.
Thirdly, confusion is also an absolute
measure—all the greatest men being
confused.

Diary entry, Paris, 1858, *The Diaries of John Ruskin 1848–1873*, vol. 2, sel. and ed.
Joan Evans and J. H. Whitehouse (Oxford: Clarendon Press, 1958), p. 511.

OPPOSITE:
Fribourg, Switzerland. Pencil with watercolor wash, 8¾ × 11¼".
British Museum, London. Department of Prints and Drawings

RIGHT, ABOVE:
The Campanile, Venice. 1852. Pencil with watercolor wash,
6⅜ × 5". British Museum, London. Department of Prints and
Drawings

I am sitting with Effie in the outside balcony of the Hotel Royal,
Newton is kicking my chair so that I cannot write so well as usual,
the soft air of the afternoon is just breathing past, and no more, and a
subdued sunshine rests on the red roofs high above us, and on some
streaks of white cloud which cross the arches of a campanile far down
the narrow street.

Letter to Ruskin's father from Venice, 28 August 1857, in Derrick Leon, *John Ruskin:*
The Great Victorian (London: Routledge & Kegan, 1949), p. 150.

RIGHT, BELOW:
Jeanne d'Arc Pillar. c. 1868. Pencil with watercolor wash,
11 × 8⅝". British Museum, London. Department of Prints and
Drawings

MIKHAIL LERMONTOV
RUSSIAN | 1814–1841

And now, here in this tedious fortress, I often ask myself as I recall the past: why did I not want to tread that path which fate had opened up to me? A path where quiet joys and spiritual peace awaited me. No, I could not have survived such a fate! I am like a sailor, born and raised on the deck of a pirate brig. He is used to storms and battles, and if he is thrown up on the shore, no matter how the shady groves beckon or the peaceful sun shines on him, he is bored and pines away.

A Hero of Our Times: Mikhail Yurevich Lermontov, trans.
Philip Longworth (New York: The New American Library, 1964), p. 176.

Untitled. From Album 3, belonging to Varvara Lopukhina-Bakhmeteva. 24 January (1830s). Pencil, 3⅝ × 3¼". Rare Book and Manuscript Library, Columbia University, New York. Lermontov Collection

OPPOSITE, ABOVE:
Varvara Lopukhina-Bakhmeteva. From Album 2, belonging to Alexandra Vereshchagina von Hügel (Baroness Karl). 1831–33. Watercolor with white, 3½ × 5½". Rare Book and Manuscript Library, Columbia University, New York. Lermontov Collection

Varvara was the sister of Lermontov's schoolfriend Alexei. Their friendship ripened into romance, but she married an older, wealthier man in 1835.

OPPOSITE, BELOW:
Quadrille. From Album 2, belonging to Alexandra Vereshchagina von Hügel (Baroness Karl). 1831–33. Pencil and ink, 5⅞ × 9⅞". Rare Book and Manuscript Library, Columbia University, New York. Lermontov Collection

How oft, surrounded by the motley crowd,
Mid whirling dance, and din of music loud,
 I sink my senses in a dream,—
When phrased convention, polished fiction, fly
And all the men and women pass me by,—
 Like masks their faces seem.

"At a Ball," in Leo Winter, ed., *Anthology of Russian Literature* (New York: Benjamin Blom, 1902), p. 174.

CHARLOTTE BRONTË

BRITISH | 1816–1855

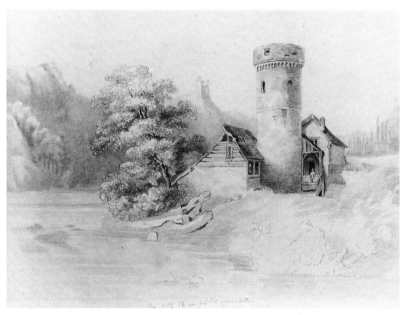

"*Were you happy when you painted these pictures?*" *asked Mr. Rochester presently.*

"*I was absorbed, sir: yes, and I was happy. To paint them, in short, was to enjoy one of the keenest pleasures I have ever known.*"

"*And you felt satisfied with the result of your ardent labours?*"

"*Far from it. I was tormented by the contrast between my idea and my handiwork; in each case I had imagined something which I was quite powerless to realize.*"

Jane Eyre, ed. Richard J. Dunn (New York: W. W. Norton, 1971), p. 111.

LEFT, ABOVE:

Untitled. c. 1831. Pencil on paper, 7⅜ × 9⅞″. Inscribed center lower edge: "By my Daughter Charlotte P Bronte Minstr." Harry Ransom Humanities Research Center Art Collection, The University of Texas at Austin

Said a fellow student at Roe's Head School: "She used to draw much better, and more quickly, than anything we had ever seen before, and she knew much about great painters and painting."

In Mrs. Gaskell, *The Life of Charlotte Brontë* (London: Smith, Elder & Co., 1900), p. 102.

LEFT, BELOW:

Lady Jersey. 1834. Pencil, 9⅛ × 6⅞″. Inscribed in pencil, center front: "English Lady." Signed and dated in pencil, lower right: "15 October 1834" and "C Bronte." The Brontë Society, The Brontë Parsonage Museum, Haworth, England

What though the stars and fair moonlight
Are quenched in moonlight dull and grey?
They are but tokens of the night,
And this, *my soul, is day.*

Untitled poem, *The Complete Poems of Emily Jane Brontë*, ed. C. W. Hatfield (New York: Columbia University Press, 1941), p. 112.

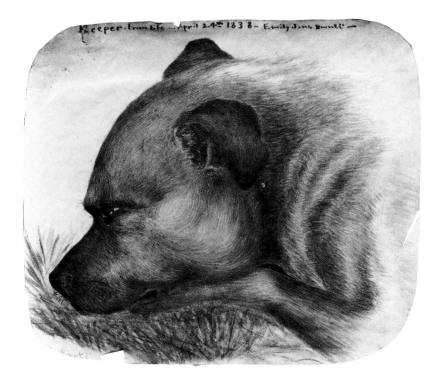

RIGHT, ABOVE:
Keeper. 24 April 1838. Watercolor, 5⅛ × 6⅛″. The Brontë Society, The Brontë Parsonage Museum, Haworth, England

"Emily had a great dog—half mastiff, half bulldog—so savage. . . . This dog went to her funeral, walking side by side with her father; and then, to the day of its death, it slept at her room door, snuffing under it, and whining every morning."

Patrick Branwell Brontë, letter to William Wordsworth, 1853, in Mrs. Gaskell, *The Life of Charlotte Brontë* (London: Smith, Elder & Co., 1900), p. 151.

RIGHT, BELOW:
Merlin Hawk. 27 October 1841. Watercolor, 9¾ × 8½″. The Brontë Society, The Brontë Parsonage Museum, Haworth, England

EDWARD LEAR

BRITISH | 1812–1888

Well—this morning I suppose I must so far sacrifice to propriety as to go and see some "pictures." Very few I intend to see. All the best I know by copies: and looking into the guide-book I see, "This is one of the best specimens of Tintoretto's corrupter style—or his blue style—or Bassano's green style—or somebody else's hoshy boshy beautiful style"—all looked on and treated as artificialities, and not the least as more or less representing nature. The presentation of Christ in the Temple—with Venetian Doges' and Senators' dresses—and Italian palaces in the background!—fibs is fibs—wrapped up in pretty colour or not. And besides— looking at pictures wearies me always. It is quite hard work enough to try and make them.

Letter to Lear's sister, Venice, 1857, in Angus Davidson, *Edward Lear: Landscape Painter and Nonsense Poet 1812–1888* (London: John Murray, 1938, 1968), p. 183.

OPPOSITE, ABOVE:
Peppering. 1846. Pencil, ink, and wash, 11 × 13⅞". Harry Ransom Humanities Research Center Art Collection, The University of Texas at Austin

OPPOSITE, BELOW:
Architectural Ruins, Athens. 1868. Pencil, ink, and watercolor, 11 × 13⅞". Harry Ransom Humanities Research Center Art Collection, The University of Texas at Austin

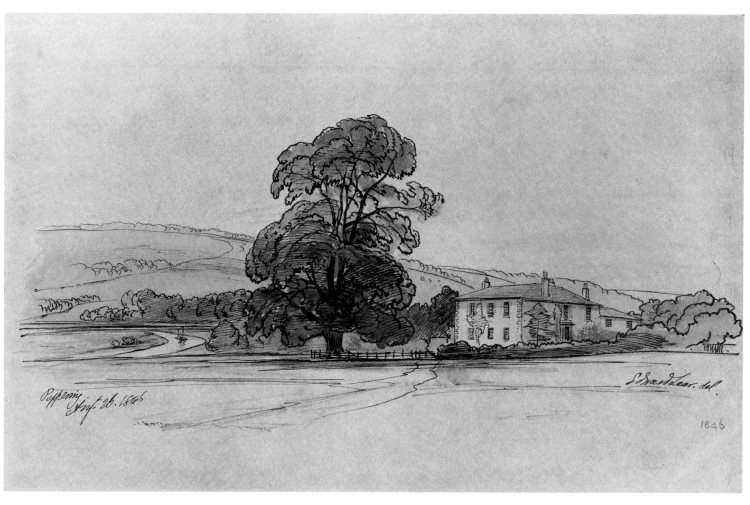

Peppering Augt. 26. 1846

E Brand Lear. del

1846

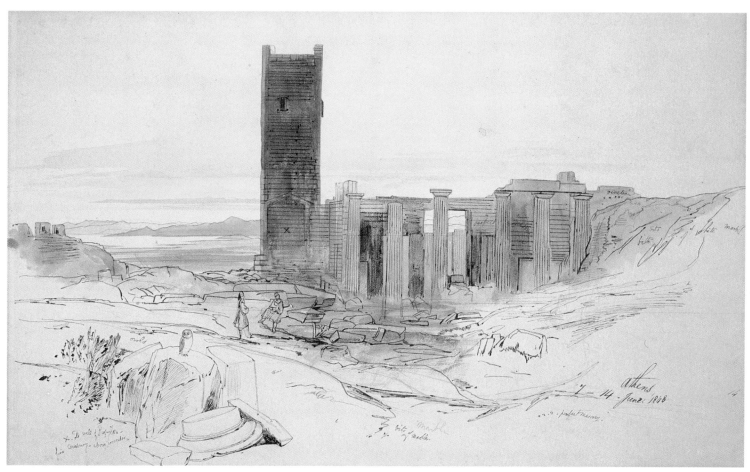

Athens
7 – 14 June 1848

CHARLES BAUDELAIRE

FRENCH | 1821–1867

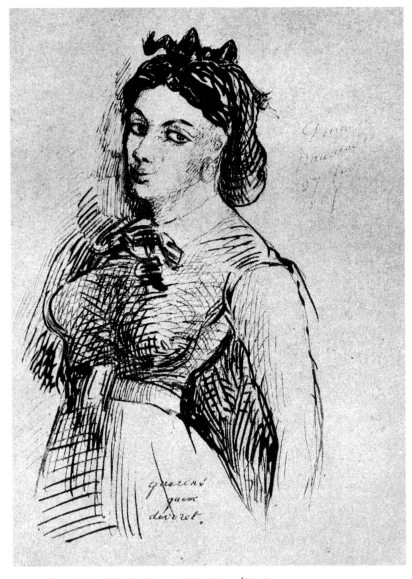

Jeanne Duval, Baudelaire's Mistress. 1865. Iron-gall ink on paper,
6 × 4½″. Whereabouts unknown

This portrait was drawn from memory in Brussels. Edouard Manet
painted a portrait of Jeanne Duval, which hangs in a museum in
Budapest.

The beautiful is composed of an eternal, invariable element of which the quantity is excessively difficult to determine, and of a relative, circumstantial element which is, if one chooses to put it like that, in turn, or altogether, period, fashion, morality, passion. Without this second element, which is the amusing, titillating, appetizing envelope of the divine cake, the first element would be indigestible, impossible to appreciate, not adapted, and not appropriate to human nature. I defy anyone to discover the least gleam of beauty which does not contain the two elements.

Essay on Constantin Guys, 1863, in Martin Turnell, *Baudelaire: A Study of His Poetry*
(New York: New Directions, 1953), p. 33.

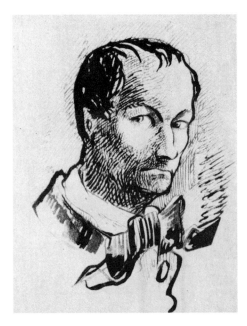

Self-portrait. 1843. Ink on paper, 2¾ × 2½″. Whereabouts
unknown

The artist, the true artist, the true poet, must paint according to what he sees and feels. He must be truly faithful to his own nature. He must avoid like the plague borrowing the eyes and the feelings of another man, however great that man may be; for his creations would then be lies, not realities.

"Salon de 1859 III," in Martin Turnell, *Baudelaire: A Study of His Poetry*, p. 46.

What am I alone, an isolated individual, a lost atom, a speck of dust amidst so many whirlwinds? A nonentity. But by associating myself with you, by pressing with my left hand the hand of an artist, with my right the hand of a prince, I become a link in the golden chain which connects the past with the future.

My Memoirs, trans. and ed. A. Craig Bell (London: Peter Owen, Ltd., 1961), p. 163.

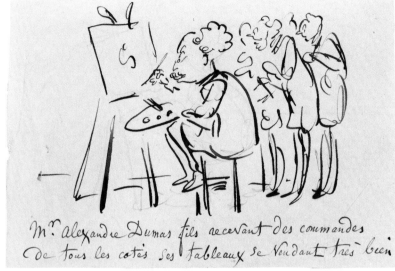

RIGHT, ABOVE:

Self-caricature. Pencil on notepad paper, 3 × 5″. Harry Ransom Humanities Research Center Art Collection, The University of Texas at Austin. Artine Artinian Collection

The caption reads: "Mr. Alexandre Dumas fils recevant des commandes de tous les cotés ses tableaux se vendant très bien " (Mr. Alexandre Dumas fils receiving commissions from all sides his paintings selling very well).

RIGHT, BELOW:

François Guillaume Jean Stanislas Ardrieux. Charcoal pencil on paper, 8⅜ × 7½″. Harry Ransom Humanities Research Center Art Collection, The University of Texas at Austin. Artine Artinian Collection

Ardrieux—lawyer, dramatist, classicist—was best known for his publication of *Lucius Junius Brutus* in 1830. He was also one of the select group of "Parnassians" that entertained Verlaine and Rimbaud in London during their European odyssey.

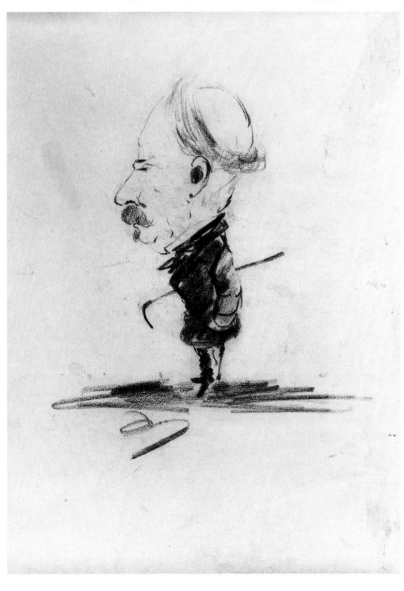

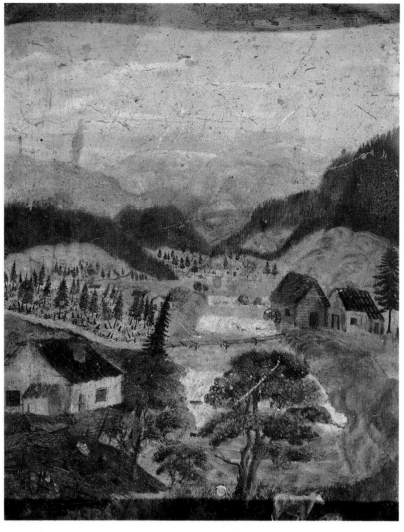

Jønnevold, Skien. c. 1845–46. Oil on metal, 17¾ × 11¾".
Ibsenhuset, Grimstad Bymuseum, Grimstad, Norway

As a boy I attended drawing school at Skien for a year and learned a little pencil drawing. At the same time, or a little later, I had some instruction in oil painting from a young landscape painter, Mandt, from Telemark, who sometimes stayed at Skien. . . . But in 1860 I began to be much occupied with preparations for writing Love's Comedy *and* The Pretenders. *After that I shelved forever all my aspirations as a painter.*

Letter to Jens Braage Halvorsen, 1889, *Ibsen: Letters and Speeches*, ed. Evert Sprinchorn (New York: Hill and Wang, 1964), p. 14.

The Pilot from Haaø. c. 1849. Oil on paper/wooden plate, 17¾ × 11¾". Ibsenhuset, Grimstad Bymuseum, Grimstad, Norway

Ibsen's model was Svend Haaø, a harbor pilot. Ibsen used him as a prototype for the hero of his great dramatic poem *Terje Viigen*, which concerned the legends of the Grimstad district.

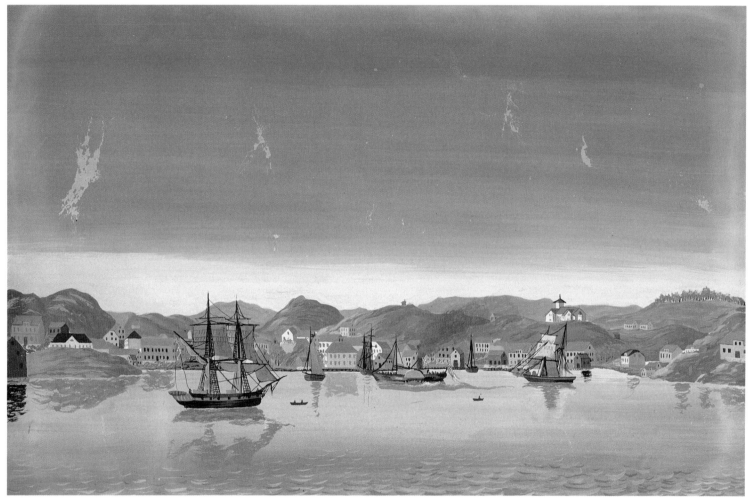

Grimstad Landscape. 1849. Watercolor, 15¾ × 19⅝". Ibsenhuset,
Grimstad Bymuseum, Grimstad, Norway

When he was fifteen, Ibsen left home, booking passage on the ship
Lucky Chance to Grimstad. He lived there six years, an
"impoverished but happy warrior," but wrote that he feared he
would never find a place for himself in this world.

More than life, gentlemen,
Is a dream never brought to life.
It is like the poem I lock
within the barred cell of my heart;
with lion's rage it slashes, snarls,
demanding night and day to be.

"Without Name," 1869, in Halvdan Koht, *Life of Ibsen* (New York:
Benjamin Blom, 1971), p. 268.

DANTE GABRIEL ROSSETTI

BRITISH | 1828–1882

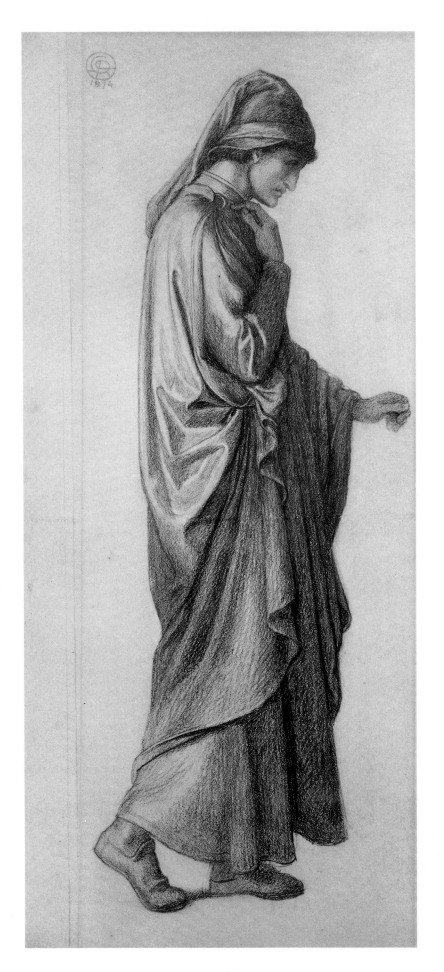

If any man has any poetry in him he should paint it, for it has all been said and written, and they have hardly begun to paint it. Every man who has that gift should paint.

Letter to Edward Burne-Jones, in Derrick Leon, *Ruskin: The Great Victorian* (London: Routledge & Kegan, 1949), p. 253.

Dante. 1874. Charcoal pencil, 35⅜ × 13⅜". Harry Ransom Humanities Research Center Art Collection, The University of Texas at Austin

The model was Mr. W. J. Stillman.

Follow his feet's appointed way;
But little light we find that clears
The darkness of the exiled years.
Follow his spirit's journey:—nay,
What fires are blent, what winds are blown
On paths his feet may tread alone?

"The Dante of Verona," 1870, in Elisabeth Luther Cary, *The Rossettis: Dante Gabriel and Christina* (New York: G. P. Putnam's Sons, 1900), p. 133.

OPPOSITE:
La Pia. Pastel on paper, 37⅜ × 28⅜". Harry Ransom Humanities Research Center Art Collection, The University of Texas at Austin

La Pia is based on the story of the wife of an Italian nobleman who jealously locked his wife in a tower, where she either committed suicide or was secretly poisoned. The model was Jane Burden, the wife of William Morris.

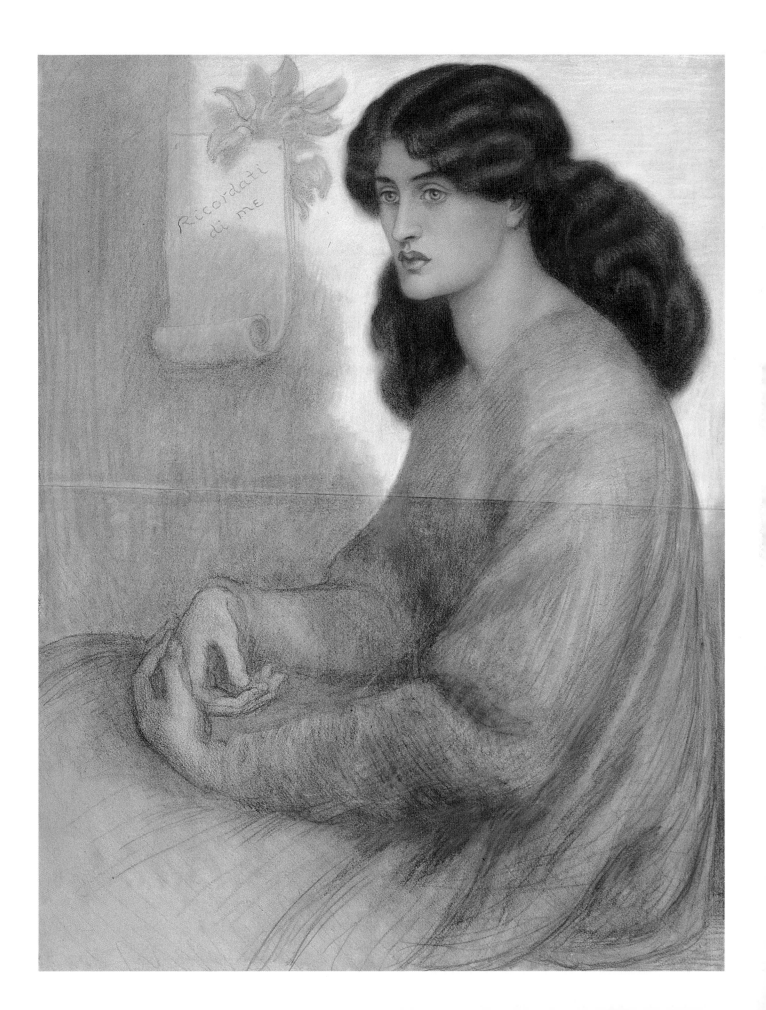

OSCAR WILDE
BRITISH | 1854–1900

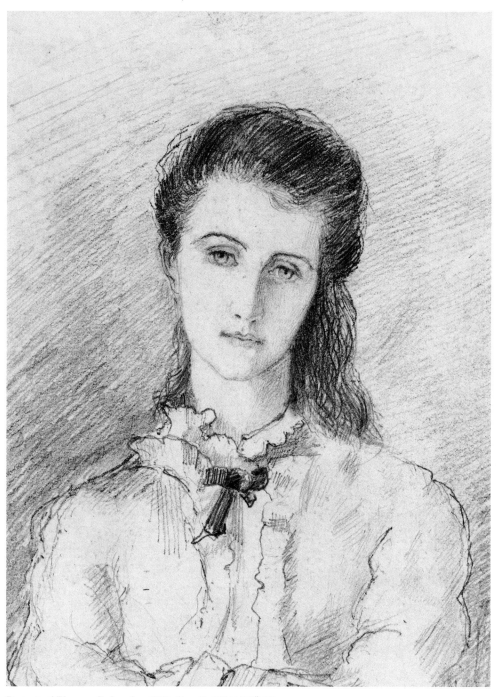

The final revelation is that Lying, the telling of beautiful untrue things, is the proper aim of Art.

"The Decay of Lying," *Complete Works of Oscar Wilde*, ed. and intro. Vyvyan Holland (London and Glasgow: Collins, 1970), p. 992.

Portrait of Florence Balcombe. 1876. Pencil, 6⅞ × 4⅞". Harry Ransom Humanities Research Center Art Collection, The University of Texas at Austin

During vacations from Oxford, Wilde courted the lovely Florence in Dublin, though her parents considered him "not suitable" for marriage. When Florence married a young Irish author (*Dracula*), Oscar was incensed enough to demand the return of his gifts of jewelry. In the opinion of George du Maurier, she was one of the most beautiful women in London society.

ARNOLD BENNETT

BRITISH | 1867–1931

The attitude of the general public towards a picture—by which apparently they regard it as a story first and a work of art afterwards— is not as indefensible as it seems, or at least not so inexcusable. In the attitude of the perfectly cultured artist himself, there is something of the same feeling—it must be so. Graphic art cannot be totally separated from literary art, nor vice versa. They encroach on each other.

The Journal of Arnold Bennett, 1896–1910 (New York: Viking Press, 1932), p. 5.

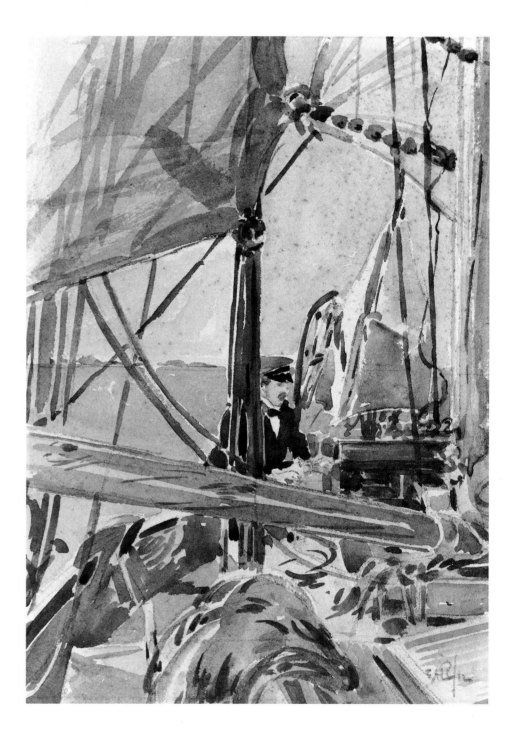

Self-portrait Aboard the Yacht Velsa. 1912. Watercolor on watercolor paper, 8⅝ × 6⅛". Harry Ransom Humanities Research Center Art Collection, The University of Texas at Austin

Bennett's American successes enabled him to purchase the Dutch barge *Velsa* and inspired him to publish, a year later, a book on amateur yachting.

51

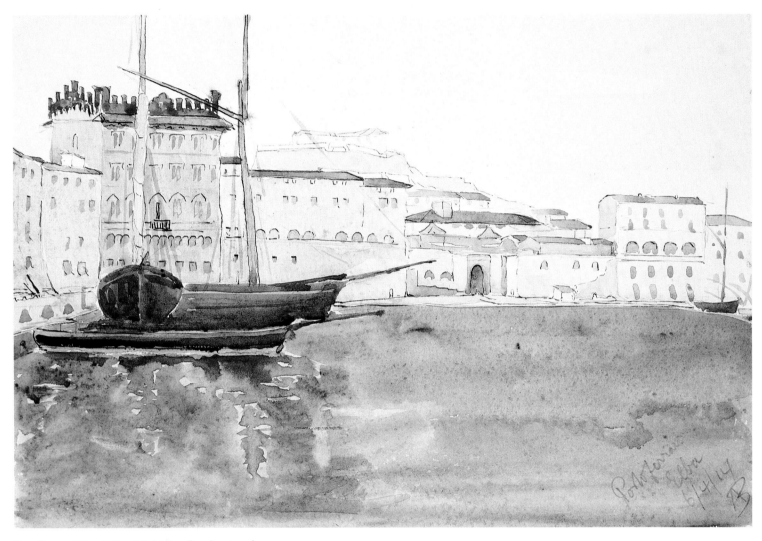

Portoferrais, Elba. 4 May 1914. Pencil and watercolor,
9¾ × 14¼″. Harry Ransom Humanities Research Center Art
Collection, The University of Texas at Austin

This was Bennett's last voyage on the *Velsa* before he volunteered
her to the British Admiralty for war duty.

OPPOSITE:
Untitled. 24 June 1914. Watercolor on watercolor paper,
14⅛ × 9¾″. Harry Ransom Humanities Research Center Art
Collection, The University of Texas at Austin

An entry in Bennett's journal for this date describes his visit to
Madame Le Gallienne and her daughter Eva (later the famous
actress) in their flat in an old chateau, once a convent.

THOMAS HARDY

BRITISH | 1840–1928

*Creativeness in its full and ancient sense—
the making a thing or situation out of
nothing that ever was before—is apparently
ceasing to satisfy a world which no longer
believes in the abnormal—ceasing at least
to satisfy the van-couriers of taste; and
creative fancy has accordingly to give more
and more place to realism, that is, to an
artificiality distilled from the fruits of closest
observation.*

Life and Art (Freeport, N.Y.: Books for Libraries Press, 1968), p. 87.

OPPOSITE, ABOVE:
Illustration for "She, to Him" (1866). Pen and ink with white,
2¾ × 4½". Signed lower right: "T H," interlocked. City Museums
and Art Gallery, Birmingham, England

This drawing was used as an illustration for Hardy's poem "She, to
Him" in his illustrated edition of *Wessex Poems* of 1898.

> *One who would die to spare you touch of ill!—*
> *Will you not grant to old affections' claim*
> *The hand of friendship down Life's sunless hill?*

"She, to Him," 1866, *Wessex Poems* (1898), in *Collected Poems of Thomas Hardy* (New
York: The Macmillan Company, 1928), p. 11.

OPPOSITE, BELOW:
Illustration for "A Sign-Seeker." Pen and ink with white, 2¼ × 6⅛".
Signed lower right: "T H," interlocked. City Museums and Art
Gallery, Birmingham, England

> *I learn to prophesy the hid eclipse,*
> *The coming of eccentric orbs;*
> *To mete the dust the sky absorbs,*
> *To weigh the sun, and fix the hour each planet dips.*

"A Sign-Seeker," *Wessex Poems* (1898), in *Collected Poems of Thomas Hardy*, p. 43.

GERARD MANLEY HOPKINS

BRITISH | 1844–1889

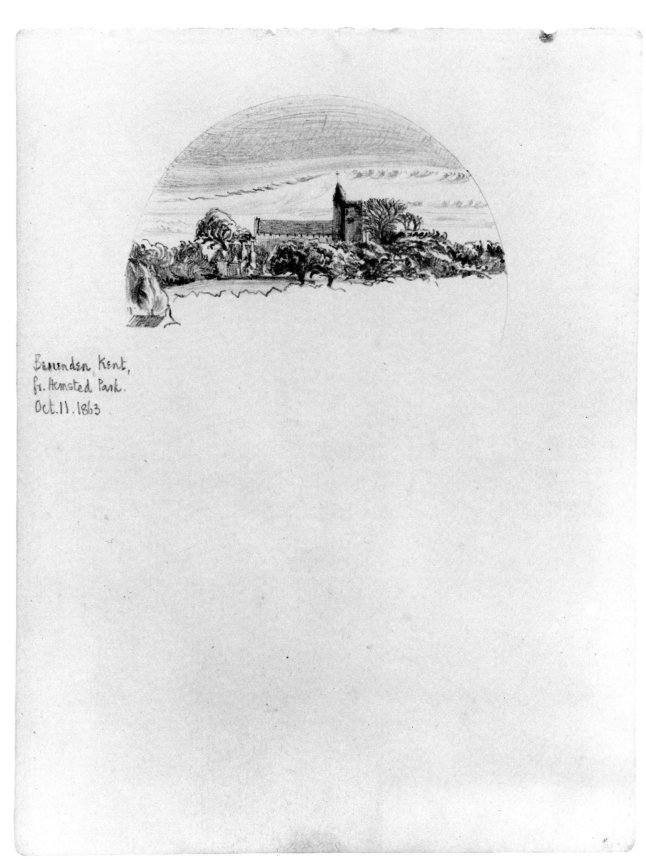

Benenden, Kent,
fr. Hemsted Park.
Oct. 11. 1863

You know I once wanted to be a painter. But even if I could I wd. not I think, now, for the fact is that the higher and more attractive parts of the art put a strain upon the passions which I shd. think it unsafe to encounter.

Letter to Alexander Mowbray Baillie, 1868, *Further Letters of Gerard Manley Hopkins*, ed. Claude Colleer Abbot (London: Oxford University Press, 1956), p. 231.

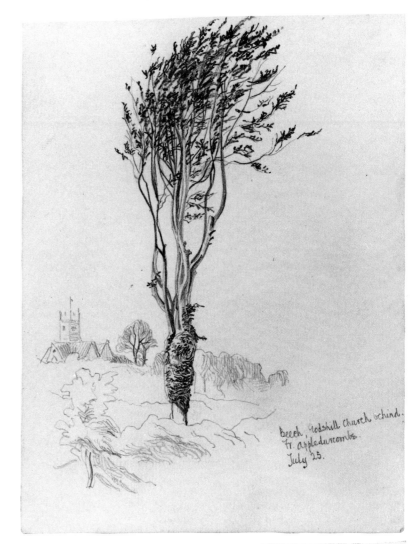

OPPOSITE:
Benenden, Kent, from Hemsted Park. Dated Oct. 11 1863. Pencil on drawing pad paper, 11 × 8½″. Harry Ransom Humanities Research Center Manuscripts Collection, The University of Texas at Austin

RIGHT, ABOVE:
Beech, Godshill Church Behind. Dated July 25. Pencil on drawing pad paper, 11 × 8½″. Harry Ransom Humanities Research Center Manuscripts Collection, The University of Texas at Austin

I think I have told you that I have particular periods of admiration for particular things in Nature; for a certain time I am astonished at the beauty of a tree, shape, effect etc., then when the passion, so to speak, has subsided, it is consigned to my treasury of explored beauty, and acknowledged with enthusiasm and interest ever after, while something new takes its place in my enthusiasm.

Letter to Alexander Mowbray Baillie, 1863, *Further Letters of Gerard Manley Hopkins*, p. 202.

RIGHT, BELOW:
From the Keep. Carisbrooks Castle. Dated July 25. Pencil on drawing pad paper, 11 × 8½″. Harry Ransom Humanities Research Center Manuscripts Collection, The University of Texas at Austin

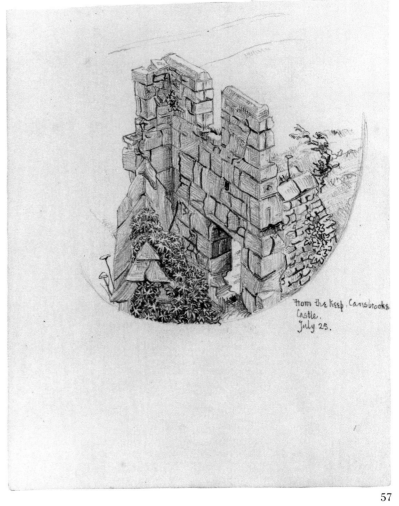

PAUL VERLAINE

FRENCH | 1844–1896

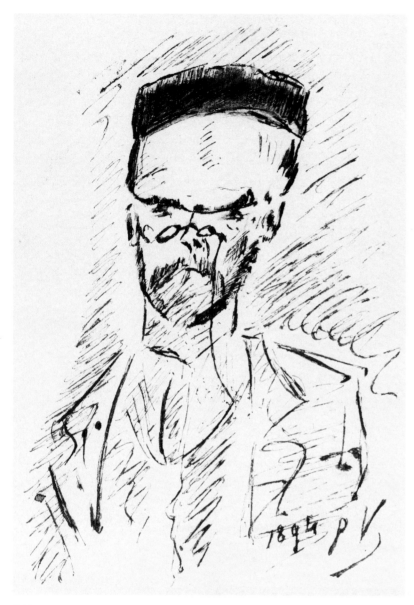

Self-portrait. 1894, Paris. Ink, 8¼ × 5¼″. Harry Ransom
Humanities Research Center Art Collection, The University of
Texas at Austin. Artine Artinian Collection

I went stale with Pedantry,
More than dead, unborn, a fog wallowing
In the bogs of decadent art.

In Antoine Adam, *The Art of Paul Verlaine*, trans. Carl Morse (New York: New York
University Press, 1963), p. 127.

I used to scrawl in pencil and spread
crimson lake, Prussian blue and gamboge
on every piece of paper that came to
hand. . . . From these artistic attempts I have
retained a mania for blackening the
margins of my manuscripts and the main
part of my private letters with formless
illustrations which flatterers pretend to find
amusing. Who knows? I might have been a
great painter instead of the poet that I am.

Confessions of a Poet, trans. Joanna Richardson (Westport, Conn.: Hyperion Press,
1979), pp. 32–33.

OPPOSITE, ABOVE:
Portrait Sketch of Maurice Maeterlinck. c. 1891. Brown ink on a
fragment of note paper, 3 × 4⅜″. Harry Ransom Humanities
Research Center Art Collection, The University of Texas at Austin.
Artine Artinian Collection

While living in Paris, Maeterlinck collaborated with Claude
Debussy to produce *Pelléas et Mélisande* in 1892. Maeterlinck
became a devotee of Verlaine's poetry, and, when he returned to his
native Belgium, he invited Verlaine to present a series of readings
there. Ironically, Verlaine's last lecture was held in the Palais de
Justice in Brussels where, twenty years earlier, Verlaine had been
sentenced to two years in prison for shooting Arthur Rimbaud.

OPPOSITE, BELOW:
Self-portrait. Ink sketch, on a letter to Rene Gimpel. Archives of
American Art, Smithsonian Institution, Washington, D.C. The
Rene Gimpel Papers

Child Standing. Pen and ink, 2½ × 2⅜″.
Collection Artine Artinian

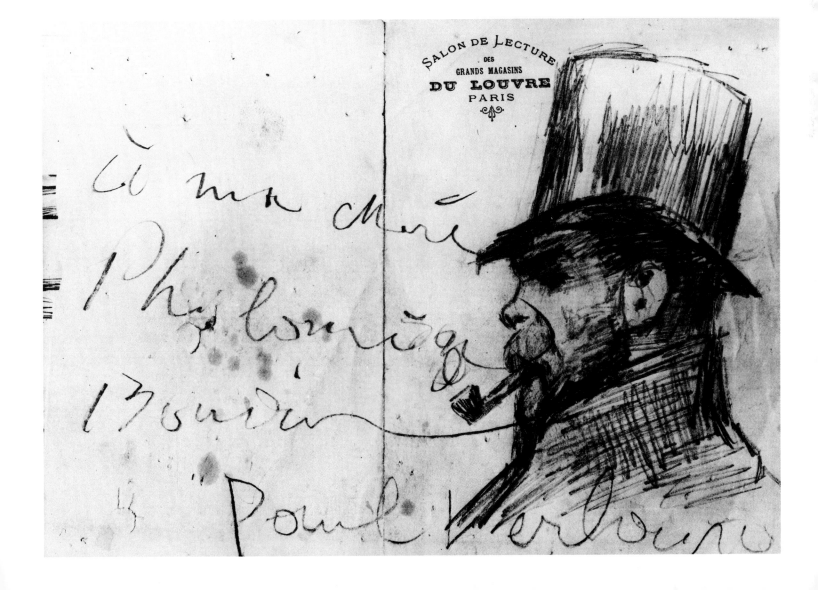

SALON DE LECTURE
DES
GRANDS MAGASINS
DU LOUVRE
PARIS

à ma chère
Philomège
Boudin

Paul Verlaine

AUGUST STRINDBERG

SWEDISH | 1849–1912

*I find my only consolation now in Buddha, who tells
me clearly that life is a phantasm, an illusion that we
shall see turned rough way round in another life. My
hope and future lie on the other side; that's why life is
so difficult for me. Everything here disappoints and
mocks one, and should only be seen at a distance.
This morning I saw my favorite landscape from my
desk. You know, in sunlight, and so supernally
beautiful I fell into an ecstasy. I wanted to go down
to the field and take a closer look. But then it
vanished behind the knolls, and when I got closer, it
didn't look the same. What you go after runs away
from you.*

Letter to Harriet Bosse, c. 1907, in Evert Sprinchorn, *Strindberg as Dramatist* (New
Haven and London: Yale University Press, 1982), p. 269.

The Town. c. 1900–1907. Oil on canvas, 33¼ × 20⅞".
Nationalmuseum, Stockholm

ROBERT LOUIS STEVENSON

BRITISH | 1850–1894

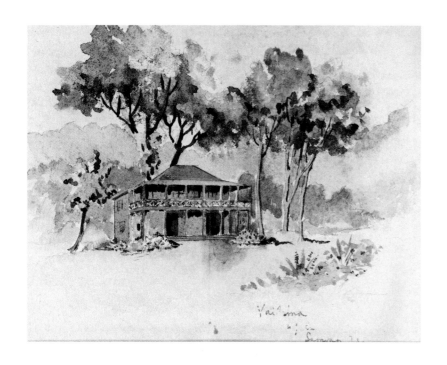

Words were with him a mere accomplishment, like dancing. When he was by himself, his pleasures were almost vegetable. He would slip into the woods towards Acheres, and sit in the mouth of a cave among grey birches. His soul stared straight out of his eyes; he did not move or think; sunlight, thin shadows moving in the wind, the edge of firs against the sky, occupied and bound his faculties. He was pure unity, a spirit wholly abstracted. A single mood filled him, to which all the objects of sense contributed, as the colours of the spectrum merge and disappear in white light.

"The Treasure of Franchard," *The Novels and Tales of Robert Louis Stevenson*, vol. 2 (New York: Charles Scribner's Sons, 1903), p. 233.

Vailima. c. 1893, Samoa. Ink, 6¼ × 7⅛". The Beinecke Rare Book and Manuscript Library, Yale University, New Haven, Conn. Norman Holmes Pearson Collection

Stevenson's last home, his "simple and sunny heaven," stands below the mountain where he is buried. At the top, overlooking the sea, a stone monument bears his words:

Here he lies where he longed to be;
Home is the sailor, home from the sea,
* And the hunter home from the hill.*

OPPOSITE, ABOVE:
Untitled. c. 1864–67. Watercolor, 5 × 7⅝". The Beinecke Rare Book and Manuscript Library, Yale University, New Haven, Conn.

OPPOSITE, BELOW:
Untitled. c. 1864–67. Watercolor, 3½ × 7⅛". The Beinecke Rare Book and Manuscript Library, Yale University, New Haven, Conn.

He spent long whiles on the eminence, looking down the rivershed and abroad on the flat lowlands.... everything that went that way, were it cloud or carriage, bird or brown water in the stream, he felt his heart flow out after it in an ecstasy of longing.

"Will o' the Mill," *The Merry Men and Other Tales and Fables*, vol. 7 of *The Biographical Edition of Stevenson's Works* (New York: Charles Scribner's Sons, 1927), pp. 81–82.

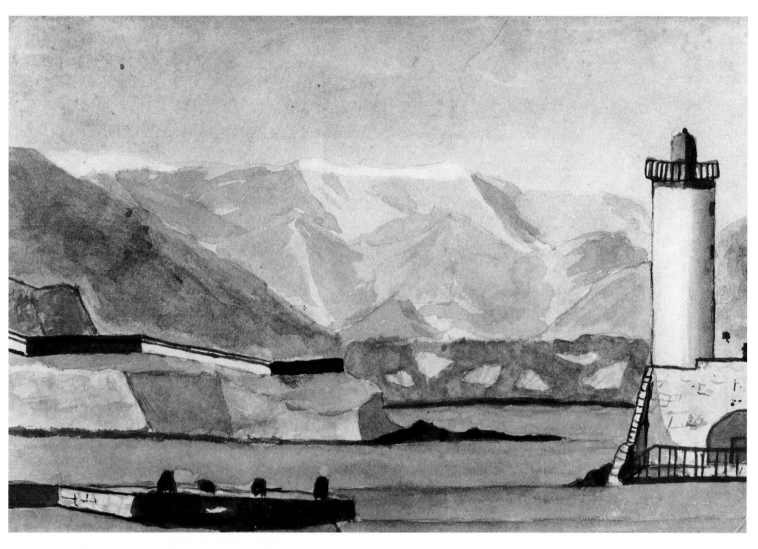

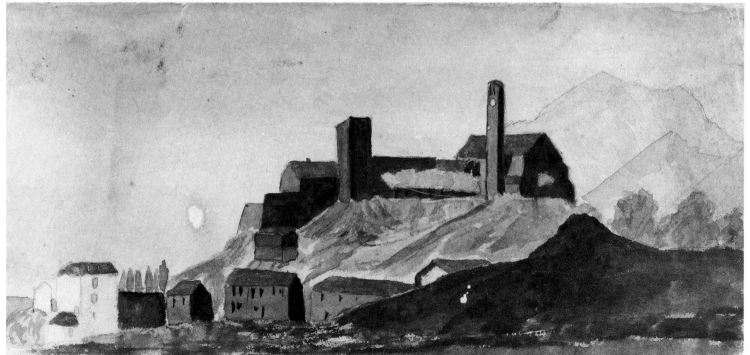

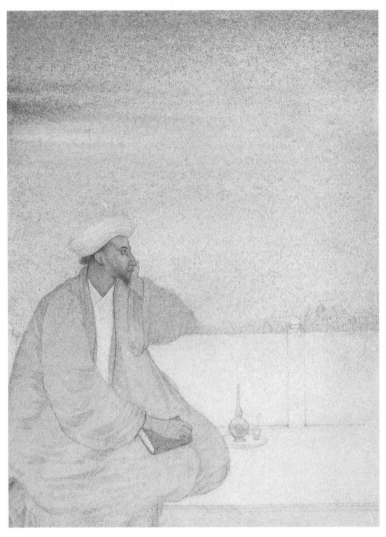 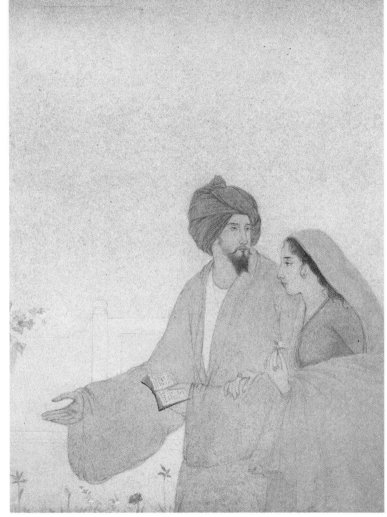

RABINDRANATH TAGORE

INDIAN | 1861–1941

I know not who paints the pictures on memory's canvas; but whoever he may be, what he is painting are pictures; by which I mean that he is not there with his brush simply to make a faithful copy of all that is happening. He takes in and leaves out according to his taste. He makes many a big thing small and small thing big. He has no compunction in putting into the background that which was to the fore, or bringing to the front that which was behind. In short he is painting pictures, and not writing history.

My Reminiscences (New York: The Macmillan Co., 1917), p. 1.

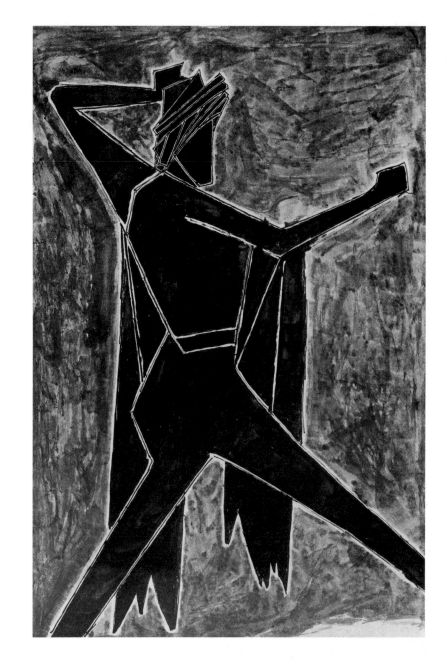

OPPOSITE, LEFT:
Scene from "Omar Khayyam." Watercolor, 6⅜ × 4¾". Harry Ransom Humanities Research Center Art Collection, The University of Texas at Austin

Inscription on verso:
"Dreaming when Dawn's left hand was in the sky. I heard a voice within the tavern cry, 'Awake, my little ones and fill the cup. Before life's liquor in its cup be dry.'
R. TAGORE"

OPPOSITE, RIGHT:
Scene from "Omar Khayyam." Watercolor, 6⅜ × 4¾". Harry Ransom Humanities Research Center Art Collection, The University of Texas at Austin

Inscription on verso:
"Jiam indeed is gone with all its Rose, and jamshyd's seva ring'd cup where no one knows. But Still The Vine has ancient Ruby yields, And Still a garden by the water blows.
R. TAGORE"

Abstract Figure. Lithograph, 11 × 8⅜". Harry Ransom Humanities Research Center Art Collection, The University of Texas at Austin

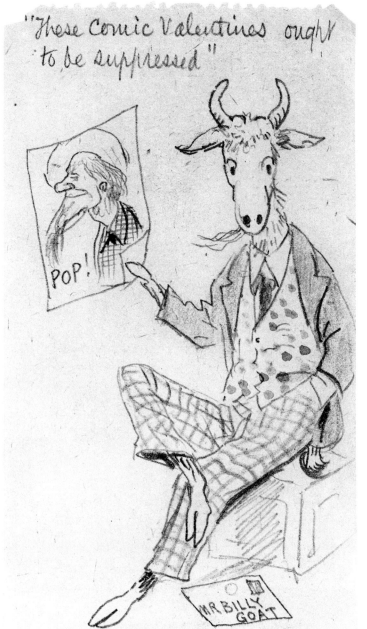

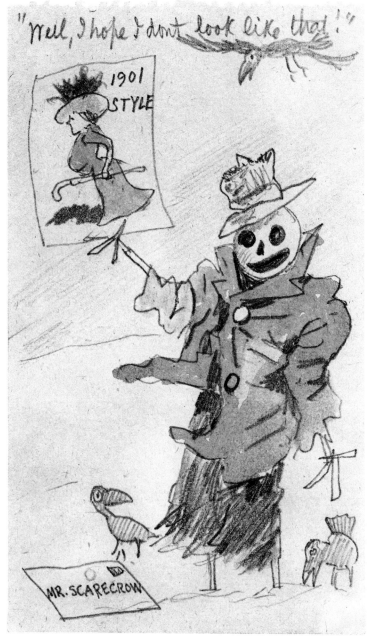

O. HENRY

AMERICAN | 1862–1910

*"You don't understand, Billy," said
White, with an uneasy laugh. "Some of us
fellows who try to paint have big notions
about Art. I wanted to paint a picture some
day that people would stand before and
forget that it was made of paint. I wanted it
to creep into them like a bar of music and
mushroom there like a soft bullet."*

"Masters of Arts," *The Complete Works of O. Henry* (New York: Garden City Publishing
Co., Inc., 1937), p. 637.

OPPOSITE, LEFT:
Mr. Billy Goat. c. 1892. Pencil with watercolor wash on notepad
paper, 8½ × 5″. Harry Ransom Humanities Research Center
Manuscripts Collection, The University of Texas at Austin

These are among a series of cartoons that Porter drew to amuse his
daughter.

OPPOSITE, RIGHT:
Mr. Scarecrow. c. 1892. Pencil with watercolor wash on notepad
paper, 8½ × 5″. Harry Ransom Humanities Research Center
Manuscripts Collection, The University of Texas at Austin

Mr. Hog. c. 1892. Pencil with watercolor wash on notepad paper,
8½ × 5″. Harry Ransom Humanities Research Center Manuscripts
Collection, The University of Texas at Austin

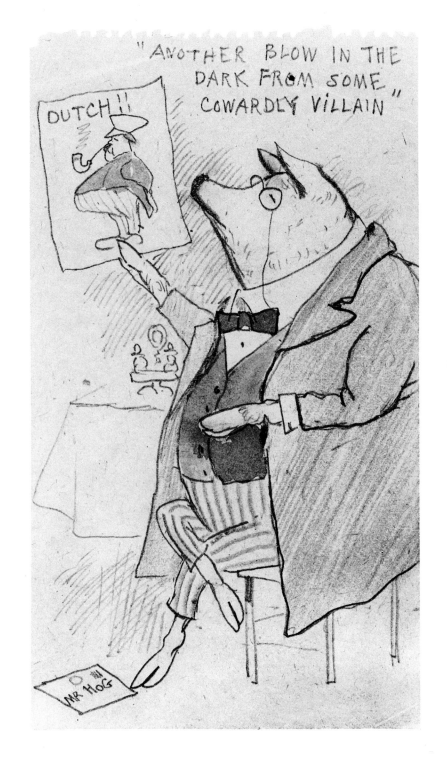

F. R. Ripley.

Colossal Carr.
The Mammoth Comique.

RUDYARD KIPLING
BRITISH | 1865–1936

When the flush of a new-born sun fell first on
* Eden's green and gold,*
Our father Adam sat under the Tree and scratched
* with a stick in the mould;*
And the first rude sketch that the world had seen
* was joy to his mighty heart,*
Till the Devil whispered behind the leaves, "It's
* pretty, but is it Art?"*

"The Conundrum of the Workshops," *Barrack-Room Ballads and Other Verses* (London:
Methuen & Co., 1911), p. 168.

Outward Bound
for
A & E Lewis
from
Rudyard Kipling.

OPPOSITE:
Colossal Carr: The Mammoth Comique. c. 1890, London. Ink on
note paper, folded twice, 7 × 5″. Harry Ransom Humanities
Research Center Art Collection, The University of Texas at Austin

When Kipling arrived in London from India in 1889, he took a
small apartment across the street from Gatti's Music-Hall.

It was here . . . that I listened to the observed and compelling songs
of the Lion and Mammoth Comiques. . . . Those monologues I could
never hope to rival, but the smoke, the roar, and the good-fellowship
of relaxed humanity at Gatti's "set" the scheme for a certain sort of
song.

Kipling's "certain sort of song" became later his *Barrack-Room*
Ballads (1892).

Something of Myself: For My Friends Known and Unknown (New York: Doubleday,
Doran & Company, 1937), pp. 88–89.

Outward Bound. c. 1893. Ink, 7⅛ × 4½″. Harry Ransom
Humanities Research Center Art Collection, The University of
Texas at Austin

This is a design suggested by Kipling for a logo to be used on
American publications of his books by the firm of A. & E. Lewis.

GEORGE RUSSELL "AE"

IRISH | 1867–1935

I do not think I will ever try to get literary or artistic fame; art and literature do not interest me now, only one thing interests and that Life or Truth. I want to become rather than to know. If I raise myself I raise the rest of the world so much, and if I fail I drag others down also.

In C. C. Coates, *Some Less Known Chapters in the Life of AE (George Russell)*, a lecture given in Belfast, 1936 (Dublin: privately printed, 1939), p. 10.

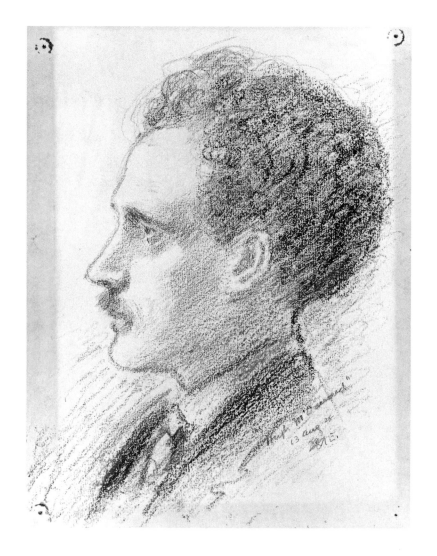

Hugh MacDiarmid. 13 August 1928. Pastel on drawing paper, 12 × 10″. Harry Ransom Humanities Research Center Art Collection, The University of Texas at Austin

Hugh MacDiarmid was the pseudonym of Christopher Murray Grieve, author of *Sangschaw, First Hymn to Lenin and Other Poems*, and *Lucky Poet*. At the time of this portrait, he was considered Ireland's leading poet, heir to the laurels of W. B. Yeats.

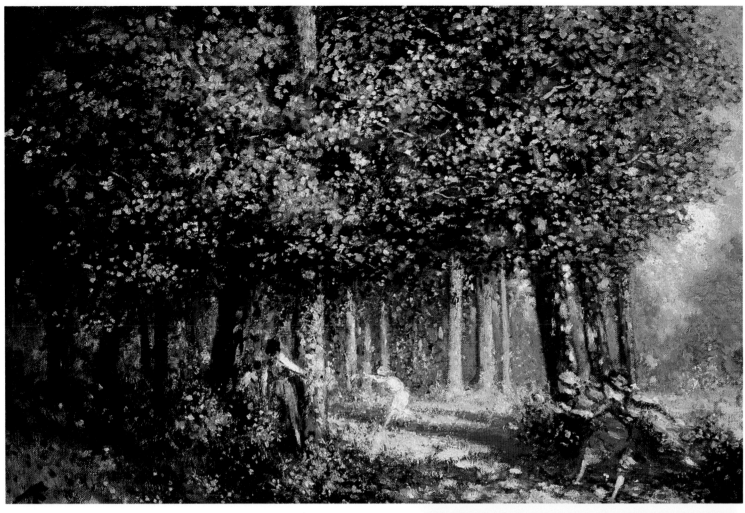

In the Clearing. 1925–33, Dublin. Oil on canvas, 21 × 32″. Harry
Ransom Humanities Research Center Art Collection, The
University of Texas at Austin

Path Through the Woods. 1925–33, Dublin. Oil on canvas,
32 × 21″. Harry Ransom Humanities Research Center Art
Collection, The University of Texas at Austin

Description of Russell's Bournemouth office by Monk Gibbon:
"AE's office, a room at the top of that building, seemed like an
opening in fairy woods. He had painted each wall, from roof to
floor, and there you looked on trees, and, beyond them, on beings
rarely seen on land or sea, but always seen in the woods of vision
and the air of dream. And there in the painted wood AE sat."

Monk Gibbon, ed., *The Living Torch* (London: Macmillan, 1938), pp. 20–21.

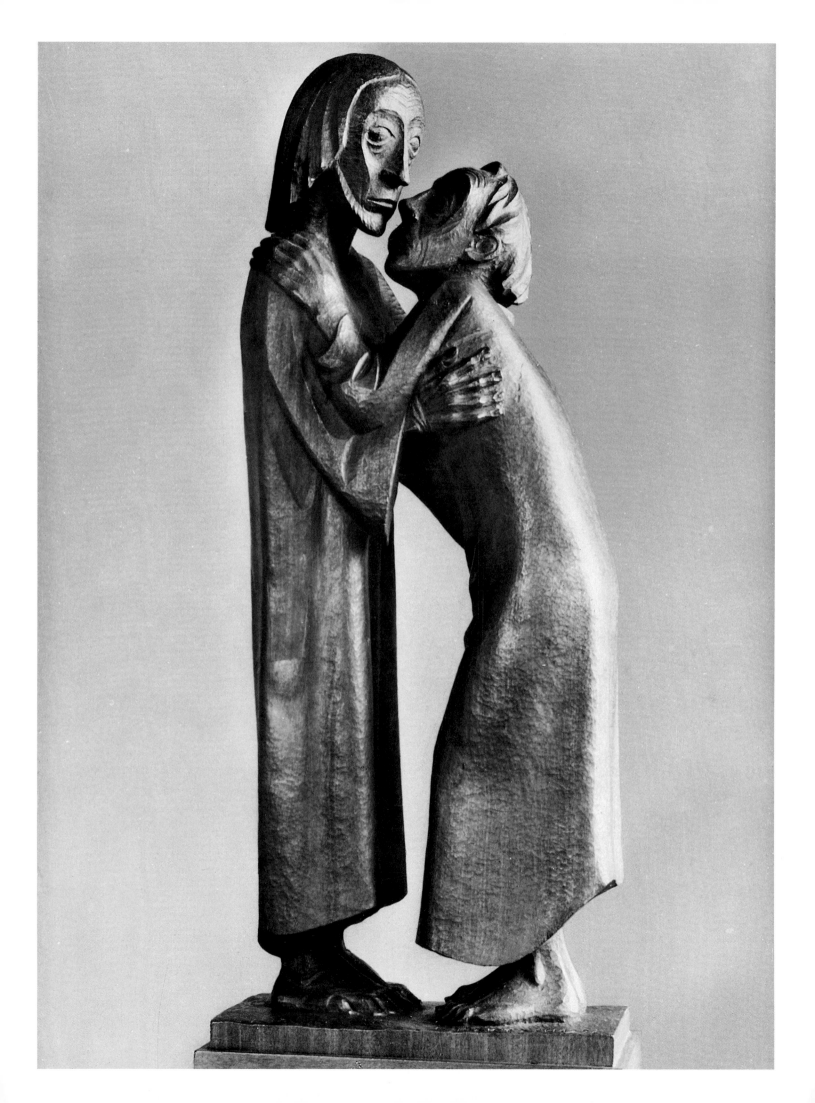

ERNST BARLACH

GERMAN | 1870–1938

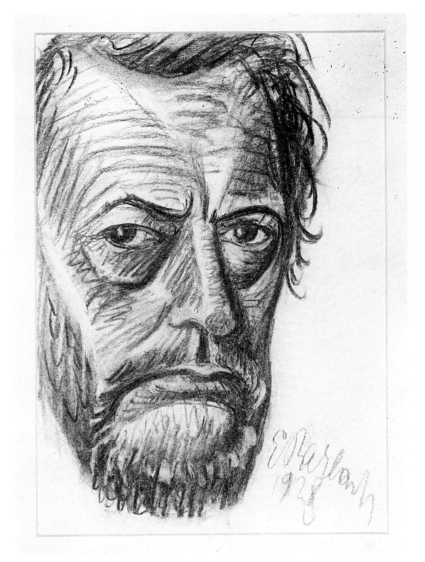

*So, too, all of my figures are probably
nothing other than fragments of this
unknown darkness, born to speak and to act,
and I have nothing to say against the notion
that my sculptures are nothing but intervals
of longing between a Where from? and a
Where to?*

Letter to Edzard Schaper, 10 May 1926, in *Katalog des Ernst Barlach Hauses*, Stiftung
Hermann F. Reemtsma (Hamburg: Mewes & Co., 1977), cover.

OPPOSITE:
The Return, Christ and Saint Thomas. 1926. Wood, overall height
35½″. Ernst Barlach Haus, Hamburg

*The word [God] is too big for my mouth. I understand that he is not
to be understood, that is all my knowledge of him.*

The Flood, 1924, *Three Plays by Ernst Barlach*, trans. Alex Page (Minneapolis:
University of Minnesota Press, 1964), p. 73.

RIGHT, ABOVE:
Self-portrait. 1928. Charcoal pencil, 12½ × 9⅛″. Ernst Barlach
Haus, Hamburg

RIGHT, BELOW:
The Singing Man. 1928. Bronze, overall height 19⅜″. Ernst
Barlach Haus, Hamburg

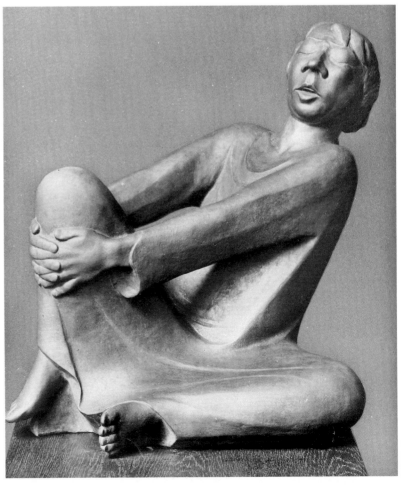

MAX BEERBOHM

BRITISH | 1872–1956

When I draw a man, I am concerned simply and solely with the physical aspects of him. I don't bother for one moment about his soul. . . . I see all his salient points exaggerated (points of face, figure, port, gesture and vesture), and all his insignificant points proportionately diminished. . . . In the salient points a man's soul does reveal itself, more or less faintly. . . . Thus if one underlines these points, and let the others vanish, one is bound to lay bare the soul.

In W. H. Auden, *Forewords & Afterwords*, ed. Edward Mendelson (New York: Random House, 1973), p. 376.

Self-portrait. c. 1900. Watercolor, 12⅛ × 7¾″. Harry Ransom Humanities Research Center Art Collection, The University of Texas at Austin

My gifts are small. I've used them very well and discreetly, never straining them; and the result is that I've made a charming little reputation.

In John Felstiner, *Max Beerbohm's Parody and Caricature* (New York: Alfred A. Knopf, 1972), p. 28.

OPPOSITE, ABOVE:
Twenty-one Literary Figures. c. 1922. Tempera on gesso ground on canvas, affixed to board and framed, 41 × 47½″. Harry Ransom Humanities Research Center Art Collection, The University of Texas at Austin

This mural once hung in Beerbohm's villa at Rapallo. The figures pictured are, from left to right: 1) E. Ray Lankester, 2) Edmund Gosse, 3) Edward Carson, 4) E. Gordon Craig, 5) R. B. Cunninghame-Graham, 6) Philip Wilson Steer, 7) Henry Tonks, 8) John Davidson, 9) George Bernard Shaw, 10) G. K. Chesterton, 11) John Masefield, 12) Lytton Strachey, 13) Herbert Asquith, 14) John Singer Sargent, 15) John Galsworthy, 16) Charles Conder, 17) Henry Chaplin, 18) William Nicholson, 19) Arthur Balfour, 20) Charles Boyd, and 21) G. S. Street.

OPPOSITE, BELOW:
Mr. Shaw's Apotheosis. 1925. Pencil and watercolor wash, 12⅝ × 15⅛″. Harry Ransom Humanities Research Center Art Collection, The University of Texas at Austin

Beerbohm's caricature of Shaw is based on A. B. Walkley's comment in *The Times*, 9 July 1924: "Mr. Shaw's Apotheosis is one of the wonders of the age." In the drawing, five small worshipers burn incense before an enormous Shaw.

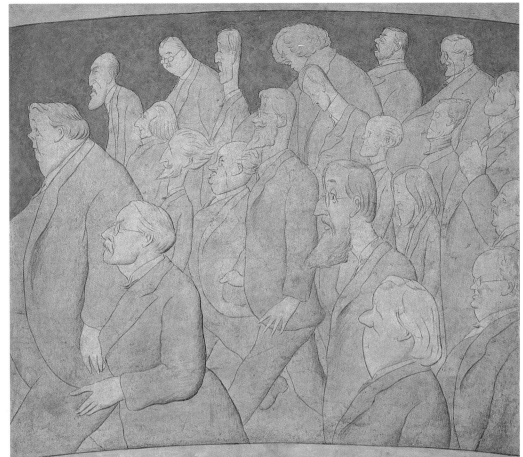

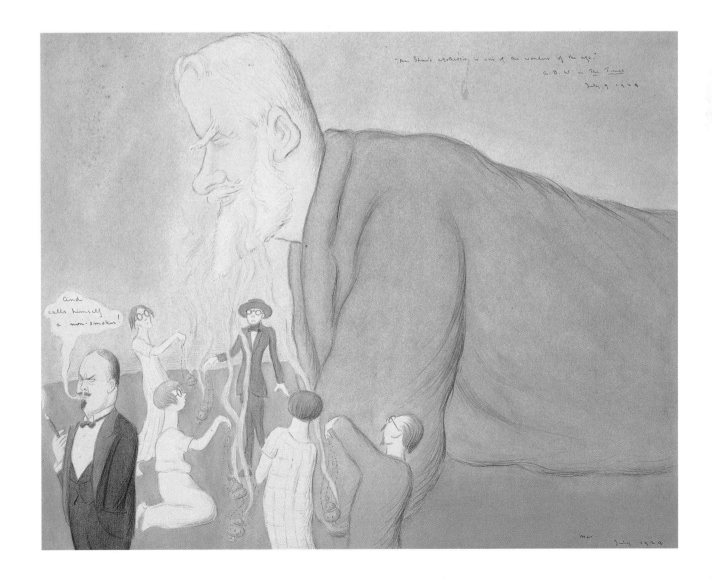

G. K. CHESTERTON

BRITISH | 1874–1936

There is at the back of every artist's mind something like a pattern or a type of architecture. The original quality in any man of imagination is imagery. It is a thing like the landscape of his dreams; the sort of world he would wish to make or in which he would wish to wander; the strange flora and fauna of his own secret planet; the sort of thing he likes to think about.

In W. H. Auden, "G.K. Chesterton's Non-Fictional Prose," *Forewords & Afterwords*, ed. Edward Mendelson (New York: Random House, 1973), p. 403.

LEFT, ABOVE:
Medieval Procession. c. 1909. Blue pencil on paper, 4⅞ × 8⅞".
Harry Ransom Humanities Research Center Art Collection, The University of Texas at Austin

LEFT, BELOW:
Untitled. Colored pencil, 9 × 7". Lilly Library, Indiana University, Bloomington, Ind.

This is one of a series of drawings in a sketchpad illustrating a Sherlock Holmes story by Arthur Conan Doyle.

OPPOSITE:
Editorial Board of the "New Witness." c. 1912. Pencil on paper, 11½ × 7¼". Harry Ransom Humanities Research Center Art Collection, The University of Texas at Austin

G. K. Chesterton became a contributor to the magazine *Eye Witness*, later renamed *New Witness*, a radical publication designed by Hilaire Belloc to expose corruption. Gilbert made this sketch during a meeting of the editorial board when his brother, Cecil, was the editor.

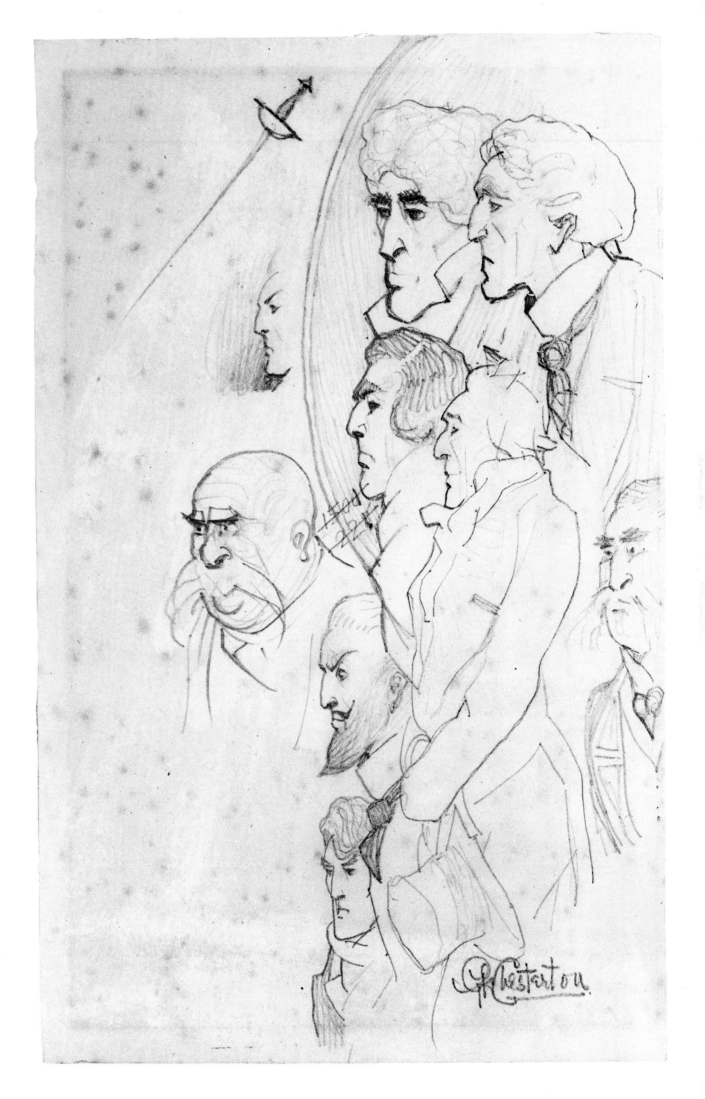

SHERWOOD ANDERSON

AMERICAN | 1876–1941

And here let me explain what the artist is. . . . The artist, any man born artist as I was, and caught as I was and, I dare say, as all such men are caught, has this hunger always to remake, to recreate. There is this shapeless thing all about him everywhere and the fingers ache to reshape it.

"Trumpeter," *Sherwood Anderson's Memoirs: A Critical Edition*, ed. Ray Lewis White (Chapel Hill, N.C.: University of North Carolina Press, 1969), p. 237.

LEFT, ABOVE:
Abstract Landscape. Watercolor, 11¾ × 17¾". The Newberry Library, Chicago. Sherwood Anderson Papers

There was a kind of painting I was seeking in my prose, word to be laid against word in just a certain way, a kind of word color, an arch of words and sentences, the color to be squeezed out of simple words, simple sentence construction. Just how much of all of this had been thought out, as I have spoken of it here, I do not now know.

Sherwood Anderson's Memoirs: A Critical Edition, p. 338.

LEFT, BELOW:
Face of Woman. Watercolor, 6¾ × 4¾". The Newberry Library, Chicago. Sherwood Anderson Papers

OPPOSITE:
Leaves and Fronds. Watercolor, 13¾ × 19¾". The Newberry Library, Chicago. Sherwood Anderson Papers

OPPOSITE:

Lady Kitty Somerset at an Easel. c. 1922. Oil on canvas, 27 × 20″.
Collection Edwina Sandys

Trying to paint a picture is like trying to fight a battle. It is, if anything, more exciting than fighting it successfully. But the principle is the same. It is the same kind of problem as unfolding a long, sustained, interlocked argument.

Maxims and Reflections of the Honorable Winston S. Churchill (Boston: Houghton Mifflin Co., 1949), p. 167.

LEFT:

Interior at Blenheim Palace. c. 1922. Oil on canvas, 24 × 20″.
Collection Edwina Sandys

RIGHT:

Terrace at Trent Park. 1935. Oil on canvas, 24 × 20″. Collection Edwina Sandys

Happy are the painters, for they shall not be lonely. Light and colour, peace and hope, will keep them company to the end, or almost to the end, of the day.

Painting as a Pastime (New York: McGraw-Hill Book Company, 1950), p. 13.

MAX JACOB

à François
que j'aime bien
mai 22

Max

When one paints a picture, at each touch the picture changes entirely. It turns like a cylinder and it's nearly an interminable process. When it stops turning, it's because it's finished.

Prose poem from *Cornet à dés*, in Gerald Kamber, *Max Jacob and the Poetics of Cubism* (Baltimore: Johns Hopkins University Press, 1971), p. 157.

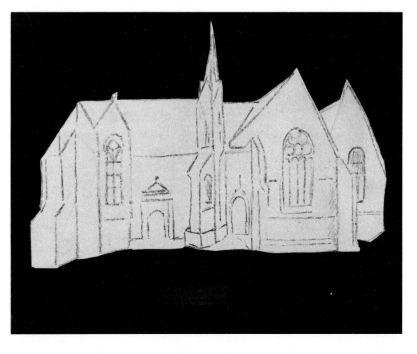

OPPOSITE:
Self-portrait. 1922. Ink and watercolor wash on pulled title page with printed letters "MAX JACOB," 7 × 5″. Inscribed in ink: "à Francois que j'aime bien mai 22 MJ." Harry Ransom Humanities Research Center Art Collection, The University of Texas at Austin. Artine Artinian Collection

RIGHT, ABOVE:
Portrait of Marcel Bealu. 1937. Pencil and ink, 9¼ × 8″. Harry Ransom Humanities Research Center Art Collection, The University of Texas at Austin. Artine Artinian Collection

Marcel Bealu was the companion to Roger Iribes and to the painter Josiah Adis. At their villa in Montargis, they were visited in 1937 by Jean Cocteau, his companion the actor Jean Marais, and by Max Jacob.

RIGHT, BELOW:
Church. c.1910. Carbon paper impression on drawing paper, outline cut out, irregular borders, approx. 3⅝ × 6″. Harry Ransom Humanities Research Center Art Collection, The University of Texas at Austin. Carlton Lake Collection

Max Jacob saw a vision that converted him to Catholicism while walking down the aisle of a movie theater. For his baptism, Pablo Picasso stood as godfather.

JOHN MASEFIELD

BRITISH | 1878–1967

Only a beauty, only a power,
Sad in the fruit, bright in the flower,
Endlessly erring for its hour,

But gathering, as we stray, a sense
Of life, so lovely and intense,
It lingers when we wander hence,

That those who follow feel behind
Their backs, when all before is blind,
Our joy, a rampart to the mind.

"The Passing Strange," *Poems* (New York: Macmillan Co., 1960), p. 158.

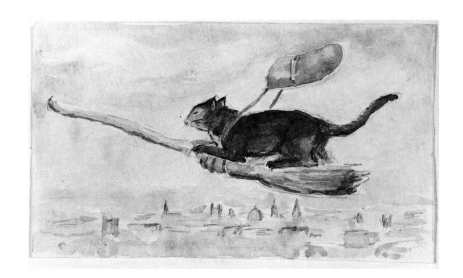

Sketch for *The Midnight Folk*. c. 1926. Pencil and watercolor,
3¼ × 5⅞". Harry Ransom Humanities Research Center Art
Collection, The University of Texas at Austin

This is Masefield's illustration for his tale of a young boy in search
of treasure, aided by "the midnight folk," night animals with powers
of magic.

It was merry to be so high in the air. . . . A couple of white owls drifted
up alongside Kay like moths; he could see their burning yellow eyes.

The Midnight Folk (London: William Heinemann, 1927), p. 28.

OPPOSITE:
Sailing Schooner. c. 1914. Linoleum cut, 4⅜ × 3⅛". Harry
Ransom Humanities Research Center Art Collection, The
University of Texas at Austin

When Masefield first saw the gallant sailing ship *The Wanderer* he
was in naval training school on the Mersey River at Liverpool. *The
Wanderer* was cruelly damaged by a storm and finally was struck and
sunk by a steamer at the mouth of the Elbe River in Germany. She
was the poet's lifelong symbol of courage and nobility in spite of
failure.

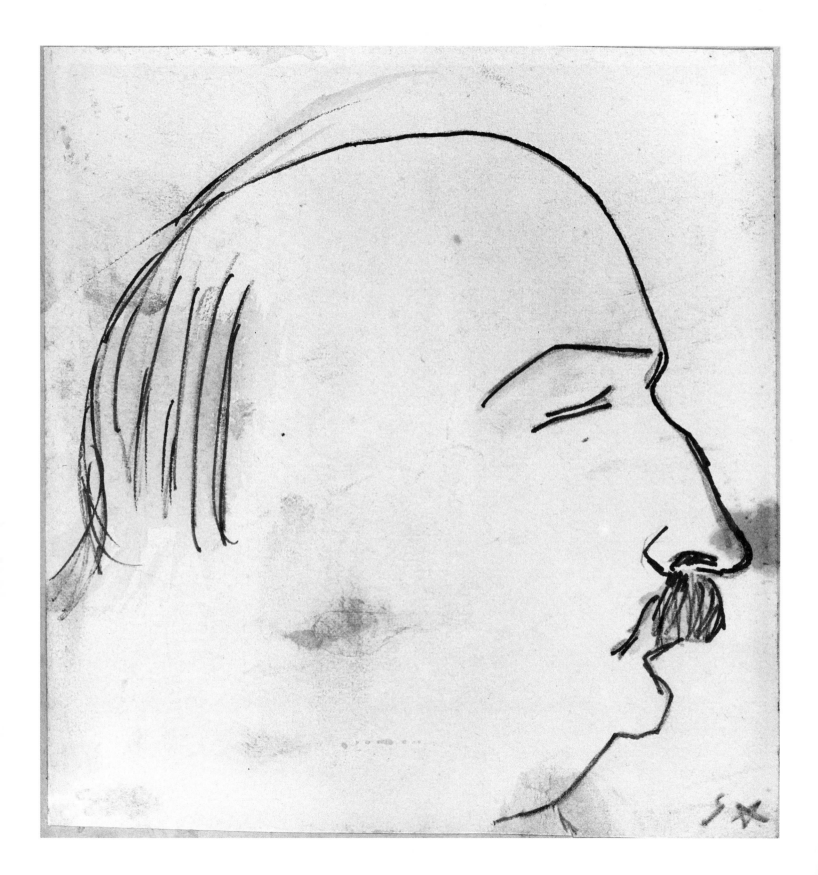

I personally am a great admirer of the modern school of painting, because it seems to me the most audacious school that ever existed. It has raised the question of what beauty is in itself.

The modern painters want to represent beauty detached from the pleasure that man finds in man—and that is something that no European artist, from the beginning of recorded time, had ever dared to do. The new artists are searching for an ideal beauty that will no longer be merely the prideful expression of the species.

Apollinaire on Art, Essays and Reviews 1902–1918, ed. LeRoy C. Breunig, trans. Susan Suleiman (New York: Viking Press, 1972), p. 225.

OPPOSITE:

Portrait Sketch of Jean Royère. c. 1911. Ink and watercolor wash on paper, 4⅞ × 4¾″. Harry Ransom Humanities Research Center Art Collection, The University of Texas at Austin. Artine Artinian Collection

Apollinaire bribed a servant to hide him in the house where the Committee for Freedom of Art was having its first secret meeting. He overheard Jean Royère, his publisher, say: "On the contrary, severe action should be taken against all those who express themselves clearly. Not every truth is fit to tell, and the work of art must be obscure and sibylline."

Letter from Paris, published in *Le Passant* (Brussels), 25 November 1911, cited in *Apollinaire on Art, Essays and Reviews 1902–1918*, p. 190.

RIGHT, ABOVE:

Dog Leaping at Chair. Ink sketch on page proofs for a play by Apollinaire, 1917, *Les Mamelles de Tirésias*, image 3⅛ × 4¾″. Harry Ransom Humanities Research Center Manuscripts Collection, The University of Texas at Austin

RIGHT, BELOW:

Shipwreck on the Rocks. Ink sketch on holograph manuscript of *Les Mamelles de Tirésias*, a play by Apollinaire, 1917, image 1¾ × 2¾″. The Prologue instructions are signed "Le Directeur de la Troupe." Harry Ransom Humanities Research Center Manuscripts Collection, The University of Texas at Austin

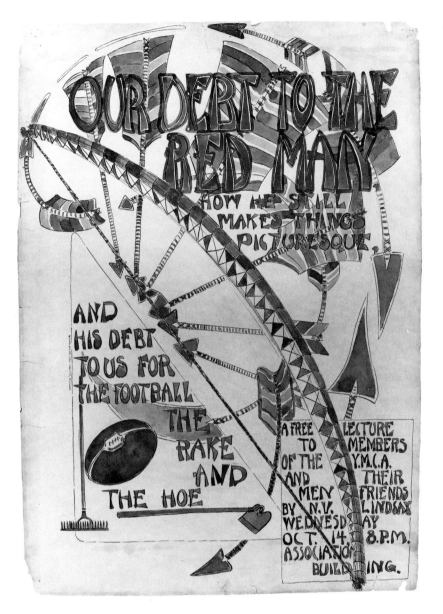

VACHEL LINDSAY
AMERICAN | 1879–1931

The life that is lived in this solitude, this beautiful life is reached in our best pictures and verses, and this in the end shared with others who take the book and the picture to their solitude, and live it over again.

In Edgar Lee Masters, *Vachel Lindsay: A Poet in America* (New York: Biblo & Tannen, 1969), p. 169.

Our Debt to the Red Man. Poster advertising a rally. 1907. Watercolor, 40 × 30″. Clifton Waller Barrett Library, The University of Virginia Library, Charlottesville. Vachel Lindsay Collection

OPPOSITE:
Xanadu. Collage with watercolor, 53½ × 43½″. Signed and dated (on the moon): "Xanadu/Vachel Lindsay/Spokane/1928." Clifton Waller Barrett Library, The University of Virginia Library, Charlottesville. Vachel Lindsay Collection

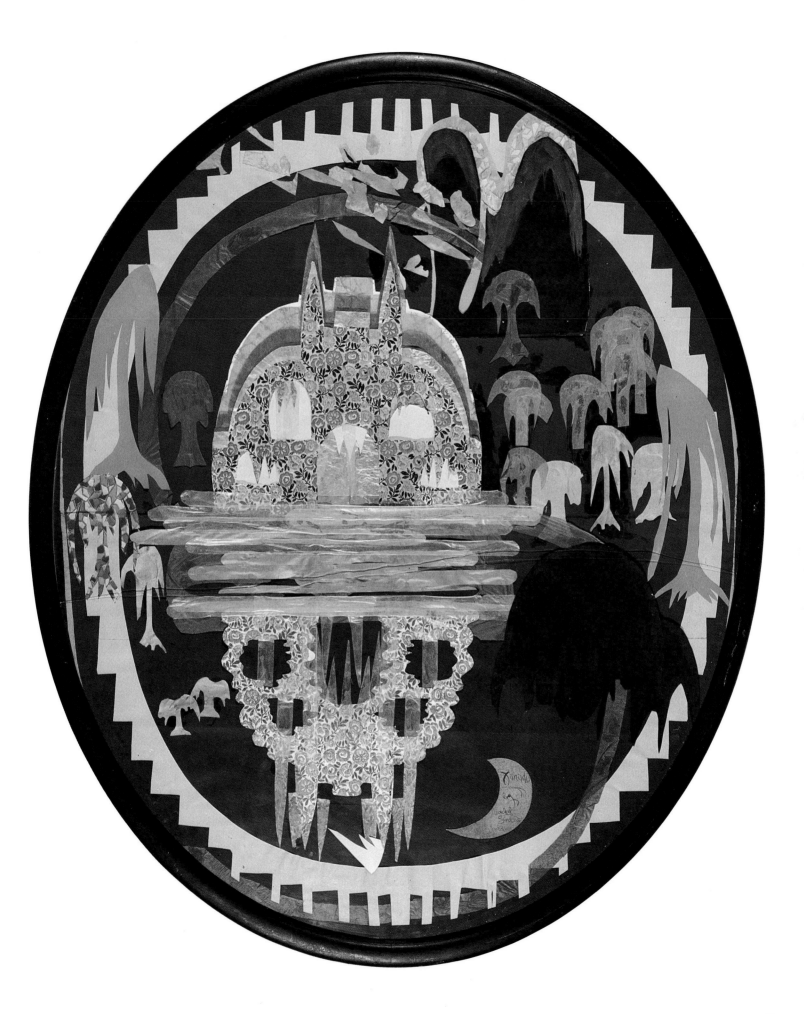

KAHLIL GIBRAN

LEBANESE-AMERICAN | 1883–1931

I paint and write now and then, and in the midst of my paintings and writings, I am like a small boat sailing between an ocean of an endless depth and a sky of limitless blue—strange dreams, sublime desires, great hopes, broken and mended thoughts; and between all these there is something which the people call Despair, and which I call Inferno.

Letter to Jamil Malouf, 1908, *A Self-Portrait*, trans. Anthony R. Ferris (New York: The Citadel Press, 1959), pp. 20–21.

Portrait of Blanche Knopf (Mrs. Alfred A. Knopf). 1920. Pencil, 21¼ × 16½". Inscribed by the artist: "To Alfred A. Knopf Jr. / With best wishes / From Kahlil Gibran / May - 1920." Harry Ransom Humanities Research Center Art Collection, The University of Texas at Austin. The Blanche and Alfred A. Knopf Collection. Courtesy The National Committee for Gibran

The Knopfs introduced Gibran's writings in the United States, the most successful of which was *The Prophet*, which has had 113 printings since 1923.

Self-portrait. c. 1923. Ink and wash, 7 × 5". Courtesy Alfred A. Knopf, New York, and The National Committee for Gibran

This was used as the cover for *The Prophet* in 1923.

T. S. ELIOT

*No poet, no artist of any art, has his
complete meaning alone. His significance,
his appreciation is the appreciation of his
relation to the dead poets and artists. You
cannot value him alone; you must set him,
for contrast and comparison, among the
dead. I mean this as a principle of aesthetic,
not merely historical, criticism.*

Selected Essays (New York: Harcourt Brace & Co., 1950), pp. 4–5.

Three Female Saints or the Three Marys. Copy after a museum
piece. 1910. Graphite on white paper, darkened, 6⅜ × 6¼". Fogg
Art Museum, Harvard University, Cambridge, Mass. Edward W.
Forbes Bequest

Eliot made these studies while receiving art instruction from E. W.
Forbes in 1910.

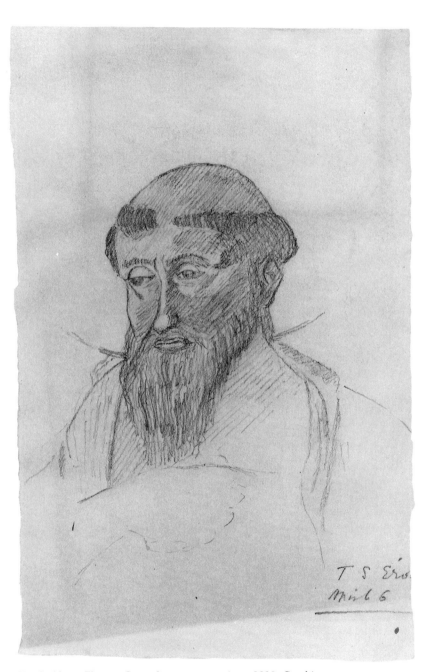

Head of Saint Thomas. Copy after a museum piece. 1910. Graphite
on white paper, darkened, 9⅝ × 6⅛". Fogg Art Museum,
Harvard University, Cambridge, Mass. Edward W. Forbes Bequest

T. E. LAWRENCE

BRITISH | 1888–1935

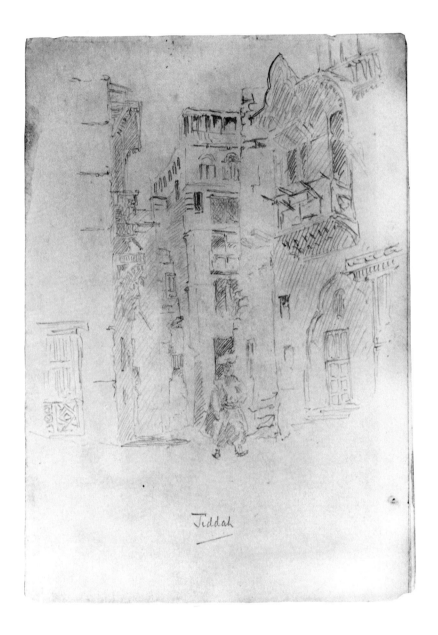

Jiddah

These drawings were found in a sketchbook purchased
by the Harry Ransom Humanities Research Center, The
University of Texas at Austin, at a sale at Sotheby's, London,
23 June 1959. Sotheby's named T. E. Lawrence as the author
of the sketchbook. However, the executor of the estate of
T. E. Lawrence states that this is not the work of the author.

*True there lurked always that Will uneasily
waiting to burst out. My brain was sudden
and silent as a wild cat, my senses like mud
clogging its feet, and my self (conscious
always of itself and its shyness) telling the
beast it was bad form to spring and vulgar
to feed on the kill. So meshed in nerves and
hesitation, it could not be a thing to be
afraid of; yet it was a real beast, and this
book its mangy skin, dried, stuffed and set
up squarely for men to stare at.*

Seven Pillars of Wisdom, in Stephen Ely Tabachnick, *T. E. Lawrence* (Boston: Twayne
Publishers, 1978), p. 130.

Jiddah. c. 1918. Pencil, 7⅛ × 5″. Harry Ransom Humanities
Research Center Art Collection, The University of Texas at Austin

Jiddah is the port on the Red Sea of Mecca, sacred city of Islam.

*One would say that for years Jidda had not been swept through by a
firm breeze; that its streets kept their air from year's end to year's end,
from the day they were built for so long as the houses should endure.*

Seven Pillars of Wisdom (Garden City, N.Y.: Doubleday & Co., 1935), p. 47.

OPPOSITE, ABOVE:
Untitled. Pencil and watercolor on notepad paper, 5 × 7″. Harry
Ransom Humanities Research Center Art Collection, The
University of Texas at Austin

OPPOSITE, BELOW:
Camel and Driver. c. 1918. Pencil drawing in small sketchpad, on
drawing paper, 5 × 7″. Inscribed in pencil on lower edge: "Arab
Levy. belonging to Hussein's Force." Harry Ransom Humanities
Research Center Art Collection, The University of Texas at Austin

*Nasir led us, riding his Ghazala—a camel vaulted and huge-ribbed
as an antique ship; towering a good foot above the next of our
animals, and yet perfectly proportioned, with a stride like an
ostrich's—a lyrical beast, noblest and best bred of the Howeitat
camels....*

Seven Pillars of Wisdom, p. 247. •

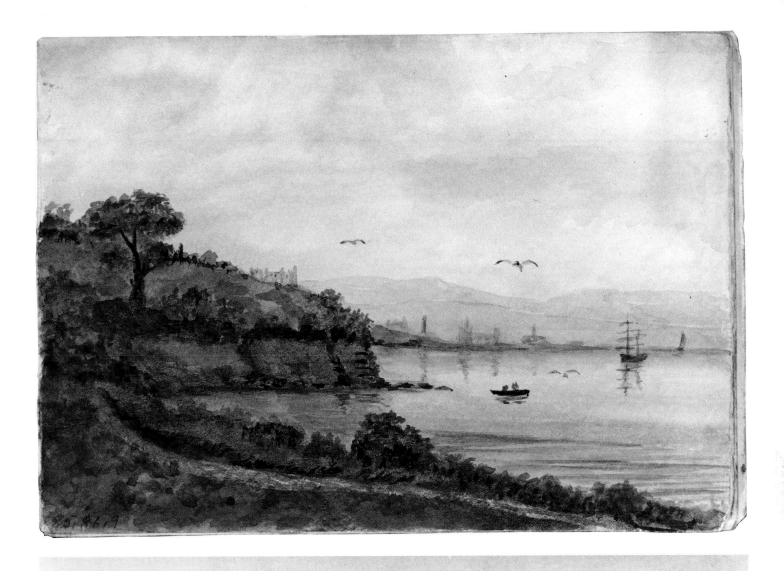

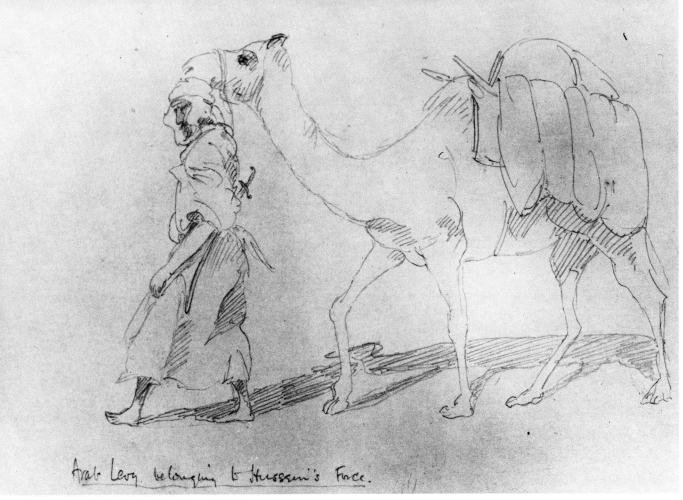

Arab Levy belonging to Hussein's Force.

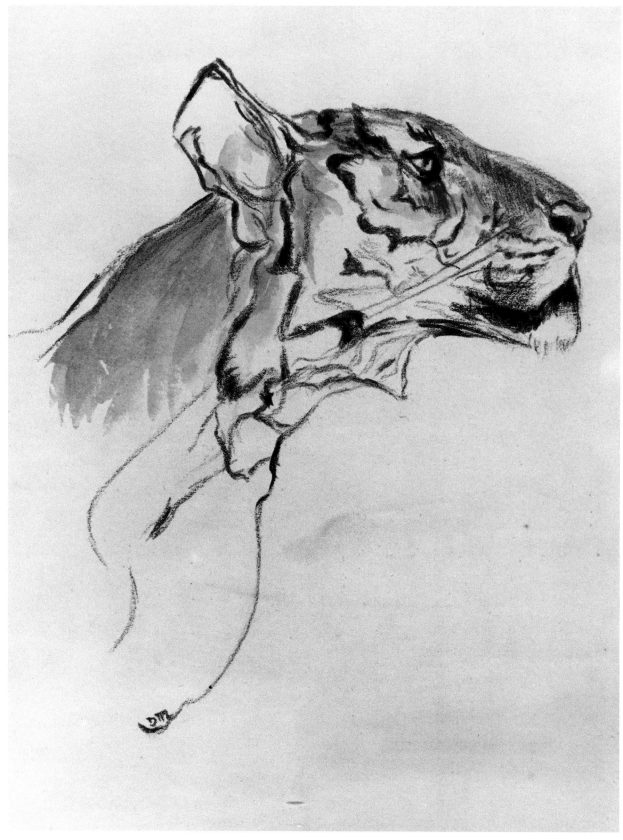

It needs a certain purity of spirit to be an artist, of any sort.... An artist may be a profligate and, from the social point of view, a scoundrel. But if he can paint a nude woman, or a couple of apples, so that they are a living image, then he was pure in spirit, and, for the time being, his was the kingdom of heaven. This is the beginning of all art, visual or literary or musical: be pure in spirit. It isn't the same as goodness. It is much more difficult and nearer the divine. The divine isn't only good, it is all things.

"Making Pictures," *Phoenix II: Uncollected, Unpublished and Other Prose Works by D. H. Lawrence,* coll. & ed. Warren Roberts and Harry T. Moore (New York: Viking Press, 1968), p. 604.

OPPOSITE:
Head of Tiger. c. 1912. Pencil and watercolor, 7⅛ × 5½″. Harry Ransom Research Center Art Collection, The University of Texas at Austin

Dated early in the year of Lawrence's departure from England, this drawing might be one of Lawrence's copies of old master drawings on which he prided himself.

The Escaped Cock. Title page. 1928. Pencil and watercolor, 8 × 5″. Harry Ransom Humanities Research Center Art Collection, The University of Texas at Austin

Lawrence's title page is inscribed: "O thou River of miracles that is / within me, pour the healing waters / of compassion on the wounded body / of Man and make him whole." The title page and eleven pages of printed text from *The Forum,* February 1928, are enclosed in a folded sheet of turquoise paper, bound with yarn.

"The Escaped Cock" tells the story of Jesus Christ following his resurrection. After finishing part one, Lawrence described the story:
... Jesus gets up and feels very sick about everything, and can't stand the old crowd any more—so cuts out—and as he heals up, he begins to find what an astonishing place the phenomenal world is, far more marvellous than any salvation or heaven—and thanks his stars he needn't have a "mission" any more.

Letter to E. H. Brewster, 13 May 1927, in *The Collected Letters of D. H. Lawrence,* ed. Harry T. Moore (New York: Viking Press, 1962), p. 975.

OPPOSITE:
Behind the Villa Mirenda. c. 1927. Oil on canvas, 21¾ × 16″. Harry Ransom Humanities Research Center Art Collection, The University of Texas at Austin

The seated figures are D. H. Lawrence and his wife Frieda, sister of the war ace Baron von Richthofen. In the background stands their landlord, Count Angelo Ravagli, who would become Frieda's third husband.

Resurrection. 1927. Oil on canvas, 37 × 36½″. Harry Ransom Humanities Research Center Art Collection, The University of Texas at Austin

After his sojourn in New Mexico and his journey through Mexico, Lawrence felt he had experienced a resurrection of health and spirit. The female figure on the left may be Dorothy Brett, the male figure on the right perhaps Willard "Spud" Johnson, publisher of *The Laughing Horse* magazine in Taos.

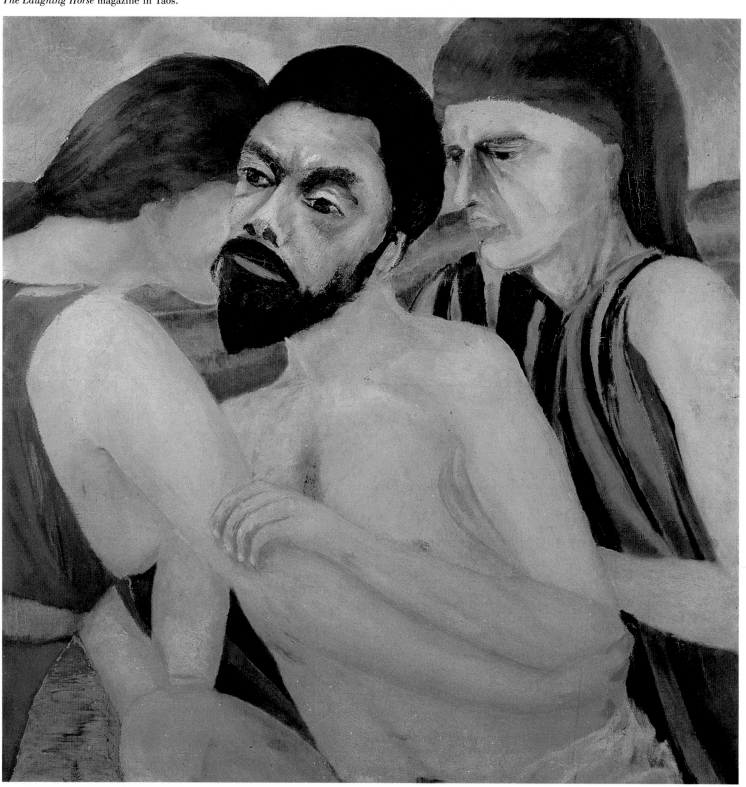

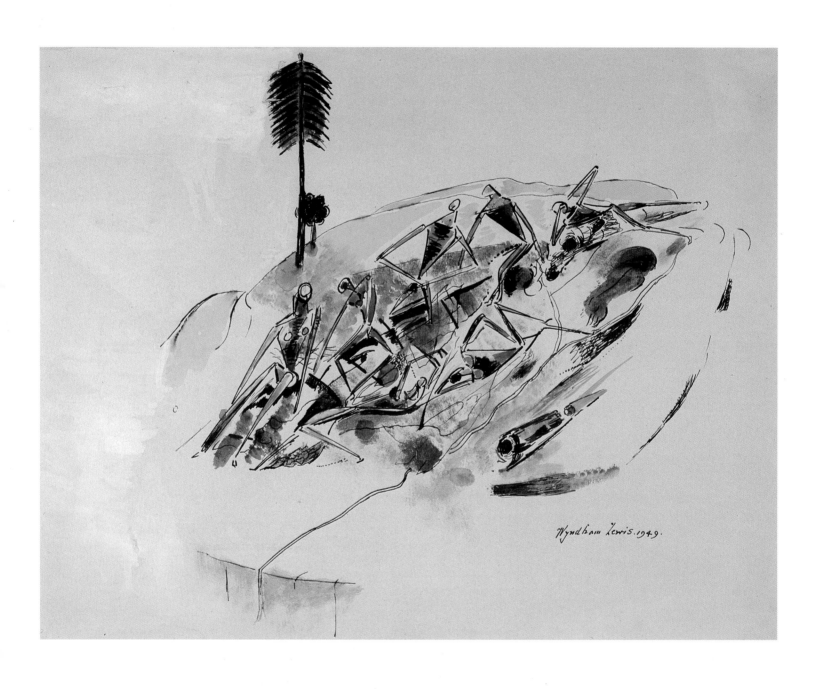

Yet the artist is, in any society, by no means its least valuable citizen. Without him the world ceases to see itself and to reflect. It forgets all its finer manners. For art is only manner, it is only style. That is, in the end, what "art" means. At its simplest, art is a reflection: a far more mannered reflection than that supplied by the camera.

Blasting & Bombardiering (Berkeley: University of California Press, 1967), p. 259.

OPPOSITE:
Women. 1949. Pen and ink and watercolor, 10¾ × 14″. Private collection, New York

RIGHT:
T. S. Eliot. c. 1948–49. Charcoal pencil, 22 × 13″. Preliminary study for Lewis's portrait of Eliot of 1949. Harry Ransom Humanities Research Center Art Collection, The University of Texas at Austin

Of this portrait, Eliot said: "I shall not turn in my grave if, after I am settled in the cemetery, this portrait is the image that will come into people's minds when my name is mentioned."

T. S. Eliot, quoted in *Time* magazine review of Wyndham Lewis's "Redfern Show," 30 May 1949.

Self-portrait. 1931. Pencil, 9¾ × 7¾″. Harry Ransom Humanities Research Center Art Collection, The University of Texas at Austin

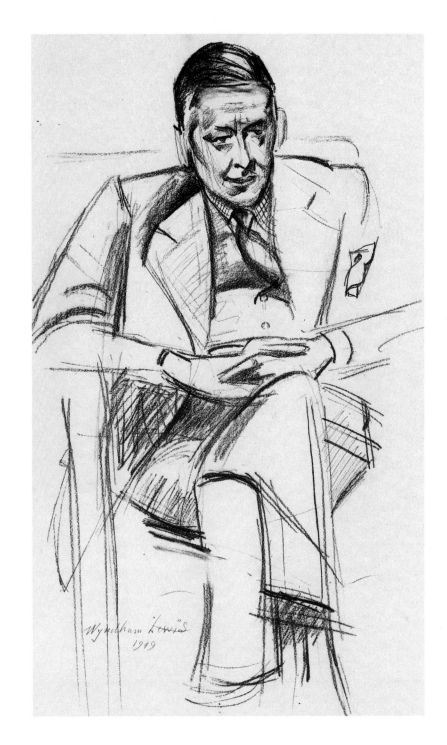

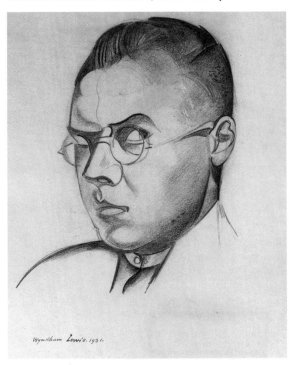

JEAN COCTEAU
FRENCH | 1889–1963

ORPHÉE: *What are the thoughts of the marble from which a sculptor shapes a masterpiece? It thinks: I am being struck, ruined, insulted, and broken, I am lost. This marble is stupid. Life is shaping me, Heurtebise. It is making a masterpiece.*

Orphée, trans. Carl Wildman, in *Five Plays* (New York: Hill & Wang, 1961), pp. 37–38.

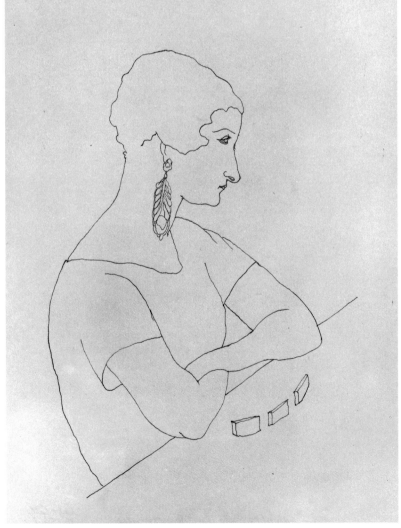

LEFT, ABOVE:
L'U. Dada. c. 1919. Ink, 8½ × 11″. Harry Ransom Humanities Research Center Art Collection, The University of Texas at Austin. Carlton Lake Collection

When the Dadaists moved in on Paris, Cocteau caricatured the new arrival of "les boches" (slang for Germans; according to one theory, the "anti-art" movement was originally championed by German poets in German-speaking Zurich).

LEFT, BELOW:
Valentine Gross Hugo. 1917. Ink, 10½ × 8⅛″. Harry Ransom Humanities Research Center Art Collection, The University of Texas at Austin. Carlton Lake Collection

Valentine Gross befriended Cocteau, and their friendship became an intimate threesome when she married the grandson of Victor Hugo. As Paul Morand described her: "Valentine Gross, with her wide-open eyes, her face painted like a doll's, her hair smoothly parted in the center... looking like Titian's 'Man with Glove.'"

Paul Morand, diary entry of 1917, in Francis Steegmuller, *Jean Cocteau: A Biography* (Boston: Little, Brown & Co., 1970), pp. 197–98.

Barbette? 1923. Pencil, ink, and watercolor, 19⅝ × 8¼″. Harry Ransom Humanities Research Center Art Collection, The University of Texas at Austin. Carlton Lake Collection

Barbette learned the art of the trapeze on his mother's backyard clothesline in Georgetown, Texas.

...he is no mere acrobat in women's clothes, nor just a graceful daredevil, but one of the most beautiful things in the theatre. Stravinsky, Auric, poets, painters and I myself have seen no comparable display of artistry on the stage since Nijinsky.

Letter to Paul Collaer, a Belgian theater critic, in Francis Steegmuller, *Jean Cocteau: A Biography*, p. 365.

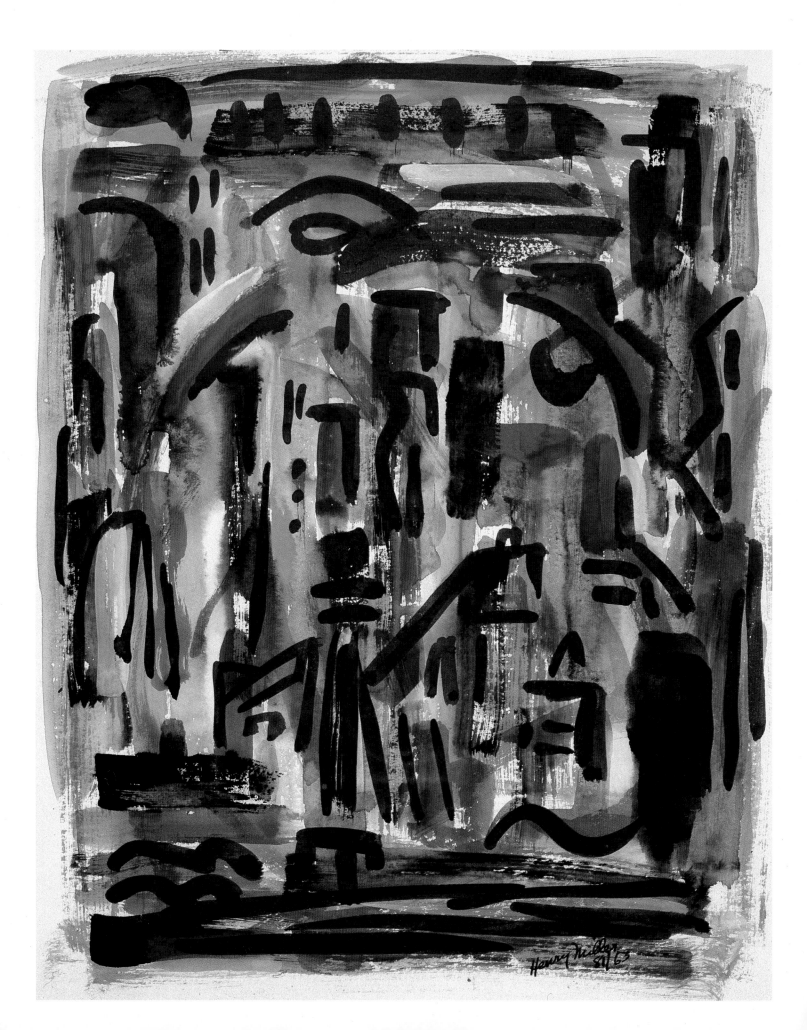

HENRY MILLER

AMERICAN | 1891–1980

To paint is to love again. It's only when we look with eyes of love that we see as the painter sees. His is a love, moreover, which is free of possessiveness. What the painter sees he is duty bound to share. Usually he makes us see and feel what ordinarily we ignore or are immune to. His manner of approaching the world tells us, in effect, that nothing is vile or hideous, nothing is stale, flat and unpalatable unless it be our own power of vision. To see is not merely to look. One must look-see.

To Paint Is to Love Again: Including Semblance of a Devoted Past (New York: Grossman Publishers, 1968), p. 9.

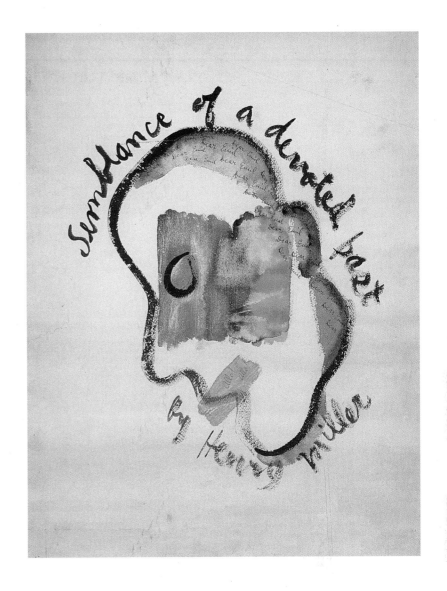

OPPOSITE:
The Kasba. 1963. Watercolor, 15¾ × 13⅛″. Private collection, New York

Semblance of a Devoted Past. 1968. Watercolor, 30¼ × 23⅝″. Harry Ransom Humanities Research Center Art Collection, The University of Texas at Austin

The watercolor is enhanced with words of greeting to Miller's friend Emil Schnellock, to whom he dedicated his book about painting, *To Paint Is to Love Again: Including Semblance of a Devoted Past.*

DJUNA BARNES
AMERICAN | 1892–1982

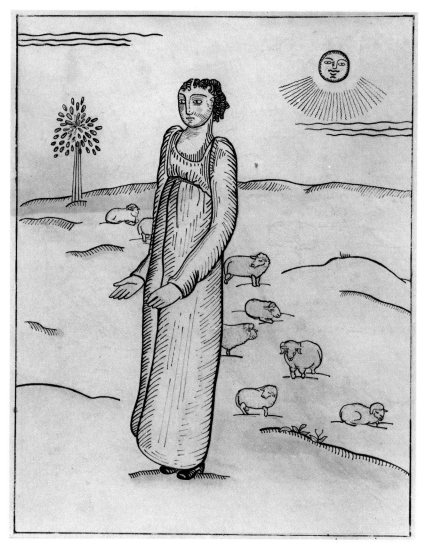

BURLEY:

"A poet is a light and winged thing, and holy,"
As Plato said. You are in the wash of such;
The which your people know; it is their cruel pleasure.

The Antiphon: A Play (New York: Farrar, Straus & Cudahy, 1958), p. 97.

RIGHT, ABOVE:
Untitled. Late 1920s. Ink and watercolor on watercolor paper, image 11⅝ × 8⅞″. Private collection, New York

RIGHT, BELOW:
Vignette. Possibly intended for *Ladies Almanack.* c. 1928. Ink on parchment, 2¼ × 3″. Private collection, New York

OPPOSITE:
Cover design, front, for *Ladies Almanack showing their Signs and their tides . . . written & illustrated by a lady of fashion.* 1928. Watercolor and ink on parchment, image 7 × 5½″. Private collection, New York

Ladies Almanack was a short satirical novel divided into twelve chapters, each named for a month of the year. The heroine is Dame Evangeline Musset, or "Saint Musset," and editorial comment is provided by Patience Scalpel. It was privately printed in Dijon in a limited edition of 1,050.

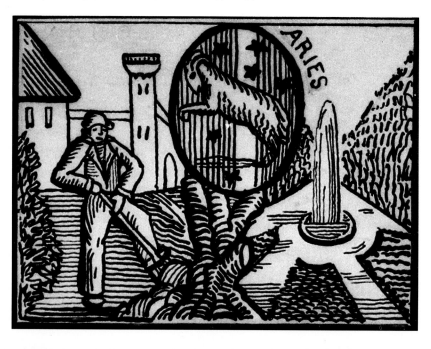

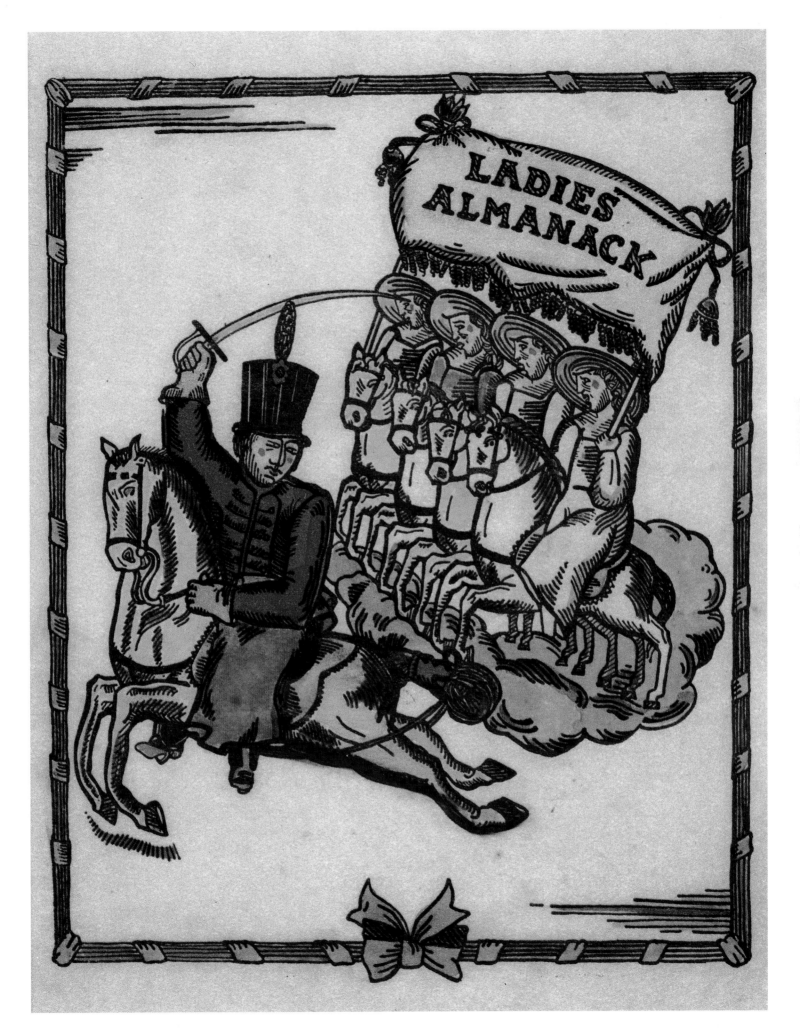

For the man or woman obsessed by these dream people can never be a very happy person. He lives a thousand lives besides his own, suffers a thousand agonies as really as though they were what is called actual, and he dies again and again. He is doomed to be possessed by spirits until he cannot tell what is himself, what are his real soul and mind. He is thrall to a thousand masters. He is exhausted bodily and spiritually by creatures alive and working through his being, using his one body, his one mind, to express their separate selves, so that his one poor frame must be the means of all those living energies. It is no wonder that much of his time he sits bemused, silent and spent. . . . If you would be yourself, therefore, free and unpossessed, never begin to be a novelist.

"Introduction," *The First Wife and Other Stories* (New York: John Day Company, 1933), p. 31.

OPPOSITE, LEFT:

Jean. Terra cotta, height 19″. The Pearl Buck Foundation, Perkasie, Pa.

Pearl Buck's daughter Jean at age seven.

OPPOSITE, RIGHT:

John. Terra cotta, height 17½″. The Pearl Buck Foundation, Perkasie, Pa.

Pearl Buck's son John at age eight.

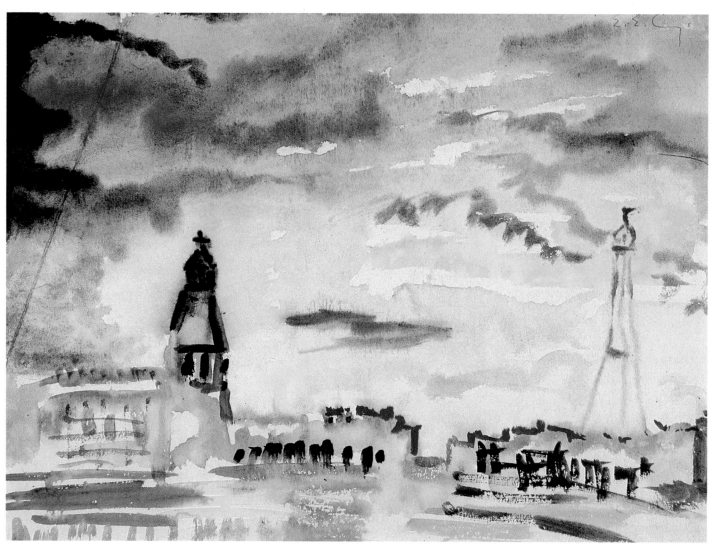

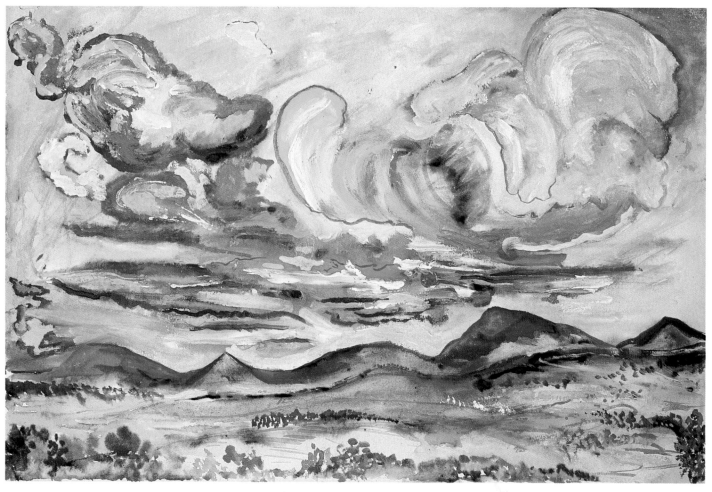

Why do you paint?
For exactly the same reason I breathe.
That's not an answer.
There isn't any answer.
How long hasn't there been any answer?
As long as I can remember.
And how long have you written?
As long as I can remember.
I mean poetry.
So do I.
Tell me, doesn't your painting interfere with your writing?
Quite the contrary: they love each other dearly.

Foreword to exhibition catalogue *Paintings and Drawings of e. e. cummings* (Rochester, N.Y.: Memorial Art Gallery of the University of Rochester, 1945).

OPPOSITE, ABOVE:
Paris. 1926. Watercolor on paper, 5⅛ × 6⅜". Harry Ransom Humanities Research Center Art Collection, The University of Texas at Austin

Paris; this April sunset completely utters
utters serenely silently a cathedral
before whose upward lean magnificent face
the streets turn young with rain,

..

"Post Impressions, V," &, *e. e. cummings: Poems 1923–1954* (New York: Harcourt, Brace & World, 1954), pp. 75–76.

OPPOSITE, BELOW:
View from Joy Farm, Silver Lake, New Hampshire. Watercolor, 11⅞ × 17⅞". Harry Ransom Humanities Research Center Art Collection, The University of Texas at Austin

Edward Estlin loved his childhood visits to Joy Farm, particularly riding with his grandfather in the old jalopy. Following his ludicrous incarceration in Paris during World War I, he returned to the farm to write of his experiences (*The Enormous Room*, 1922) in the tree house he had built there as a boy.

Portrait of Anne Abbot Thayer. c. 1929. Oil on board, 16½ × 8¼". Private collection, New York

Anne Abbot Thayer was cummings's first wife. Her first husband was Abbot Thayer, publisher of *The Dial* magazine, for whom cummings wrote poetry and art criticism. Along with John Dos Passos, cummings became Paris correspondent for *The Dial*.

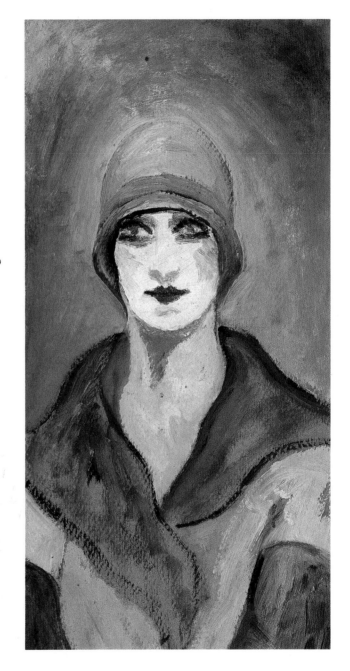

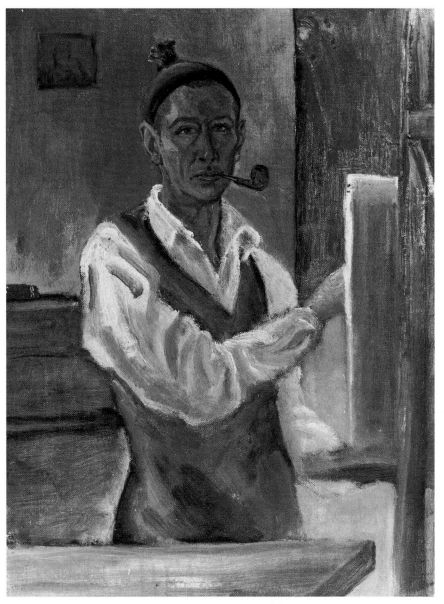

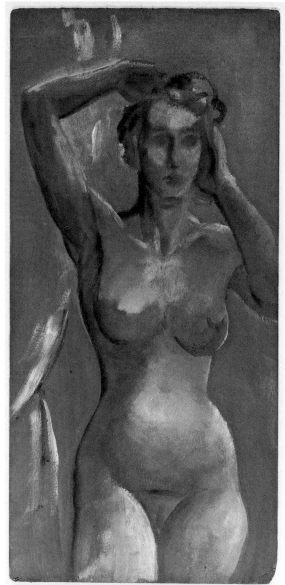

OPPOSITE, LEFT:

Self-portrait. 1945. Oil on canvasboard, 19⅞ × 11⅞″. Harry Ransom Humanities Research Center Art Collection, The University of Texas at Austin

Came the forties; and culture (lucely translated You Never Had It So Good) leaped like a weed....Nobody and nothing escaped The New Look: children of parents who'd honestly hated my writing were taught how to pity my painting instead.

"Videlicet (Little Autobiography)," in an article on cummings by William Carlos Williams for *Art Digest*, 1954, in Charles Norman, *The Magic-Maker: e. e. cummings* (New York: Duell, Sloan & Pearce, 1964), p. 274.

OPPOSITE, RIGHT:

Marion Morehouse Cummings. 1957. Oil on canvasboard, 18 × 9″. Harry Ransom Humanities Research Center Art Collection, The University of Texas at Austin

A successful photographer in her own right and the woman Stieglitz called "the most beautiful model in the world," Marion Morehouse became cummings's third wife.

RIGHT, ABOVE:

Elizabeth Cummings. 1905. Pencil on paper, 10¾ × 7⅞″. Harry Ransom Humanities Research Center Art Collection, The University of Texas at Austin

Elizabeth adored her older brother Edward Estlin: "My brother was great fun to be with. He could draw pictures, and tell stories, and imitate people and animals, and invent games, and could make you laugh, even when you thought you felt very miserable."

Elizabeth Cummings, in Charles Norman, *The Magic-Maker: e. e. cummings*, p. 20.

RIGHT, BELOW:

Bois de Boulogne. Charcoal, 10⅞ × 8½″. Private collection, New York

JAMES THURBER
AMERICAN | 1894–1961

Out of trivia often grows the serious, after the serious often comes the trivia, after the labor of writing came the relaxation of my drawings or there wouldn't be any. This, to me, makes up the Human Comedy and the unmethodical system of the serious comic writer or artist.

Letter to Robert E. Morsberger, 23 June 1959, in Robert E. Morsberger, *James Thurber* (New York: Twayne Publishers, Inc., 1964), p. 187.

Indenture. Ink, 10⅝ × 8″. Harry Ransom Humanities Research Center Art Collection, The University of Texas at Austin. Morris Ernst Collection

"Latin *indentare*, to furnish with teeth. When an agreement was reached between an employer and an apprentice, the articles of *indenture* were torn in half, leaving toothed edges. The genuineness of either half could then be tested—the paper teeth fitted into each other."

Margaret Samuels Ernst, *In a Word*, illustrated by James Thurber (Great Neck, N.Y.: Channel Press, 1939), p. 129.

OPPOSITE, ABOVE:
Morris Ernst. c. 1928. Pencil, 9 × 12″. Harry Ransom Humanities Research Center Art Collection, The University of Texas at Austin. Morris Ernst Collection.

Ernst framed this cartoon drawn by his friend Thurber and hung it on the wall of his office in New York, where it stayed for twenty years until his death.

OPPOSITE, BELOW:
Morris Ernst. c. 1927. Pencil on paper, 9 × 12″. Harry Ransom Humanities Research Center Art Collection, The University of Texas at Austin. Morris Ernst Collection

Thurber drew this cartoon for his friend Morris Ernst, a brilliant New York attorney. Ernst made himself famous by successfully negotiating for permission to publish in the United States the previously banned *Lady Chatterley's Lover* by D. H. Lawrence.

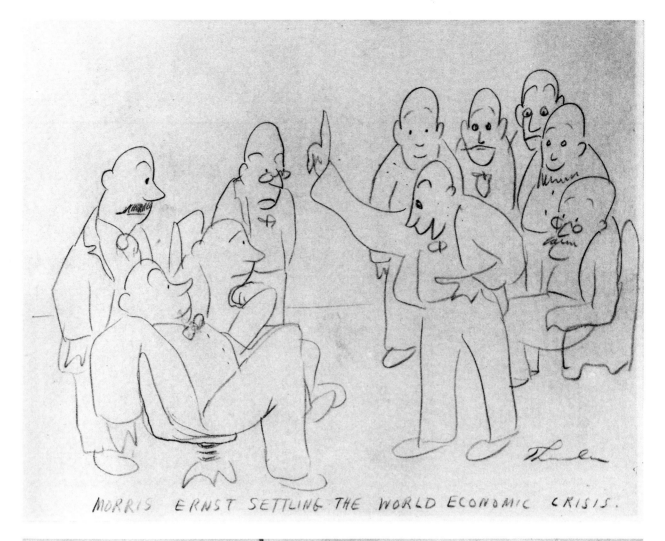

MORRIS ERNST SETTLING THE WORLD ECONOMIC CRISIS.

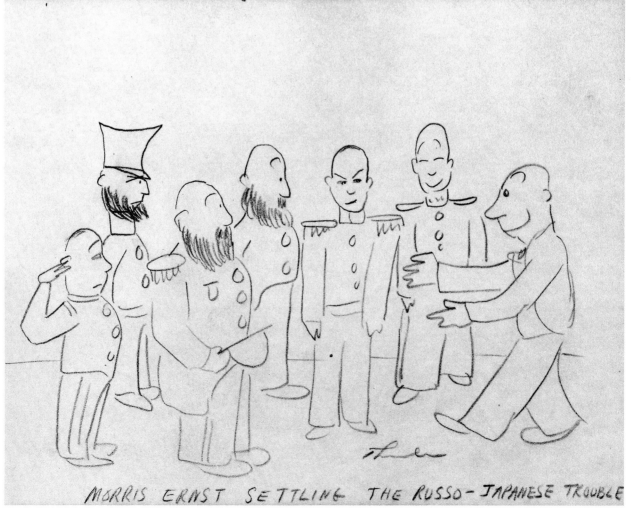

MORRIS ERNST SETTLING THE RUSSO-JAPANESE TROUBLE

ANDRÉ BRETON

FRENCH | 1896–1966

Perhaps life needs to be deciphered like a cryptogram. Secret staircases, frames from which the paintings quickly slip aside and vanish (giving way to an archangel bearing a sword or to those who must forever advance), buttons which must be indirectly pressed to make an entire room move sideways or vertically, or immediately change all its furnishings; we may imagine the mind's greatest adventure as a journey of this sort to the paradise of pitfalls.

In Michel Carrouges, *André Breton and the Basic Concepts of Surrealism*, trans. Maura Prendergast (Tuscaloosa: University of Alabama Press, 1974), p. 167.

LEFT, ABOVE:

André Breton and Valentine Hugo. *Cadavre exquis.* c. 1927. Pencil, ink, and Chinese white. Musée National d'Art Moderne, Centre Georges Pompidou, Paris

Le Cadavre exquis (the exquisite corpse) was a Surrealist "game" with folded paper in which each participant contributed a drawing on one of the folds without knowing what had come before.

LEFT, BELOW:

André Breton, Man Ray, Tanguy, and others. *Cadavre exquis.* Ink and pencil. Musée National d'Art Moderne, Centre Georges Pompidou, Paris

OPPOSITE, LEFT:

André Breton and Tanguy. *Cadavre exquis.* Pencil and ink. Musée National d'Art Moderne, Centre Georges Pompidou, Paris

OPPOSITE, RIGHT:

André Breton, Moise, Man Ray, and Tanguy. *Cadavre exquis.* 17 May 1927. Pencil. Musée National d'Art Moderne, Centre Georges Pompidou, Paris

Actually, it is in painting that it—poetry—seems to have discovered its widest field of influence: it is so well established there that today poetry can in a large measure claim to share its most important object which is, as Hegel has said, the revelation to the consciousness of the powers of the spiritual life.

In Michel Carrouges, *André Breton and the Basic Concepts of Surrealism*, p. 166.

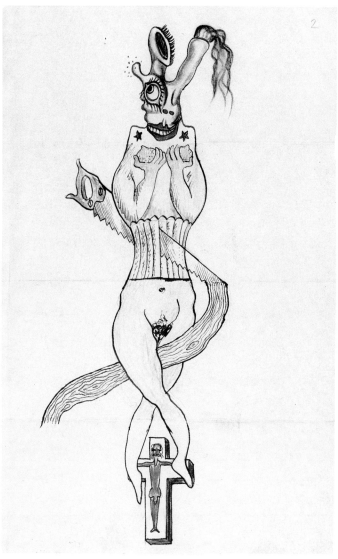

JOHN DOS PASSOS

AMERICAN | 1896–1970

There has never been great art that did not beat with every beat of the life around it.... this moment is so on the brink of things. Overpopulation combined with the breakdown of food has wrecked the checks and balances of the industrialized world. In ten years we may be cavemen snatching the last bit of food from each others' mouths amid the stinking ruins of our cities, or we may be slaving—antlike—in some utterly systematized world where the individual will be utterly crushed that the mob (or the princes) may live. Every written word should be thought of as possibly the last humanity will ever write....

The Fourteenth Chronicle: Letters and Diaries of John Dos Passos, ed. Townsend Ludington (Boston: Gambit, 1973), pp. 278–81.

LEFT, ABOVE:
Bassano, Italy. March 13, 1918. Pencil, 4¾ × 6¼". University of Virginia Library, Charlottesville. John Dos Passos Papers

Dos Passos joined a volunteer ambulance unit during World War I, an experience he recorded in his diary, with sketches.

LEFT, BELOW:
Italy. 1918. Pencil, 6¼ × 4¾". University of Virginia Library, Charlottesville. John Dos Passos Papers

I'm not a professional, my sketches are like the pencilled notes you jot down in your notebook and forget to do anything with.

The Best Times (New York: Signet Books, 1968), p. 149.

OPPOSITE:
Processional. 1926. Gouache and pencil, 29¾ × 21⅞". University of Virginia Library, Manuscript Department, Charlottesville

For three years, Dos Passos was associated with the New Playwrights Theatre in New York, directed by his friend John Howard Lawson. This design was probably used as a poster for Lawson's play *Processional,* a satire about West Virginia coal miners on strike.

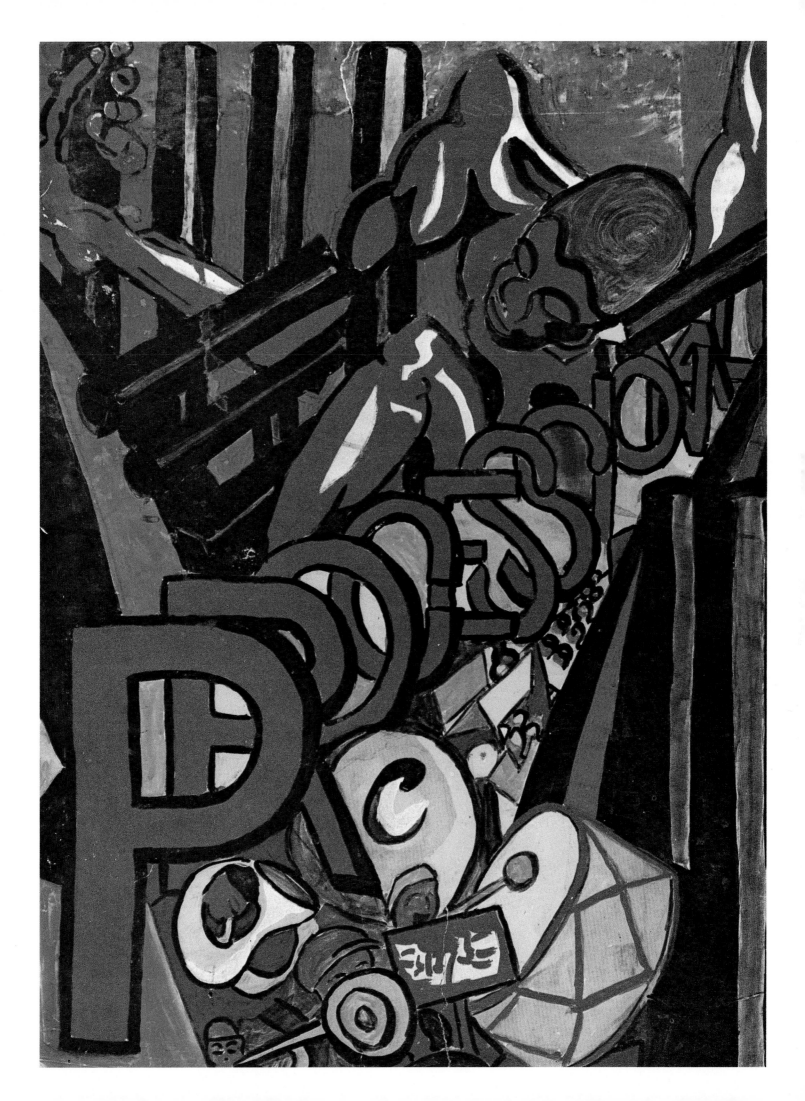

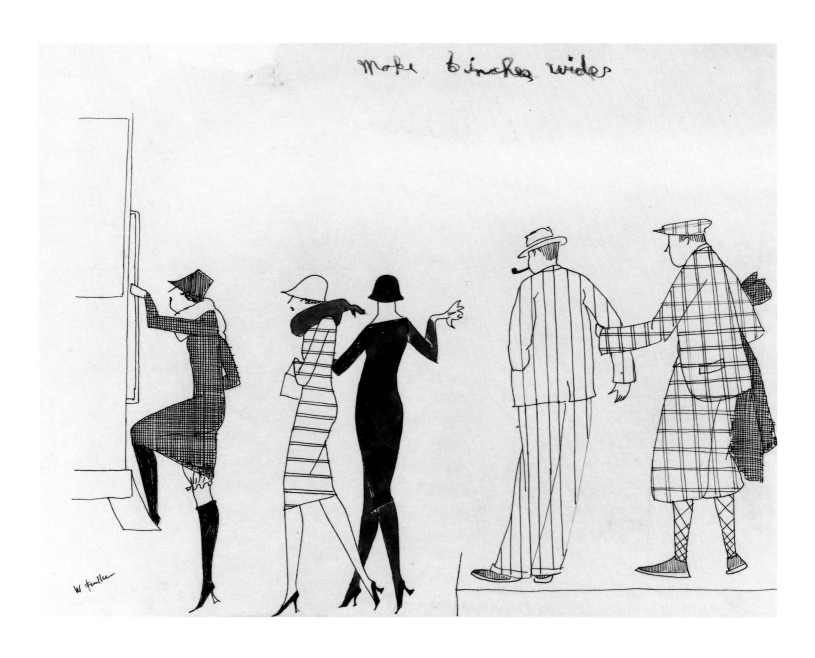

WILLIAM FAULKNER

The aim of every artist is to arrest motion, which is life, by artificial means and hold it fixed so that 100 years later when a stranger looks at it, it moves again since it is life.

In James B. Meriwether and Michael Millgate, *Lion in the Garden: Interviews with William Faulkner 1926–1962* (New York: Random House, 1968), p. 253.

OPPOSITE:
Girl Boarding Bus. 1925. Ink, 7⅝ × 10⅛″. Harry Ransom Humanities Research Center Art Collection, The University of Texas at Austin

("Lit" asks "Law" if he is going to the show and "Law" replies): "Na-ah, what I wanta spend good money on a show for?"

Faulkner executed these cartoons when he was art editor for the humor magazine *The Scream* in Oxford, Mississippi. The captions were added to a rerun of the drawings just before the magazine went bankrupt.

RIGHT, ABOVE:
Drunk Speaking to Statue. 1925. Ink, 5¾ × 7½″. Harry Ransom Humanities Research Center Art Collection, The University of Texas at Austin

"Poo' girl, poo' li'l girl; shree mile' f'm town, no clo', ca' even walk!"

RIGHT, BELOW:
Beaver-clad "Sport" with Model-T Ford. 1925. Ink, 5⅛ × 6¾″. Harry Ransom Humanities Research Center Art Collection, The University of Texas at Austin

HART CRANE

AMERICAN | 1899–1932

Literature has a more tangible relationship to painting [than to music]; and it is highly probable that the Symbolist movement in French poetry was a considerable factor in the instigation first, of Impressionism, and later, of Cubism. Both arts have had parallel and somewhat analogous tendencies toward abstract statement and metaphysical representation. In this recent preoccupation it is certain that both media were responding to the shifting emphasis of the Western World away from religion toward science. Analysis and discovery, the two basic concerns of science, became conscious objectives of both painter and poet.

"Modern Poetry," *The Collected Poems of Hart Crane*, ed. and intro. Waldo Frank (New York: Liveright, 1933), p. 176.

Isadora Duncan. 1922. Pencil and ink, 3½ × 5″. Rare Book and Manuscript Library, Columbia University, New York

It was like a wave of life, a flaming gale that passed over the heads of the nine thousand in the audience without evoking response other than silence and some maddening cat-calls.

Letter to Gorham Munson from Cleveland, 12 December 1922, *The Letters of Hart Crane 1916–1932*, ed. Brom Weber (New York: Heritage House, 1952), p. 109.

OPPOSITE:
Trees. 1908. Oil on canvas, 7⅛ × 5¼″. Rare Book and Manuscript Library, Columbia University, New York

Hart Crane painted *Trees* at the age of ten.

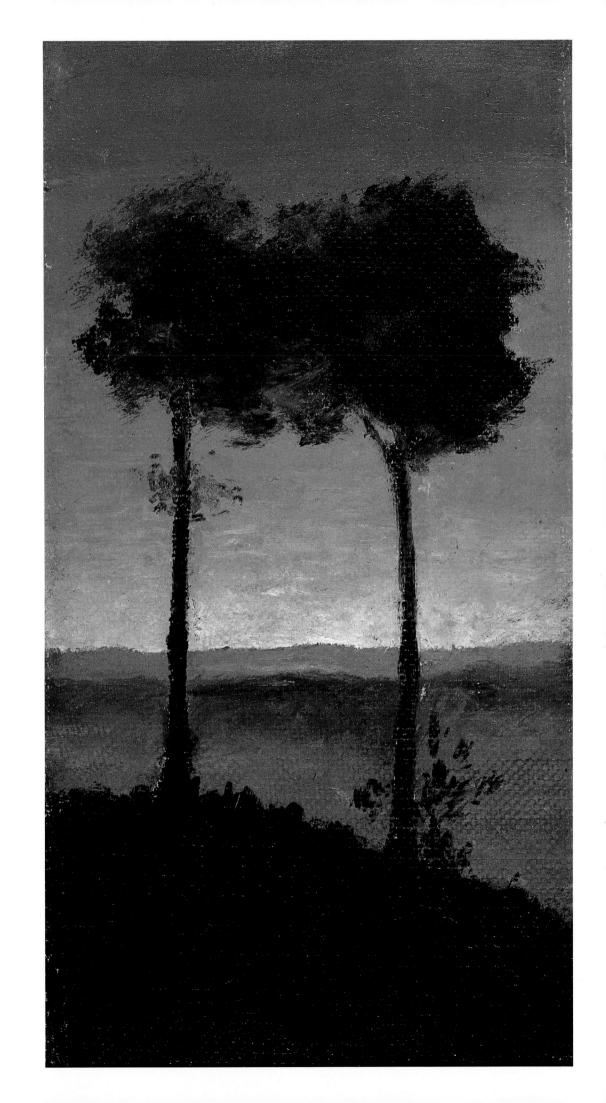

ANTOINE DE SAINT-EXUPÉRY

FRENCH | 1900–1944

The Little Prince. c. 1942. Pencil and ink, 11 × 8½″. Archives of
American Art, Smithsonian Institution, Washington, D.C. The
Hedda Sterne Papers

OPPOSITE, LEFT:
The Little Prince and a Baobab. Preliminary sketch. c. 1941.
Pencil and watercolor, 9 × 8″. Harry Ransom Humanities
Research Center Art Collection, The University of Texas at Austin.
Carlton Lake Collection

*A baobab is something you will never, never be able to get rid of if
you attend to it too late. It spreads over the entire planet. It bores
clear through it with its roots. And if the planet is too small, and the
baobabs are too many, they split it in pieces. . . .*

The Little Prince, trans. Katherine Woods (New York: Harcourt Brace & World, 1943),
p. 23.

OPPOSITE, RIGHT:
The Little Prince on His Planet. Preliminary sketch for Saint-
Exupéry's *The Little Prince.* c. 1941. Pencil and watercolor,
9 × 8″. Harry Ransom Humanities Research Center Art
Collection, The University of Texas at Austin. Carlton Lake
Collection

*"Yes," I said to the little prince. "The house, the stars, the desert,—
what gives them their beauty is something that is invisible!"*

*And the little prince added: "But the eyes are blind. One must look
with the heart . . ."*

The Little Prince, p. 85.

Male and Female Stick Figures in Conversation. Ink on tracing
paper fragment, 2⅛ × 2¾″. Verso: inscription by Valentine Hugo
in red pencil: "dessin de St. Exupery/Lundi 3/9/34/ donné par
Consuelo." Harry Ransom Humanities Research Center Art
Collection, The University of Texas at Austin

Drawing by Saint-Exupéry given to Valentine Hugo by Saint-
Exupéry's wife, Consuelo, on 3 September 1934.

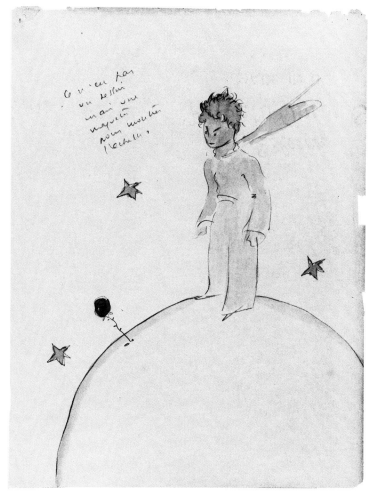

I hate my own period with all my heart. Today man is dying of thirst. There is only one problem, General, only one problem in the whole world. It is the need to restore a spiritual meaning to men's lives, and to reawaken their capacity for spiritual disquiet....It is impossible to survive on refrigerators, politics, balance sheets, and crossword puzzles, you see! It is impossible! It is impossible to live without poetry and color and love.

Letter to General X, left in his barracks room the day Saint-Exupéry disappeared in his plane, 1944, *Un Sens à La Vie*, trans. Adrienne Foulke (Paris: Éditions Gallimard, 1956), pp. 215–16.

FEDERICO GARCÍA LORCA

SPANISH | 1898–1936

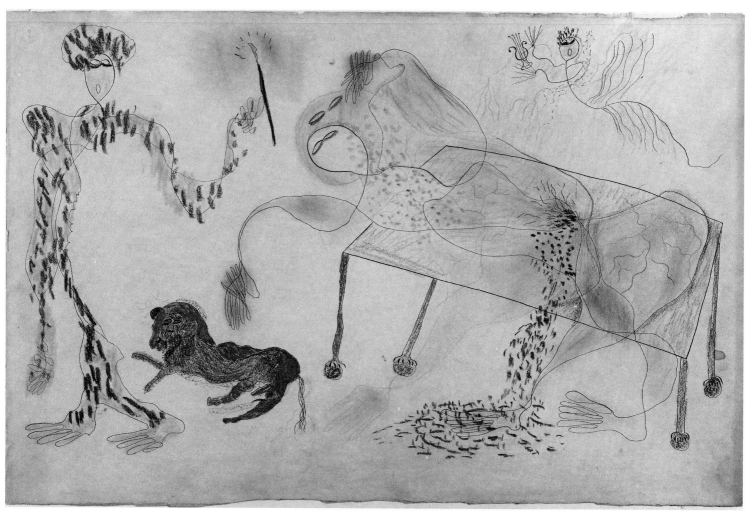

The Death of Petenera. Illustration for "Muerte de la Petenera." Pen and ink with colored crayons on drawing board, 14⅜ × 22⅞". The Pierpont Morgan Library, New York

OPPOSITE, LEFT:
Seated Woman. 1929. Pastel and ink, 14 × 11".
Collection Carmen del Rio de Piniés

OPPOSITE, RIGHT:
Clown. Pastel and ink, 14½ × 11½".
Collection Miss Carmen T. Piniés

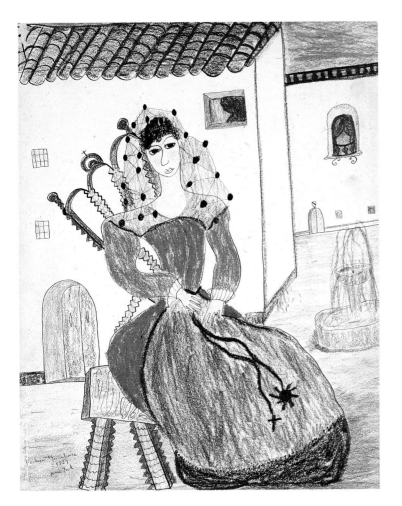

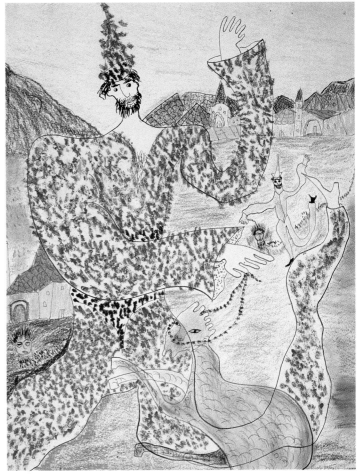

The inspired state is a state of self-withdrawal, and not a creative dynamism. Conceptual vision must be calmed before it can be clarified. I cannot believe that any great artist works in a fever. Even mystics return to their tasks when the ineffable dove of the Holy Ghost departs from their cells and is lost in the clouds.

Poet in New York, trans. Ben Belitt (New York: Grove Press, 1955), p. 176.

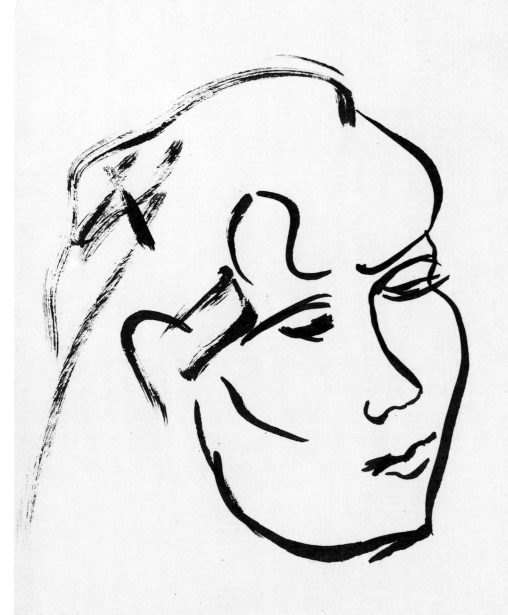

JAMES AGEE

AMÈRICAN | 1909–1955

At night I'm starting to draw, heads of Alma and copies of postcard American city streets. I would never have known how much even a little of it sharpens your eye and gives you more understanding and affection for even some small part of a human or architectural feature. . . . I now "possess" and "know" Alma's face and a Brooklyn street in 1938 as if they were a part of me, as much as my hand. . . .

Letters of James Agee to Father Flye, ed. James Harold Flye (Boston: Houghton Mifflin Company, 1971), p. 115.

OPPOSITE:
Head of Alma. c. 1939. Watercolor on newsprint, 9 × 7¼". Harry Ransom Humanities Research Center Art Collection, The University of Texas at Austin

RIGHT, ABOVE:
Squirrel. 1939. Watercolor on newsprint, 10⅞ × 8⅜". Harry Ransom Humanities Research Center Art Collection, The University of Texas at Austin

RIGHT, BELOW:
Cock. 1939. Watercolor on newsprint, 10⅞ × 8⅜". Harry Ransom Humanities Research Center Art Collection, The University of Texas at Austin

We are all painting or drawing our lives. Some draw with pencil, weakly and timidly, continually breaking the point and taking up another, continually trying to rub things out and always leaving an ugly smear. Some use ink and draw firmly and irrevocably with strong, broad lines. Some of us use colour, rich and lurid, layed on in full glowing brushfuls, with big sweeps of the wrist. Some draw a straggling haphazard design, the motive being eternally confused with unnecessary and meaningless parts. The threads pass out of the picture and are lost. The whole is an intricate incoherent maze. But some, and these are the elect, draw their design cleanly and fully. No part is unnecessary. Each twist and curl of the fanciful foliage adds to and carries on the original motive. Each part works into the whole and there is no climax or end to it.

Diary entry, 1921, in Christopher Sykes, *Evelyn Waugh: A Biography* (Boston: Little, Brown & Co., 1975), pp. 27–28.

LEFT, ABOVE:
Youth Reaching for Education. Design for cover of Oxford magazine *Broom.* 1923. Ink and watercolor, 10½ × 8″. Harry Ransom Humanities Research Center Art Collection, The University of Texas at Austin

Waugh suggested that this design be executed in bronze and erected as a fountain on the mall at Oxford.

LEFT, BELOW:
Boy in Flames. c. 1923. Woodcut, 9⅝ × 7⅞″. Harry Ransom Humanities Research Center Art Collection, The University of Texas at Austin

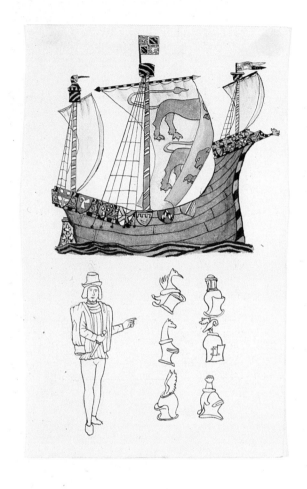

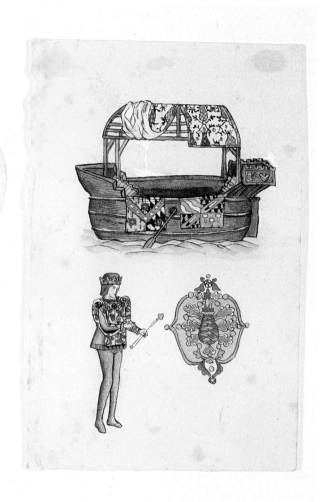

Studies for Manuscript Illumination. c. 1918. Pencil, ink, and watercolor, each page 7¼ × 4¾″; letter diameter 2¾″. Harry Ransom Humanities Research Center Art Collection, The University of Texas at Austin

Before he entered Oxford, Evelyn studied earnestly to become a professional "illuminist."

My ambition was to draw, decorate, design and illustrate. I worked with the brush and was entirely happy in my employment of it, as I was not when reading or writing.

In Christopher Sykes, *Evelyn Waugh: A Biography*, p. 47.

T. H. WHITE

BRITISH | 1906–1964

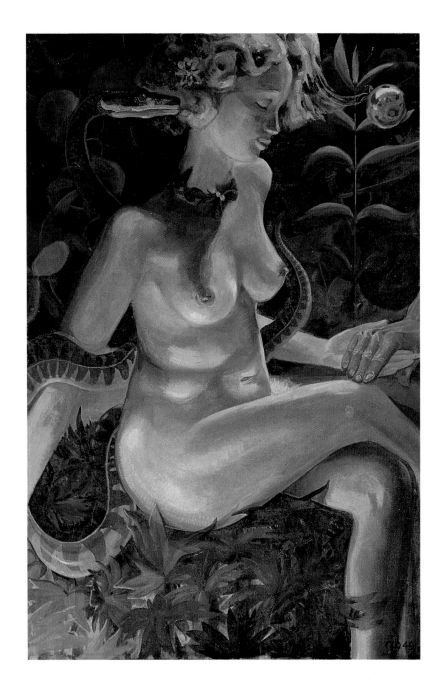

Compensating for my sense of inferiority, my sense of danger, I had to learn to paint even, and not only to paint—oils, art, and all that sort of thing—but to build and mix concrete and to be a carpenter and to saw and screw and put in a nail without bending it. I have made a list of some of the things which my compulsive sense of disaster has made me excel at.

In Sylvia Townsend Warner, *T. H. White* (London: Jonathan Cape with Chatto and Windus, 1967), p. 23.

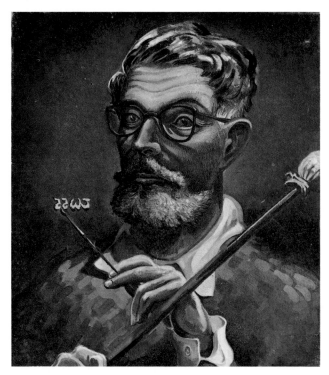

Self-portrait. 1955, Alderney. Oil on canvas, 34 × 20″. Harry Ransom Humanities Research Center Art Collection, The University of Texas at Austin

LEFT:
Eve. 1949. Oil on canvas, 35⅜ × 23⅝″. Harry Ransom Humanities Research Center Art Collection, The University of Texas at Austin

I dislike the shape of women very much and can scarcely bring myself to draw it.

Diary entry, c. 1937, in Sylvia Townsend Warner, *T. H. White: A Biography*, p. 295.

Interior Scene with Chair for Model. c. 1949. Oil on canvas, 19⅝ × 23⅝″. Harry Ransom Humanities Research Center Art Collection, The University of Texas at Austin

Note White's painting of *Eve* at the lower right.

Alderney. 1954. Oil on canvas, 17¾ × 16½″. Harry Ransom Humanities Research Center Art Collection, The University of Texas at Austin

Alderney in the Channel Islands was White's home from 1946 to 1957.

In this enormous flatness, there lived one element—the wind. For it was an element. It was a dimension, a power of darkness.

Undated diary entry, in Sylvia Townsend Warner, *T. H. White: A Biography*, p. 73.

JAMES MICHENER

AMERICAN | BORN 1907

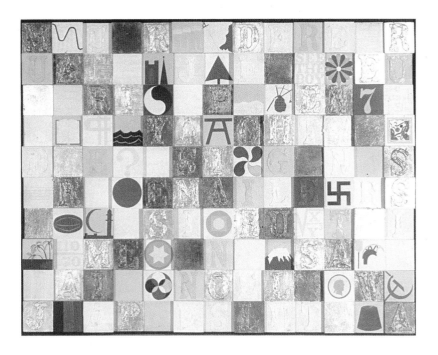

Biography. 1966. Collage, acrylic on board, 36 × 47″. Collection the artist

The composition consists of 130 squares, many of which contain symbols indicative of special events in Michener's life. Michener describes some of them:

Square six, top row, is the sword and muleta of the great bullfighter Domingo Ortega with whom I once toured the Spanish bullrings. Number two [square] is the roller-coaster ride at Willow Grove Park where I used to work at age 14. The Yang-Yin represents my long affiliation with Asia. The austere tree represents the thousands that I planted in various parts of the world to make the earth a little more attractive. There must be a mathematical formula in one square to stand for my continued work in the sciences. The swastika represents the wonderfully gifted Nazi enthusiast with whom I debated while at St. Andrews in 1932–34 and from whom I learned about the fearful possibilities of Nazism in the decade ahead. The many-petaled chrysanthemum represents my long affiliation with Japan. And the fenced-in field represents the concentration camp in which my Japanese-American wife was immured during the frenzied period of World War II.

The constant avocation of my life has been the study of art. Indeed, I might be described as the arche-typal culture-vulture. I have haunted all the world's major museums except the Pinakothek in Dresden. From high school days I have collected postcards of the best paintings, arranging them and rearranging them into what might be called the "ideal museum." I have filled filing cabinets with handsome colored reproductions of art. . . . For me, the world of art has grown constantly larger, constantly more rewarding. If you add music to painting, they represent together the two subjects which have engaged most of my leisure time. . . . There might have been some wiser way for me to have spent my spare time, but I cannot at this moment think of any.

"The World of Art," *A Michener Miscellany: 1950–1970* (New York: Random House, 1973), p. 269.

OPPOSITE, ABOVE:
Designs. 1965. Five panels, acrylic on hardboard, overall 48 ×120″. Collection the artist

Michener's description:

The base is a large, bold design in strong colors which creates a massive but not heavy impression. In front of it, on smooth-operating rollers, functioning from the top, move four vertical panels. By shifting them back and forth, left and right, in pairs, alone, bunched, one gets a series of contrasting results. The extreme right is heavy impasto with a rough surface. The second from the right is an intricate working out of bars in various sizes and overlapping positions. The third from the right is a delicate flow of dots in various sizes and colors, most pleasing to me at the end of the day. And the final panel to the left is a kind of self-portrait set amid the alphabet with the sequential words IDEA, WORD, PAGE and BOOK emerging, pretty much as they do in reality.

OPPOSITE, BELOW:
Infuriating Simplicity. 1964. Three panels, acrylic on board, overall 24 × 72″. Collection the artist

Michener's description:

If you take five square blocks and arrange them in every conceivable way contiguously you get twelve completely different and fascinating forms, for a total of sixty individual squares. Now, if you arrange a tray of ten spaces by six spaces you have an area into which the twelve pieces can be fitted, but to accomplish this requires infinite patience. There are hundreds of possible solutions. Solving the problem, painting it, and reflecting upon it in tranquility have given me much satisfaction.

HERMANN HESSE

SWISS-GERMAN | 1904–1961

LEFT, ABOVE:

Mountainscape. Dated January 7, 1933. Watercolor, 17 × 15⅜″. The Beinecke Rare Book and Manuscript Library, Yale University, New Haven, Conn. Norman Holmes Pearson Collection

Those mountains, separated from me by the lake, rose in such silent solemn beauty into the veiled sky and stood in such quiet holy repose in the approaching winter night that it seemed to me if I were over there, I could be a holy man and understand all the secrets of the earth.

"At Year's End," 1904, *My Belief: Essays on Life and Art*, p. 5.

LEFT, BELOW:

View from Montagnola, Tessin. 1931. Watercolor, glazed, 17½ × 15½″. Signed and dated: "H Hesse 1931." The Beinecke Rare Book and Manuscript Library, Yale University, New Haven, Conn. Norman Holmes Pearson Collection

*Language is a detriment, an earthbound
limitation from which the poet suffers more
than anyone else. At times he can actually
hate it, denounce it, and execrate it—or
rather hate himself for being born to work
with this miserable instrument. He thinks
with envy of the painter whose language—
color—is instantly comprehensible to
everyone from the North Pole to Africa.*

My Belief: Essays on Life and Art, ed. and intro. Theodore Ziolkowski, trans. Denver
Lindley and Ralph Manheim (New York: Farrar, Straus & Giroux, 1974), p. 26.

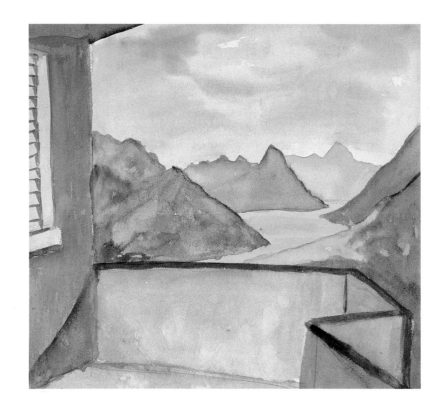

RIGHT, ABOVE:
View from the Terrace at Montagnola. 1919. Watercolor,
9⅛ × 10⅛″. The Beinecke Rare Book and Manuscript Library,
Yale University, New Haven, Conn. Norman Holmes Pearson
Collection

*In gratitude to this house I have painted it often and celebrated it in
song, in many ways I have tried to recompense it for what it gave me
and what it meant to me....*

"On Moving to a New House," 1919, *Autobiographical Writings*, ed. Theodore
Ziolkowski, trans. Denver Lindley (New York: Farrar, Straus & Giroux, 1971), p. 246.

RIGHT, BELOW:
Apricot Blossom I. 1926. Watercolor on buff paper, heightened with
white gouache, 18⅛ × 16½″. The Beinecke Rare Book and
Manuscript Library, Yale University, New Haven, Conn. Norman
Holmes Pearson Collection

*Often I sought my joy, my dream, my forgetfulness in a bottle of
wine, and very often it was of help; praised be it therefor. But it was
not enough. And then, behold, one day I discovered an entirely new
joy. Suddenly, at the age of forty, I began to paint.*

"Life Story Briefly Told," *Autobiographical Writings*, p. 56.

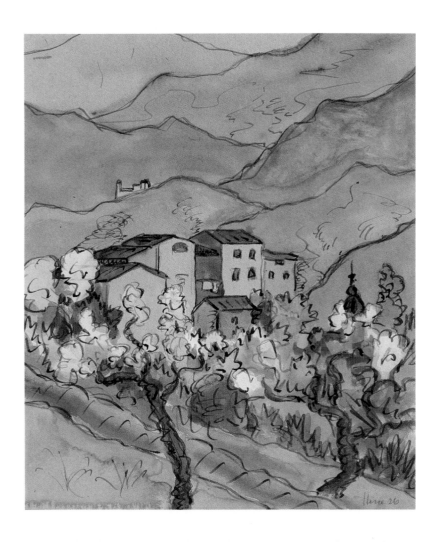

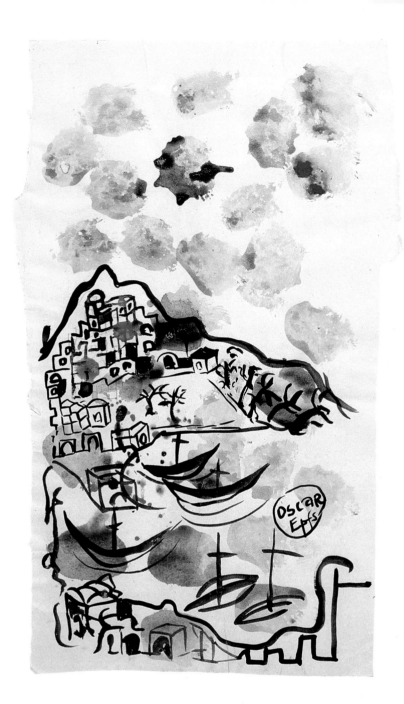

LAWRENCE DURRELL

BRITISH | BORN 1912

In the fecund silences of the
Painter, or the poet's wrestling
With choice you steer like
A great albatross, spread white
On the earth-margins the sailing
Snow-wings in the world's afterlight:

. .

"Orpheus," *Collected Poems* (New York: E. P. Dutton & Co., 1960), p. 271.

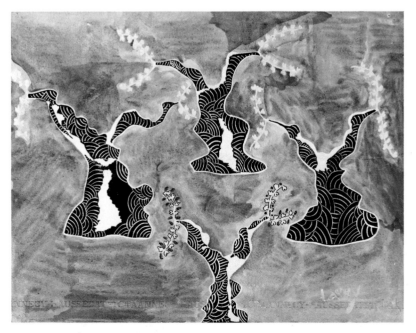

LEFT, ABOVE:
Untitled (Mediterranean Scene). Early 1960s. Watercolor on drawing paper, 14 × 8⅝". Signed with Durrell's pseudonym, "Oscar Epfs." Private collection, New York

LEFT, BELOW:
Vines in Winter. 1957. Tempera and watercolor on "Aussedat et Cⁱᵉ A Annecy" wallpaper, 19⅜ × 25⅝". Harry Ransom Humanities Research Center Art Collection, The University of Texas at Austin

OPPOSITE:
Figger. c. 1944. Tempera on paper, 25⅝ × 19¼". Harry Ransom Humanities Research Center Art Collection, The University of Texas at Austin

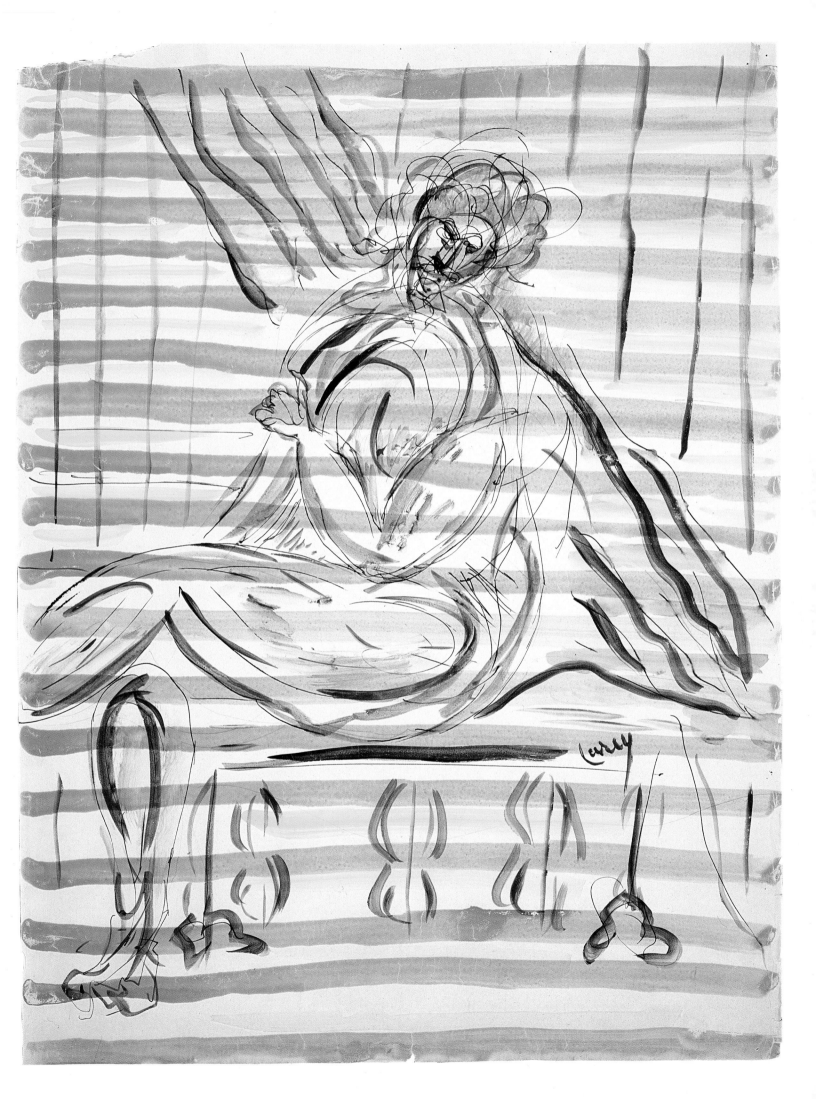

Edith Sitwell

What I like to do is to treat words as a craftsman does his wood or stone or what-have-you, to hew, carve, mould, coil, polish and plane them into patterns, sequences, sculptures, figures of sound expressing some lyrical impulse, some spiritual doubt or conviction, some dimly-realised truth I must try to reach and realise.

In Constantine Fitzgibbon, *The Life of Dylan Thomas* (Boston: Little, Brown & Co., 1965), p. 325.

a Horse

LEFT, ABOVE:

Caricature of Edith Sitwell. c. 1952. Pencil on paper, 10 × 7⅞″. Harry Ransom Humanities Research Center Art Collection, The University of Texas at Austin

And may I come to Edith Sitwell's party for you? Her parties are always brilliant opportunities for self-disgrace.

Letter to John Malcolm Brinnin, April 1951, *Selected Letters of Dylan Thomas*, ed. Constantine Fitzgibbon (New York: New Directions, 1966), p. 357.

LEFT, BELOW:

Horse. c. 1953. Ink, 11 × 8½″. Archives of American Art, Smithsonian Institution, Washington, D.C. The Knute Stiles Papers

Thomas and his American friends frequented a popular gathering spot in New York called the White Horse Tavern.

OPPOSITE:

Self-portrait. c. 1953. Pencil, 10 × 7⅞″. Harry Ransom Humanities Research Center Art Collection, The University of Texas at Austin

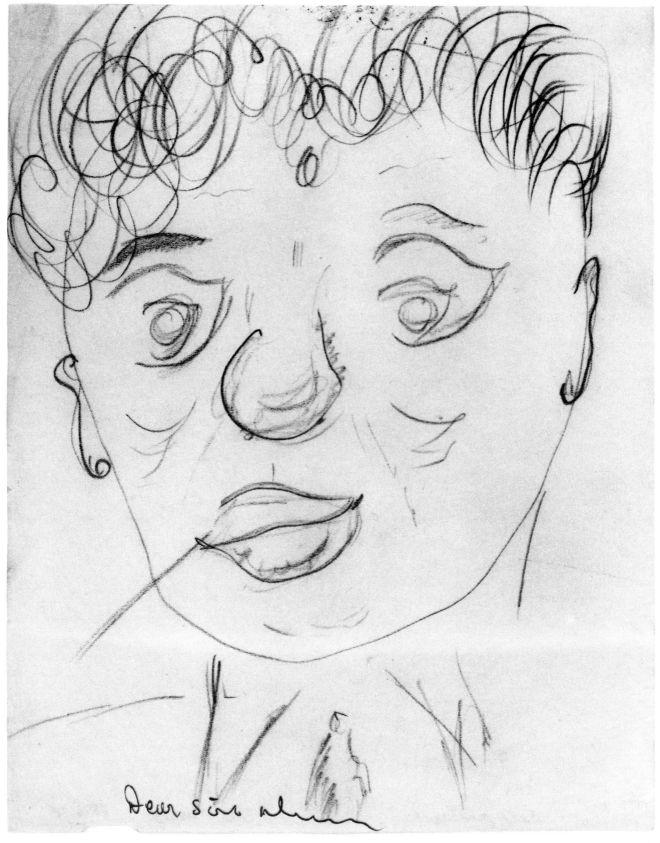

Dear Sir...

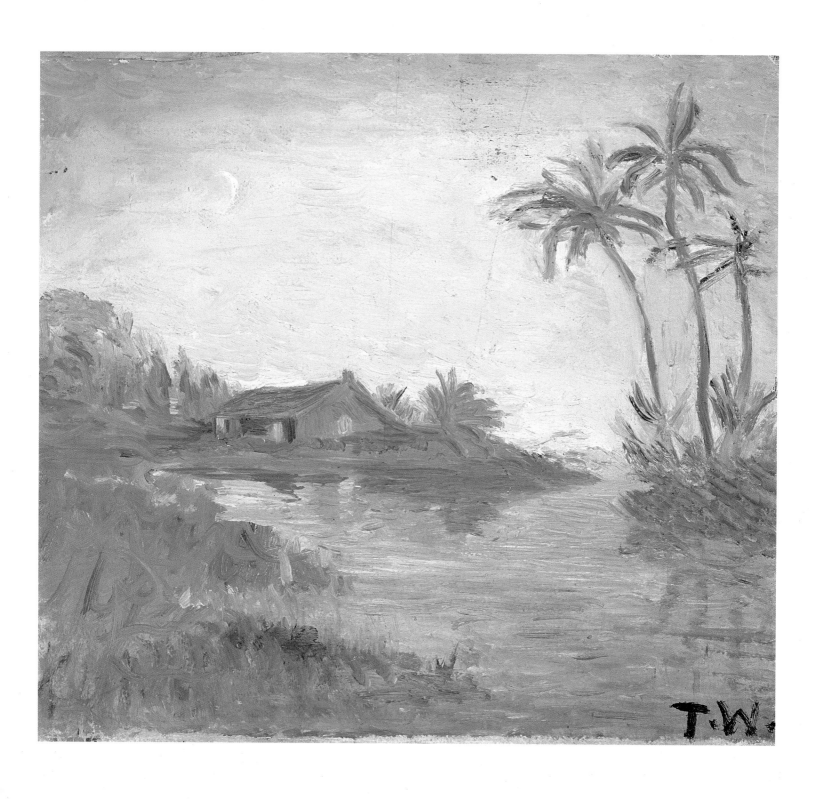

140

TENNESSEE WILLIAMS

AMERICAN | 1914–1983

*My desire was to give these audiences my
own sense of something wild and
unrestricted that ran like water in the
mountains, or clouds changing shape in a
gale, or the continually dissolving and
transforming images of a dream. This sort of
freedom is not chaos or anarchy. On the
contrary, it is the result of painstaking
design, and in this work I have given more
conscious attention to form and construction
than I have in any work before. Freedom is
not achieved simply by working freely.*

Foreword to *Camino Real*, *The Theatre of Tennessee Williams*, vol. 2 (New York: New
Directions, 1971), p. 420.

OPPOSITE:

Tropical Scene. c. 1928. Oil on canvasboard, 11 × 12¼″. Harry
Ransom Humanities Research Center Art Collection, The
University of Texas at Austin

RIGHT, ABOVE:

Self-portrait. 1945. Pencil and oil wash on canvasboard,
15⅛ × 11¾″. Harry Ransom Humanities Research Center Art
Collection, The University of Texas at Austin

*...that period, of my greatest affliction, which is perhaps
the...major theme of my writings, the affliction of loneliness that
follows me like my shadow, a very ponderous shadow too heavy to
drag after me all of my days and nights.*

Memoirs (New York: Doubleday & Co., 1975), p. 99.

RIGHT, BELOW:

Summer and Smoke. Pencil and oil wash on canvasboard, 18 × 20″.
Inscribed: " 'By that time Summer and Smoke were past.......'
Hart Crane." Harry Ransom Humanities Research Center Art
Collection, The University of Texas at Austin

*The wanderer later chose this spot of rest
Where marble clouds support the sea
And where was finally borne a chosen hero.
By that time summer and smoke were past.
Dolphins still played, arching the horizons,
But only to build memories of spiritual gates.*

Hart Crane, "Emblems of Conduct," *White Buildings*, 1930, *The Collected Poems of
Hart Crane*, ed. and intro. Waldo Frank (New York: Liveright, 1933), p. 64.

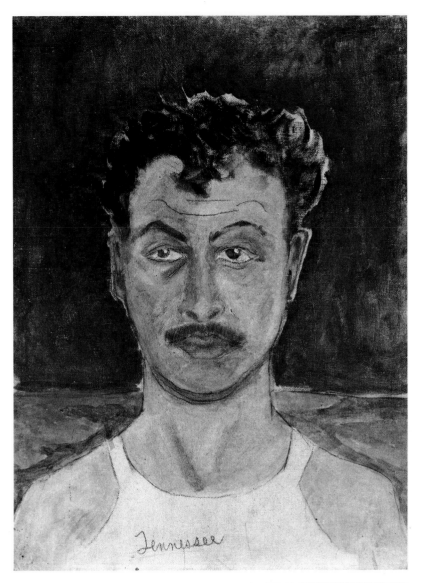

141

ALLEN GINSBERG

AMERICAN | BORN 1926

This image or energy which reproduces itself at the depths of
* space from the very Beginning*
in what might be an O or an Aum
and trailing variations made of the same Word circles round
* itself in the same pattern as its original Appearance*
creating a larger Image of itself throughout depths of Time
outward circling thru bands of faroff Nebulae & vast Astrologies
contained, to be true to itself, in a Mandala painted on an
* Elephant's hide,*
or in a photograph of a painting on the side of an imaginary
* Elephant which smiles, tho how the Elephant looks is an*
* irrelevant joke—*
it might be a Sign held by a Flaming Demon, or Ogre of
* Transcience,*
or in a photograph of my own belly in the void
or in my eye
or in the eye of the monk who made the Sign
or in its own Eye that stares on Itself at last and dies

"Lysergic Acid," *Kaddish and Other Poems* (San Francisco: City Lights Books, 1961),
pp. 88–89.

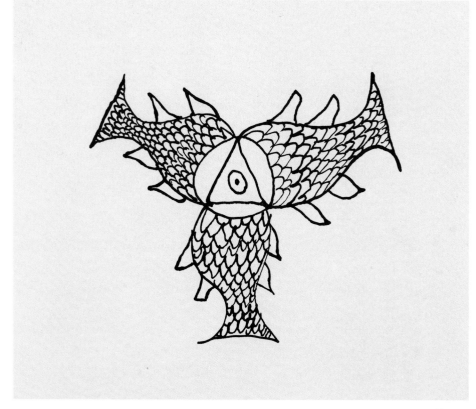

Buddha Footprint. Ink on paper, 9 × 10″. Rare Book and
Manuscript Library, Columbia University, New York

OPPOSITE:
The Hari Krishna Mantram. 1963. Watercolor, 8 × 9″.
Rare Book and Manuscript Library, Columbia University,
New York

Every possible combination of Being—all
* the old ones! all the old Hindu*
* Sabahadabadie-pluralic universes*
* ringing in Grandiloquent*
* Bearded Juxtaposition*

.

"Aether," in Paris Leary and Robert Kelly, eds., *A Controversy of Poets*
(New York: Doubleday & Co., 1965), p. 133.

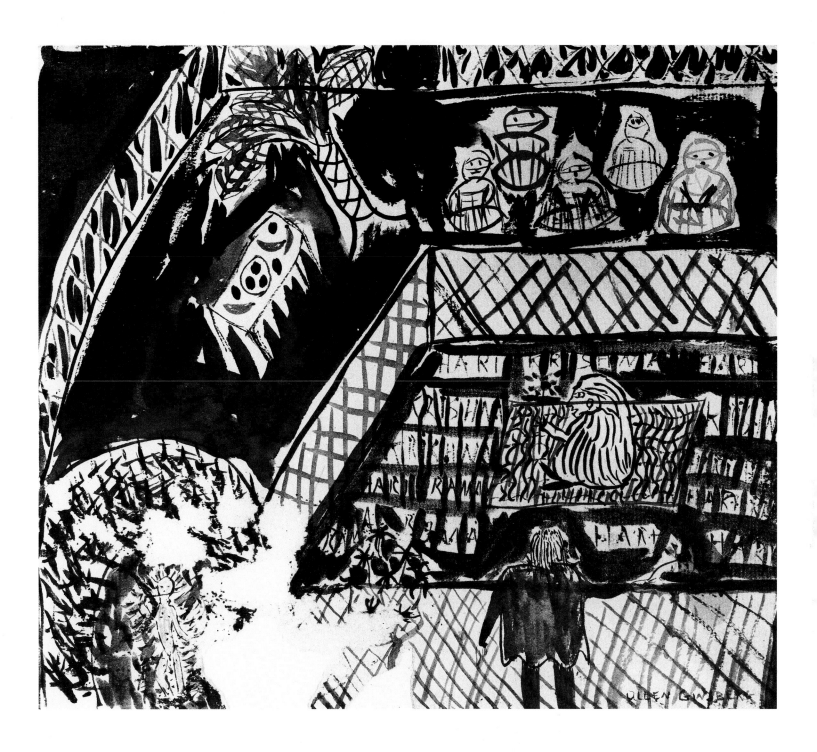

GÜNTER GRASS
GERMAN | BORN 1927

In addition to telling stories and telling stories against stories, I insert pauses between half sentences, describe the gait of various kinds of snails, do not ride a bicycle or play the piano, but hew stone (including granite), mold damp clay, work myself into muddles (aid to developing countries, social policy), and cook pretty well (even if you don't like my lentils). I can draw left or right-handed with charcoal, pen, chalk, pencil, and brush. That's why I'm capable of tenderness.

From the Diary of a Snail, trans. Ralph Manheim (New York: Harcourt Brace & Jovanovich, 1973), p. 71.

LEFT, ABOVE:
Writers Hand. 1979. Etching, 13 × 15¾". Lee Naiman Gallery, New York

LEFT, BELOW:
Self-portrait. 1981. Etching with drypoint, 17½ × 11⅜". Lee Naiman Gallery, New York

It's true. I'm not a believer; but when I draw, I become devout....But I draw less and less. It doesn't get quiet enough any more. I look out to see what the clamor is; actually it's me that's clamoring and somewhere else.

From the Diary of a Snail, p. 72.

OPPOSITE, ABOVE:
Sunflower with Rope and Nails. 1981. Lithograph, 25¼× 35⅜". Signed lower right. Collection the artist

OPPOSITE, BELOW:
Worshipers. 1980. Bronze relief, 18⅛ × 22". Signed in the mold, lower right: "Grass." Collection the artist

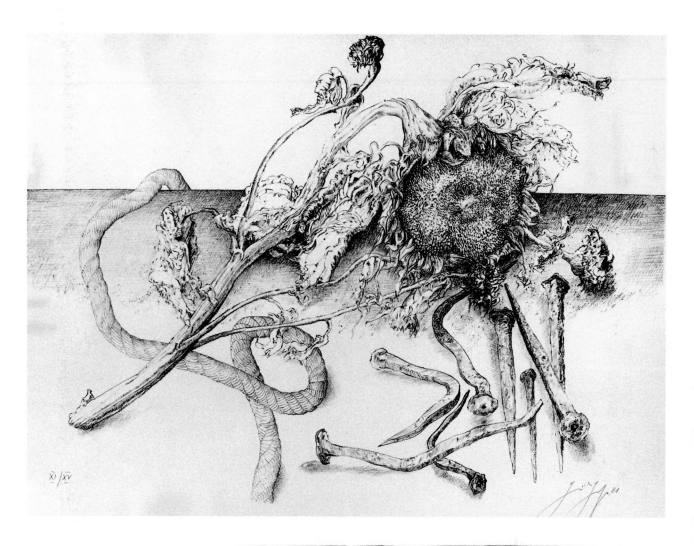

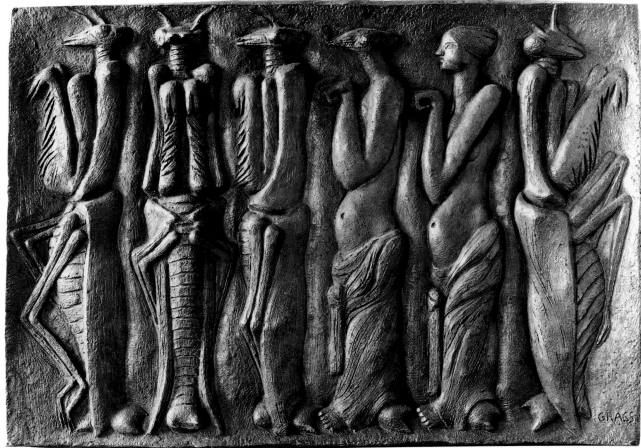

LEFT, ABOVE:

Self-portrait. Oil on canvasboard, 24 × 20″. Harry Ransom Humanities Research Center Art Collection, The University of Texas at Austin

I am unbalanced—but I am not mad with snow.
I am mad the way young girls are mad,
with an offering, an offering....

I burn the way money burns.

"The Breast," *Love Poems,* p. 5.

LEFT, BELOW:

Self-portrait. Oil on canvasboard, 19⅝ × 15⅞″. Harry Ransom Humanities Research Center Art Collection, The University of Texas at Austin

I have gone out, a possessed witch,
haunting the black air, braver at night;
dreaming evil, I have done my hitch
over the plain houses, light by light:
lonely thing, twelve-fingered, out of mind.
A woman like that is not a woman, quite.
I have been her kind.

"Her Kind," *To Bedlam and Part Way Back* (Boston: Houghton Mifflin Company, 1960).

OPPOSITE:

Untitled. Oil on canvasboard, 15⅞ × 19⅝″. Harry Ransom Humanities Research Center Art Collection, The University of Texas at Austin

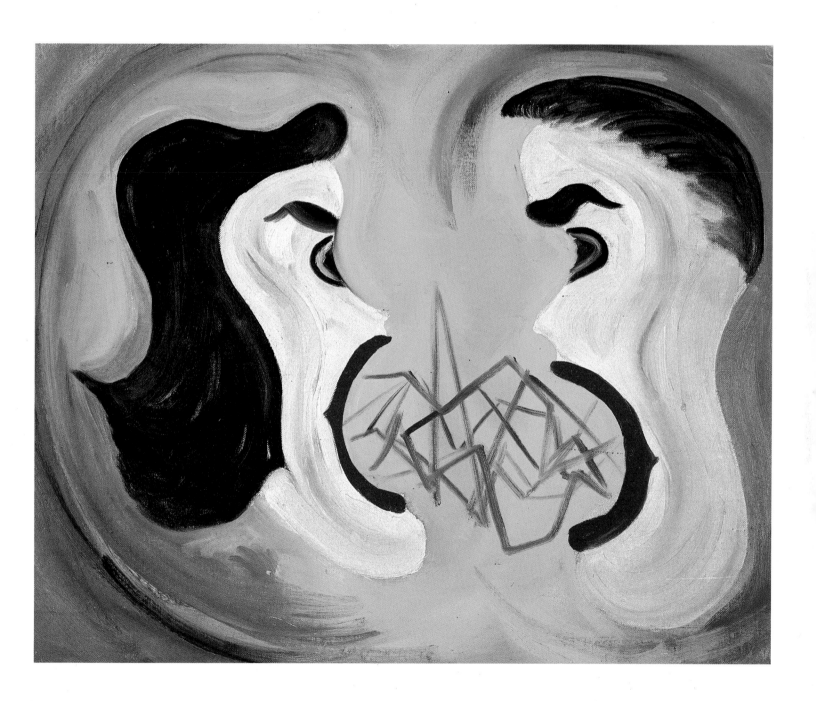

.*My bones are merely bored*
with all this waiting around. But the heart,
this child of myself that resides in the flesh,
this ultimate signature of the me, the start
of my blindness and sleep, builds a death crèche.

"The Break," *Love Poems* (Boston: Houghton Mifflin Company, 1967), p. 25.

JOHN UPDIKE
AMERICAN | BORN 1932

He saw art—between drawing and writing he ignorantly made no distinction—as a method of riding a thin pencil line out of Shillington, out of time altogether, into an infinity of unseen and even unborn hearts. He pictured this infinity as radiant. How innocent!

"The Dogwood Tree," *Assorted Prose* (New York: Alfred A. Knopf, 1963), p. 185.

LEFT, ABOVE:
Untitled. 1952. Pen and ink and crayon, 2¾ × 2¼".
Whereabouts unknown

These cartoons were made for the Harvard *Lampoon.*

LEFT, CENTER:
Brother Abelard Loves. 1951. Pen and ink, 2¾ × 2¼".
Whereabouts unknown

LEFT, BELOW:
Untitled. 1951. Pen and ink, 3½ × 2¼". Whereabouts unknown

OPPOSITE:
Untitled. 1953. Pen, ink, and Benday, 10¾ × 7¼".
Whereabouts unknown

COLLEEN MC CULLOUGH

AUSTRALIAN | BORN 1937

*The bird with the thorn in its breast, it
follows an immutable law; it is driven by it
knows not what to impale itself, and die
singing. At the very instant the thorn enters
there is no awareness in it of the dying to
come, it simply sings and sings until there is
not the life left to utter another note. But we,
when we put the thorns in our breasts, we
know. We understand. And still we do it.
Still we do it.*

The Thorn Birds (New York: Harper & Row, 1977), p. 530.

OPPOSITE, ABOVE:
Female Nude. Acrylic on canvasboard, 24 × 30″. Collection the
artist, Norfolk Islands, New South Wales, Australia

Which hat do I wear, love or duty?

An Indecent Obsession (New York: Harper & Row, 1981), p. 228.

OPPOSITE, BELOW:
Untitled. Acrylic on canvasboard, 30 × 40″. Collection the artist,
Norfolk Islands, New South Wales, Australia

Untitled. Acrylic on drawing board, 20 × 16″. Collection the artist,
Norfolk Islands, New South Wales, Australia

A strong bird needs lots of room to fly.

An Indecent Obsession, p. 324.

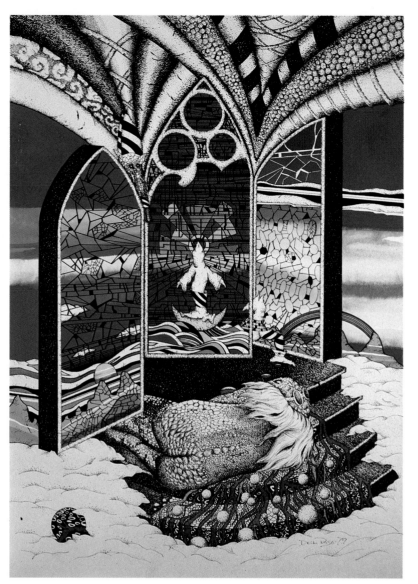

FERNANDO DEL PASO

MEXICAN | BORN 1939

To paint a dream is to fabricate a dream: dreaming and painting become simultaneous.

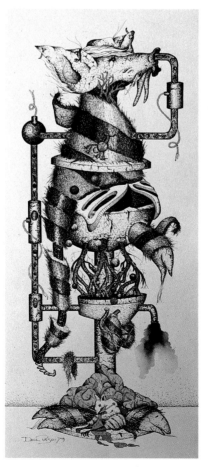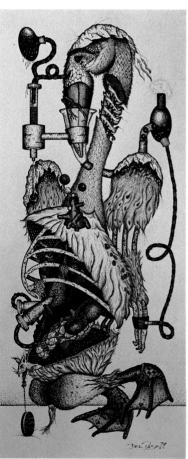

LEFT, ABOVE:
Tartarin Murdered in the Cathedral. 1979. Gouache and India ink, 20⅝ × 15″. Private collection

LEFT, BELOW:
From the series "Introduction to the Study of Anatomy and Physiology." 1979. Gouache and India ink, each 13¾ × 7¼″. Private collection

OPPOSITE:
Tartarin in Venice. 1979. Gouache and India ink, 20⅝ × 15″. Private collection

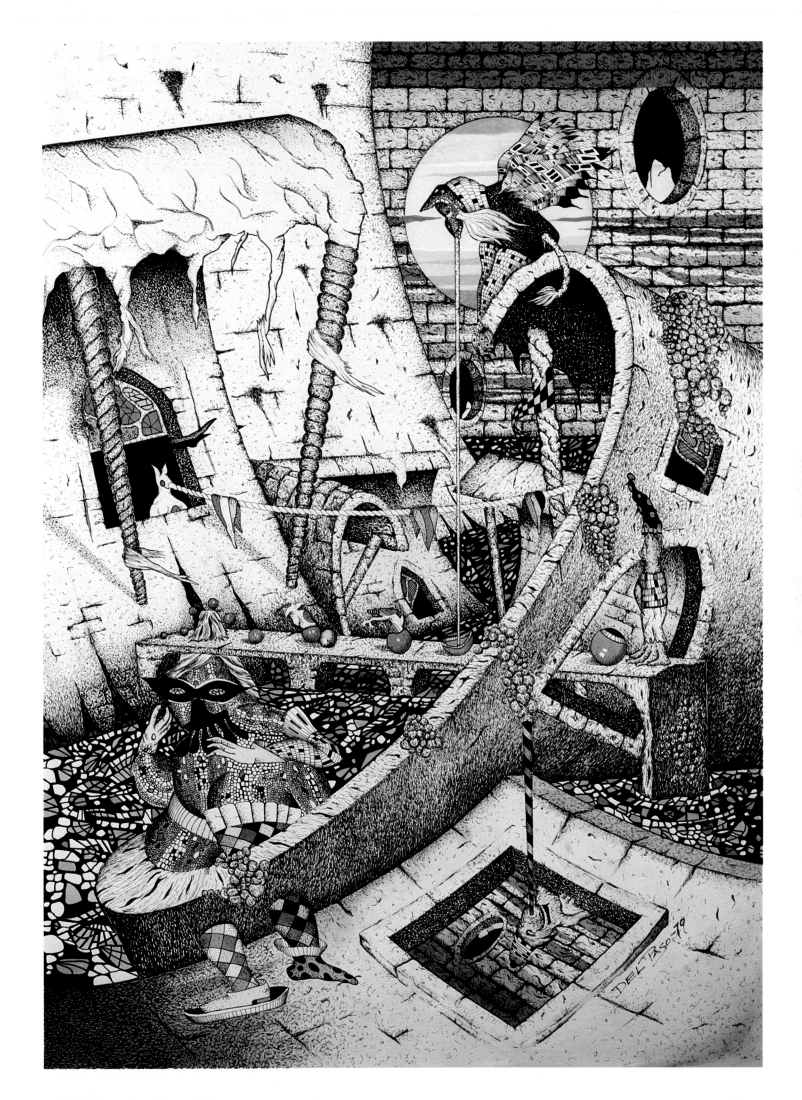

AGEE, JAMES, *pages 126–27*
American essayist, whose articles appeared in *Fortune* magazine, Agee and photographer Walker Evans were commissioned by *Fortune* to document poverty during the Depression. The resulting book, *Let Us Now Praise Famous Men*, was published in 1941. Agee's novel *A Death in the Family* was published posthumously (1957).

ANDERSON, SHERWOOD, *pages 78–79*
Anderson used his native Midwest as a setting for stories that dealt with the repressive effects of mechanization on the instincts. In order to become a writer, he quit his job as the manager of a paint company, left his family, and moved to Chicago. His first novel, *Windy McPherson's Son*, was an immediate success. Major works Novels: *Winesburg, Ohio* (1919); *Dark Laughter* (1925); *Beyond Desire* (1932). Books of short stories: *The Triumph of the Egg* (1921); *Horses and Men* (1923); *Death in the Woods* (1933). *Tar, A Midwest Childhood*, autobiographical sketches; *Memoirs*, published posthumously (1942).

APOLLINAIRE, GUILLAUME, *pages 86–87*
Born Wilhelm de Kostrowitsky, Apollinaire came to Paris in 1898 and blossomed as a modernist poet and an art theorist, friend and apologist of the Cubists and Pablo Picasso. Major works Books of poems: *Alcools* (1913); *Calligrammes* (1918). Novels: *Le Poète Assassiné* (1916); *La Femme assise* (1920). Manifestos: *Les Peintres cubistes* (1913); *L'Esprit nouveau* (1918). *Les Mamelles de Tirésias*, a play (1918).

BARLACH, ERNST, *pages 72–73*
A Faustian dramatist, sculptor, and designer, driven by a longing for God, Barlach discovered a "Christian humility" traveling in Russia and returned to spend the rest of his life in isolation in Güstrow. Major works Plays: *Der tote Tag* (*The Dead Day*, 1912); *Der Findling* (*The Foundling*, 1922); *Die Sündflut* (*The Flood*, 1924).

BARNES, DJUNA, *pages 104–5*
Barnes is considered a difficult writer, but those who are not deflected by her uncompromising language praise the formal beauty, brilliance, and insight of her works. She was a journalist in Paris when the city was crowded with expatriate American writers. Major works *The Book of Repulsive Women*, essays (1915); *A Book*, collected works (1923); *Nightwood*, a novel (1936); *The Antiphon*, a play (1958); *Spillway and Other Stories*, short stories (1962).

BAUDELAIRE, CHARLES, *page 44*
Baudelaire began his career as poet and critic by writing brochures about the art salons of 1845 and 1846. His volume of verse *Les Fleurs du Mal* (1857) became a major influence on nineteenth-century literature. Major works *Les Épaves*, poems (1866); *L'Art romantique*, art criticism (1868); *Curiosités esthétiques*, art criticism (1868); *Les Paradis artificiels*, treatise, partially an adaptation of De Quincey's *Confessions of an English Opium Eater* (1860); translations of Edgar Allan Poe, 5 vols. (1856–65); *Journaux Intimes*, memoirs, published posthumously (1887).

BEERBOHM, MAX, *pages 74–75*
Beerbohm replaced George Bernard Shaw as the drama critic for London's *Saturday Review*. He published his first book (essays) in 1896. His caricatures infuriated no one, and he recorded the great people of society and politics for half a century. Major works *The Poet's Corner*, caricatures (1904); *Zuleika Dobson*, a novel (1911); *A Christmas Garland*, a parody (1912); *Rossetti and His Circle*, caricatures (1922).

BENNETT, ARNOLD, *pages 51–53*
A naturalistic novelist, Bennett began his literary career as a journalist. He set many of his novels and stories, which accurately and dispassionately depict the lives of ordinary people, in the fictional "Five Towns," based on his native region in Staffordshire. Major works Novels: *A Man from the North* (1898); *Anna of the Five Towns* (1902); *The Old Wives' Tale* (1908); *Clayhanger* (1910); *Hilda Lessways* (1911); *These Twain* (1916)—trilogy, reprinted as *The Clayhanger Family* (1925); *Riceyman Steps* (1923).

BLAKE, WILLIAM, *pages 18–21*
The great Romantic poet Blake used painting and poetry together to express a strongly felt vision of the world that was greatly at odds with the society of his time. He printed most of his books himself. Major works *Poetical Sketches*, poems, printed by friends (1783); *Songs of Innocence*, poems (1789); *The Marriage of Heaven and Hell*, allegory (1790–93); *Visions of the Daughters of Albion*, allegory (1793); *Songs of Experience*, poems (1794); *The Book of Los*, allegory (1795).

BRETON, ANDRÉ, *pages 114–15*
Breton's writings introduced the principles of Surrealism into French literature, the visual images of *Nadja* spawning the application of fantasy to painting. Major works *Mont de Piété*, manifesto (1919); *Manifeste du Surréalisme—Poisson Soluble*, manifesto (1924); *Nadja*, semi-autobiographical novel (1928); *Qu'est-ce que le Surréalisme?*, a treatise (1934); *Poèmes* (1948).

BRONTË, CHARLOTTE, *page 40*
Reared in an isolated Yorkshire parsonage, Charlotte, Emily, and Branwell amused themselves by painting, writing, and performing their own works for each other. Only Charlotte lived long enough to enjoy the success of her labors. Major works Novels: *Jane Eyre* (1847); *Shirley* (1849); *The Professor*, published posthumously (1857). *Villette*, two stories (1853).

BRONTË, EMILY, *page 41*
Emily, the quiet Brontë, gained a secure position in literature with her one novel, *Wuthering Heights* (1847). Owing to its complex narrative, intensity, and originality, it is considered unique in English literature. Her poetry, in *Poems by Currer, Ellis, and Acton Bell* (Charlotte, Emily, and Anne Brontë, 1846) is also considered significant.

BUCK, PEARL, *pages 106–7*
The child of American missionaries living in China, Mrs. Buck

spent a good part of her life in that country. Her realistic novels about China provided Americans with a sympathetic account of life in the Far East. Major works Novels: *The Good Earth* (1931); *Sons* (1932); *A House Divided* (1935); *Dragon Seed* (1942). *The First Wife and Other Stories* (1933); *The Child Who Never Grew*, essays (1950); *China As I See It*, a narrative (1970).

CHESTERTON, G. K., *pages 76–77*
Chesterton is best remembered for his "Father Brown" stories (1929–33) and for his witty criticisms. Major works Novels: *The Napoleon of Notting Hill* (1904); *The Man Who Was Thursday* (1908); *The Flying Inn* (1914); *Manalive* (1915). *Robert Browning*, biography (1903); *Charles Dickens*, biography (1906); *Autobiography* (1936).

CHURCHILL, WINSTON, *pages 80–81*
Long before he became prime minister of Great Britain, Churchill was an established author of history and fiction. He employed fictional techniques to make history "readable." In 1953, he won the Nobel Prize for Literature. Major works History: *Lord Hamilton's March* (1900); *The Crisis* (1901); *The Crossing* (1904); *While England Slept* (1938); *The Second World War*, 6 vols. (1948–54); *A History of the English-Speaking Peoples*, 4 vols. (1956–58). *Coniston*, a novel (1906); *Life of Lord Randolph Churchill*, biography (1906); *My African Journey*, autobiographical history (1908).

COCTEAU, JEAN, *pages 100–101*
Incorporating elements of Dada and Surrealism, Cocteau wrote a ballet for Diaghilev (*Parade*, 1916, music by Satie, décor by Picasso), published poetry, prose, and plays, and produced his own films. He is perhaps best known in the United States for his film *The Blood of a Poet* (1930). Major works *Le Potomak*, a novel (1913); *Poésies 1916–23*, poems (1924); *Orphée*, a play (1927); *Les Enfants Terribles*, a novella (1929); *La Machine Infernale*, a play (1934); *Les Parents Terribles*, a play (1938); *Orphée*, a film (1949).

CRANE, HART, *pages 120–21*
Crane's poetry inspired a generation of writers with its "associative imagery." Crane mysteriously disappeared on a ship headed for New York from Mexico, presumed a suicide. Major works Books of poems: *White Buildings* (1926); *Destinations* (1928); *The Bridge* (1930); *Collected Poems*, published posthumously (1933).

CUMMINGS, E. E., *pages 108–11*
Edward Estlin Cummings explored a great variety of artistic forms: poetry, essays, criticism, novels, plays, and painting. Major works *The Enormous Room*, semi-autobiographical novel (1922); *Tulips and Chimneys*, poems (1923); *Him*, a play (1927); *Adventures in Value*, poems, in collaboration with photographer Marion Morehouse (mrs. e. e. cummings) (1962).

DEL PASO, FERNANDO, *pages 152–53*
Del Paso received the Rómulo Gallegos award for the best Latin American novel in 1982, an honor previously granted to Fuentes, García Márquez, and Vargas Llosa. He divides his time between art

and literature. Major works Novels: *José Trigo* (1966); *Palinuro de México* (1976); *Noticias del Imperio* (1982). *Sonetas de lo Diario*, poems (1958).

DOS PASSOS, JOHN, *pages 116–17*
Dos Passos's early novels concentrate on his personal experiences, including his service in World War I. He later delved into social themes on a broad scale, especially in his trilogy *U.S.A.*, a panorama of American life. Major works Novels: *One Man's Initiation—1917* (1919); *Manhattan Transfer* (1925); trilogy—*The Forty-Second Parallel* (1930); *1919* (1932); *The Big Money* (1936), published together under the title *U.S.A.* (1937); *Adventures of a Young Man* (1939); *Chosen Country* (1951). *Orient Express*, travel (1927); *Three Plays* (1934); *The Theme Is Freedom*, essays (1956).

DUMAS *fils*, ALEXANDRE, *page 45*
Dumas exceeded the fame of his father, author of *The Three Musketeers*, with the overwhelming and instant success of his own creations. He wrote romantic novels (the best known is *La Dame aux Camélias*, or *Camille*), plays that dealt realistically and honestly with social and moral issues, and comedies of manners. Major works Novels: *La Dame aux Camélias* (1848); *L'Affaire Clemenceau*, semi-autobiographical (1886). Plays: *Le Demi-Monde* (1855); *La Femme de Claude* (1873); *La Princesse de Bagdad* (1881).

DURRELL, LAWRENCE, *pages 136–37*
An Englishman born in India, Durrell spent most of his life in the islands of Greece and in Egypt, which formed the background for many of his novels. He is best known for the Alexandria Quartet, four novels that tell the same story from four different points of view. Major works Novels: The Alexandria Quartet—*Justine* (1957); *Balthazar* (1958); *Mountolive* (1959); *Clea* (1960). Essays: *Bitter Lemons* (1957); *The Black Book* (1960); *A Smile in the Mind's Eye* (1982). *Acte*, a play (1966); *The Ikons and Other Poems* (1967).

ELIOT, T. S., *page 91*
T. S. Eliot lived a quiet life while his poetry revolutionized the style and thought of twentieth-century literature. He won the Nobel Prize for Literature in 1948. Major works Books of poems: *Prufrock and Other Observations* (1917); *The Waste Land* (1922); *Ash Wednesday* (1930); *Four Quartets* (1943). Plays: *Murder in the Cathedral* (1935); *The Cocktail Party* (1949). Criticism: *Dante* (1929); *Notes Toward the Definition of Culture* (1949).

FAULKNER, WILLIAM, *pages 118–19*
Faulkner lived most of his life in Oxford, Mississippi, writing stories about his hometown that brought him international acclaim. He won the Nobel Prize for Literature in 1949 and the Pulitzer Prize in 1955. Major works Novels: *Sartoris* (1929); *The Sound and the Fury* (1929); *Sanctuary* (1931); *Light in August* (1932); *Absalom, Absalom!* (1936).

GARCÍA LORCA, FEDERICO, *pages 124–25*
García Lorca was part of the Spanish artistic movement known as "The Generation of 1927," along with his friends Manuel de Falla,

Pablo Neruda, and Salvador Dali. He was executed in Granada by a Royalist firing squad during the Spanish Civil War. Major works Books of poems: *Libro de Poemas* (1921); *Canciones* (1927); *Primer Romancero Gitano* (*Gypsy Ballads*, 1928). Plays: *El Maleficio de la Mariposa* (*The Butterfly's Evil Spell*, 1920); *Bodas de Sangre* (*Blood Wedding*, 1933); *Yerma* (1934).

GIBRAN, KAHLIL, *page 90*
A well-known writer in the Middle East before he emigrated to the United States, Gibran has explored man's relations to man, nature, and God in his mystical books. He studied art at the École des Beaux-Arts in Paris. Major works *The Forerunner: His Parables and Poems* (1920); *The Prophet* (1923); *Sand and Foam, a Book of Aphorisms* (1926); *Jesus, The Son of Man* (1928); *The Garden of the Prophet* (1933).

GINSBERG, ALLEN, *pages 142–43*
With the publication of "Howl," Ginsberg led the "Beat Poets" of the 1960s into a literary revolution that made protest a way of life for the Haight-Ashbury generation. Major works Books of poems: *Siesta in Xbalba and Return to the States* (1956); *Howl and Other Poems* (1956); *Reality Sandwiches, 1953–1960* (1963); *Ankor-Wat* (1968); *The Fall of America: Poems of These States 1965–71* (1972).

GOETHE, JOHANN WOLFGANG, *pages 16–17*
In his writings, Goethe urged the intellectuals of Europe to converge the interests of science, literature, and art into one aesthetic principle, forming the basis of the Romantic school (*Götz von Berlichingen*, springboard for the *Sturm und Drang* movement, 1773). Major works Plays: *Egmont* (1788); *Torquato Tasso* (1790); *Faust, Part I* (1808); *Faust, Part II* (1832). Novels: *The Sorrows of Young Werther* (1774); *Wilhelm Meisters Lehrjahre* (1795–96). *History of the Theories of Color*, theory (1805); *My Italian Journey*, 3 vols., autobiographical travel (1816–17).

GRASS, GÜNTER, *pages 144–45*
Born in Danzig, Grass gained literary fame as an expressionist storyteller of energy and power. He was trained as a stonemason and studied art in Düsseldorf and Berlin. Major works Novels: *Die Blechtrommel* (*The Tin Drum*, 1959); *Hundejahre* (*Dog Years*, 1963); *Oerlich betaeubt* (*Local Anesthetic*, 1969); *Der Butt* (*The Flounder*, 1976); *Das Treffen in Telgte* (*The Meeting at Telgte*, 1979). Books of poems with Grass's artwork: *Gleisdreieck* (1960); *Ausgetragt* (1967); *Kinderlied* (1983). Plays: *Hochwasser* (1963); *Onkel, Onkel* (1965); *Die Plebejer proben den Aufstand* (*The Plebeians Rehearse the Uprising*, 1966).

HARDY, THOMAS, *pages 54–55*
Hardy gained literary fame as the author of brooding, unsentimental novels set in the south English countryside. In 1898 he turned from the novel to poetry. Son of a builder, Hardy practiced architecture for several years. Major works Novels: *Far from the Madding Crowd* (1874); *The Return of the Native* (1878); *The Mayor of Casterbridge* (1886); *Tess of the D'Urbervilles* (1891); *Jude the Obscure* (1895). Books of poems: *Wessex Poems* (1898); *Time's Laughing-Stocks* (1909); *Moments of Vision* (1917).

HENRY, O. *pages 66–67*
O. Henry (William Sydney Porter) began to write short stories while serving three years in prison for embezzlement. His short stories popularized his technique of the literary "twist," a surprise ending. Major works Books of short stories: *Cabbages and Kings* (1904); *The Four Million* (1906); *Heart of the West* (1907); *The Gentle Grafter* (1908); *The Voice of the City* (1908); *Sixes and Sevens* (1911).

HESSE, HERMANN, *pages 134–35*
A leading German intellectual, Hesse explored the nature of man in his poetry and novels. In middle life, he left Germany to resume his life in Switzerland, where he had spent his boyhood. Major works Novels: *Beneath the Wheel* (1906); *Demian* (1919); *Der Steppenwolf* (1927); *Narcissus and Goldmund* (1930); *Siddhartha* (1931); *Das Glasperlenspiel* (*The Glass Bead Game*), published and retitled in the United States *Magister Ludi* (1943).

HOPKINS, GERARD MANLEY, *pages 56–57*
Poet, painter, teacher, translator, and priest, Hopkins was virtually unknown to the literary world until the publication of his poems, essays, and letters, many years after his death. Major works *Poems*, ed. Robert Bridges (1918); *Note-Books and Papers*, ed. H. House (1937); *Letters to Bridges, Dixon and Patmore*, ed. C. C. Abbott (1935–38).

HUGO, VICTOR, *pages 22–23*
Author of epic novels with social and political themes, Hugo himself became involved in the upheaval against Napoleon III and was forced into exile. He made a triumphant return to Paris and was elected a life member of the French Senate in 1876. Major works Plays: *Hernani* (1830); *Marion de Lorme* (1831); *Lucrèce Borgia* (1833); *Ruy Blas* (1838). Novels: *Notre-Dame de Paris* (1831); *Les Misérables* (1862). *Preface de Cromwell*, an essay (1827); *Les Contemplations*, poems (1856); *William Shakespeare*, biography (1864).

IBSEN, HENRIK, *pages 46–47*
Called the father of modern drama, Ibsen brought stark realism into the theater. The "Colossus of the North" earned fame by tackling such forbidden subjects as freedom of the individual, venereal disease, and women's rights. Major works Dramatic poems: *Brand* (1866); *Peer Gynt* (1867). Plays: *The Feast of Solhaug* (1856); *A Doll's House* (1879); *Ghosts* (1881); *An Enemy of the People* (1882); *The Wild Duck* (1884); *Hedda Gabler* (1890).

JACOB, MAX, *pages 82–83*
Law clerk, janitor, journalist, critic, and piano teacher, Jacob produced artworks that were appreciated for their eccentricities. When he was baptized into the Catholic Church, Picasso stood as his godfather. He died in a Nazi concentration camp. Major works Novels: trilogy—*Saint Matorel* (1909); *Les Oeuvres mystiques et burlesques de Frère Matorel* (1911); *Le Siège de Jérusalem* (1912–14); *The Man of Skin and the Man of Reflection* (1925). *Le Cornet à Dés* (*The Dice Box*), a prose poem (1917); *Art poétique*, theory (1922).

KIPLING, RUDYARD, *pages 68–69*
Reared in India by British parents, Kipling moved to London in 1889, where he quickly gained recognition for his writings. His stories reflected the glories and failures of the British Empire. Major works Novels: *Soldiers Three* (1888); *The Light That Failed* (1891); *Captains Courageous* (1897); *Kim* (1901). *The Jungle Book*, children's stories (1894); *Just So Stories*, short stories (1902); *Puck of Pook's Hill*, stories (1906); *The Irish Guards in the Great War*, verses, a memorial to Kipling's son killed in World War I (1923).

LAWRENCE, D. H., *pages 94–97*
The second son of a Yorkshire coal miner, David Herbert Lawrence in his novels opposed the instincts, expressed through sensuality, to what he perceived as the corruption of modern industrial society. The public was shocked and outraged by his erotic candor. Major works Novels: *The White Peacock* (1911); *Sons and Lovers* (1913); *The Rainbow* (1915); *Women in Love* (1920); *Lady Chatterley's Lover* (1928). *Sea and Sardinia*, travel (1921); *Studies in Classic American Literature*, criticism (1923).

LAWRENCE, T. E., *pages 92–93*
Archaeologist, secret agent, soldier, and writer, "Lawrence of Arabia" was instrumental in freeing Arabia from Turkish domination in World War I. His book recounting this struggle, *The Seven Pillars of Wisdom*, was published privately in 1926. In 1927, an abridged version appeared under the title *Revolt in the Desert*, then the complete text was published in 1935 under the original title. Other works: *The Odyssey*, translation (1932); *Oriental Assembly*, miscellaneous writings (1940).

LEAR, EDWARD, *pages 42–43*
Edward Lear earned his living by executing zoological illustrations and landscapes, never dreaming that his fame would be based on his "nonsensical" doggerel. His illustrated accounts of travel in Greece inspired Tennyson to the poem "E. L." (". . . Illyrian Woodlands, echoing falls"). Major works *The Book of Nonsense*, limericks (1846); *Journal of a Landscape Painter in Corsica*, travel (1870); *Nonsense Songs, Stories, Botany, and Alphabets*, a miscellany (1871); *Laughable Lyrics*, limericks (1877).

LERMONTOV, MIKHAIL, *pages 38–39*
Considered one of Russia's greatest Romantic poets, the "Poet of the Caucasus" was an officer in the Russian Guards. In 1837, he wrote a vigorous poetic protest against the death of Pushkin in a duel, which won him notoriety and a year in exile. In 1841, Lermontov himself was killed in a duel, in the Caucasus. Major works *A Hero of Our Times*, a novel (1840). Narrative poems: *The Demon; The Novice; The Song of the Merchant Kalashnikov; The Song of the Czar Ivan Vasilievich*.

LEWIS, WYNDHAM, *pages 98–99*
Critic, author, artist, Lewis was fond of writing about the intellectual problems of artists, politicians, and society in general. The founder of Vorticism, the first English abstract movement in art, he published *Blast*, the official journal of Vorticism, in 1914–

15. Major works Novels: *Tarr* (1918); *The Wild Body* (1931). Books of essays: *Men Without Art* (1934); *Blasting & Bombardiering* (1937); *The Vulgar Streak* (1941); *America and Cosmic Men* (1948).

LINDSAY, VACHEL, *pages 88–89*
Lecturer on art, Lindsay left New York on the first of his walking tours through the South selling copies of his poem "The Tree of the Laughing Bells" (1905) to pay his way. He was the first American poet invited to read at Oxford University (1920). Major works *Rhymes to be Traded for Bread*, poems (1912); *The Chinese Nightingale and Other Poems* (1917); *The Art of the Moving Picture*, essays (1915); *The Golden Book of Springfield*, prose (1920).

MASEFIELD, JOHN, *pages 84–85*
Masefield's writing exemplified the best traditions of English life and spirit. Masefield was made Poet Laureate of England in 1930. Major works Books of poems: *Ballads and Poems* (1910); *The Daffodil Fields* (1913); *Lollingdon Downs* (1917). Plays: *The Tragedy of Nan* (1909); *The Coming of Christ* (1928). Lyric poems: *The Everlasting Mercy* (1911); *Reynard the Fox* (1919). Novels: *Captain Margaret* (1908); *The Bird of Dawning* (1933).

McCULLOUGH, COLLEEN, *pages 150–51*
McCullough's epic novels situated in her native Australia have enjoyed great popularity. Before she began to write novels, she worked as a journalist and was trained in neuropsychology (at Yale). Major works Novels: *Tim* (1974); *The Thorn Birds* (1977); *An Indecent Obsession* (1981).

MÉRIMÉE, PROSPER, *pages 24–25*
A master of the short story, employing a spare narrative, understatement, and irony, Mérimée gained overnight fame by publishing *Le Théâtre de Clara Gazul* (1825), the "secret memoirs" of a Spanish actress, in actuality a figment of Mérimée's imagination. Archaeologist and historian, Mérimée was later appointed Inspector-General of Historical Monuments for the French government. Major works Novels: *La Chronique du Règne de Charles IX* (1829); *Carmen*, made into an opera by the composer Bizet in 1875 (1847). Short stories: *Andalucia* (1825); *La Jacquerie* (1828); *La Perle de Toledo* (1840); *Colomba* (1841). *Cromwell*, history (1824); *Mateo Falcone*, a play (1833).

MICHENER, JAMES, *pages 132–33*
Probably the best-traveled author in the world, Michener began his career as a journalist. During World War II, he was a naval historian for the United States government. Major works *Tales of the South Pacific*, short stories (1947); *The Floating World*, on art (1954); *Iberia: Spanish Travels and Reflections*, history and travel (1968); *The Quality of Life*, essays (1970). Novels: *Hawaii* (1959); *The Source* (1965); *Chesapeake* (1978); *Poland* (1983); *Space* (1984).

MILLER, HENRY, *pages 102–3*
Miller's books, which might be classified as novelistic autobiography, were written in a free, energetic, lyrical style that influenced many American writers, especially the "Beat" poets. His

earliest successes were written in Paris, where he lived for ten years. Major works Prose: *Tropic of Cancer* (1934); *Black Spring* (1936); *Tropic of Capricorn* (1939); *The Colossus of Maroussi* (1941); *The Wisdom of the Heart* (1941); *The Air-Conditioned Nightmare* (1945); *The Smile at the Foot of the Ladder* (1948); *To Paint Is to Love Again: Including Semblance of a Devoted Past* (1968).

MUSSET, ALFRED DE, *pages 28–29*
Poet, playwright, and short-story writer, Musset published his first book of poetry at the age of twenty. Major works *Contes d'Espagne et d'Italie*, poems (1830); *Les Caprices de Marianne*, a play (1833); *Confession d'un Enfant du Siècle*, the story of his liaison with George Sand (1836); *Comédies et Proverbes*, short plays (1840); *Contes*, short plays (1854).

POE, EDGAR ALLEN, *pages 30–31*
Poe explored the underside of the soul in lyric poems and psychological tales of horror. His life was saddened by the death of his young wife and by his perpetual poverty. Major works Books of poems: *Tamerlane and Other Poems* (1827); *The Raven and Other Poems* (1845). Books of short stories: *Tales of the Grotesque and Arabesque* (1840); *Tales* (1845).

ROSSETTI, DANTE GABRIEL, *pages 48–49*
The dominant personality of the Pre-Raphaelite art movement in England, Rossetti founded its short-lived journal, *The Germ*. He gained notoriety when he exhumed his wife's coffin to retrieve a volume of unpublished poems buried with her. Major works "The Blessed Damozel," a poem (1850); *The Early Italian Poets*, translations (1861); *Poems* (1870); *Dante and His Circle*, criticism and biography (1874); *Ballads and Sonnets* (1881).

RUSKIN, JOHN, *pages 36–37*
Art critic and art historian, Ruskin won his first literary prize at twenty with his poem "Salsette and Elephanta." He was invited to be the first Slade Professor of Fine Arts at Oxford in 1869. Major works Art history: *Modern Painters*, 5 vols. (1843–60); *The Seven Lamps of Architecture* (1849); *The Stones of Venice*, 3 vols. (1851–53). *Fors Clavigera: Letters to the Workmen and Labourers of Great Britain*, serial (1871–84).

RUSSELL, GEORGE, "AE," *pages 70–71*
Poet, essayist, journalist, Russell founded and edited *The Irish Theosophist*, a journal, 1892–97. From 1902 until 1930, he was editor of *The Irish Homestead* and *The Irish Statesman*. Major works Books of poems: *Homeward—Songs by the Way* (1894); *The Divine Vision* (1904); *Gods of War* (1915); *Vale and Other Poems* (1931); *The House of the Titans and Other Poems* (1934). *Deirdre*, a play (1902).

SAINT-EXUPÉRY, ANTOINE DE, *pages 122–23*
Saint-Exupéry was a trained pilot who pioneered in transcontinental flight and wrote of his experiences in *Courrier-Sud* (1928) and *Vol de Nuit* (1931). Overage during World War II, he persuaded the American forces to allow him to fly reconnaissance during the North African campaign, where he disappeared during a

routine flight over the Mediterranean. Major works *Terre des hommes*, a novel (1939); *Wind, Sand, and Stars*, autobiographical prose (1939); *Flight to Arras*, autobiographical prose (1942); *Lettre à un otage*, propaganda (1943); *Le Petit Prince (The Little Prince)*, philosophic children's tale (1943); *La Citadelle*, meditations, published posthumously (1948).

SAND, GEORGE, *pages 26–27*
On her arrival in Paris in 1831, Aurore Dupin Dudevant collaborated with Jules Sandeau on novels, published in serial form, until *Indiana*, which she wrote by herself, launched her career. Major works Novels: *Indiana* (1832); *Valentine* (1832); *Lélia* (1833); *La Mare au Diable* (1846); *Elle et Lui*, the story of her liaison with Alfred de Musset (1859); *Nanon* (1872). Plays: *Claudie* (1851); *Le Pressoir* (1853).

SEXTON, ANNE, *pages 146–47*
Anne Sexton's frankly confessional poetry traced her own life from the time she spent in an insane asylum after a nervous breakdown to her progress toward her suicide in 1974. Major works Books of poems: *To Bedlam and Part Way Back* (1960); *Live or Die* (1966); *The Book of Folly* (1972); *The Death Notebooks* (1974); *The Awful Rowing Toward God* (1975). *Mercy Street*, a play (1969).

STEVENSON, ROBERT LOUIS, *pages 62–63*
Stevenson is best known for his novels of adventure set in exotic locales. Because of fragile health, he spent much of his life traveling, looking for a favorable climate, and his travels were a major source of his material. Major works Novels: *Treasure Island* (1883); *Kidnapped* (1886); *The Black Arrow* (1888); *The Master of Ballantrae* (1889). Autobiographical prose: *An Italian Voyage* (1876); *The Amateur Emigrant* (1879). *Dr. Jekyll and Mr. Hyde and Other Stories* (1880); *A Child's Garden of Verses*, poems (1885).

STOWE, HARRIET BEECHER, *pages 32–33*
Harriet Beecher Stowe suffered from accusations that her writings had inflamed the conflict that led to the "War Between the States." In fact, *Uncle Tom's Cabin* was a major influence. In Florida, she finally found seclusion. Her other works reveal an observant eye and a Victorian sensibility. Major works Novels: *Uncle Tom's Cabin, or Life Among the Lowly*, published first in serial form in *National Era*, Washington, D.C. (1851, in book form 1852); *Dred*, based on the Dred Scott slavery case (1856); *The Minister's Wooing* (1859). Books of essays: *Sunny Memories of Foreign Lands* (1854); *Palmetto Leaves* (1873); *We and Our Neighbors* (1875). History: *Byron Vindicated* (1870); *Poganuc People* (1878).

STRINDBERG, AUGUST, *pages 60–61*
Strindberg's plays are seminal to the modern theater. In his earlier plays he furthered the movement of realism in theater, while his later plays advanced the expressionist movement. Strindberg was also a painter, photographer, and amateur chemist. At one dark point in his life he practiced black magic. Major works Plays: *The Father* (1887); *Miss Julie* (1889); *Creditors* (1889); *The Dance of Death* (1900); *A Dream Play* (1907). Novels: *The People of Hemsö* (1887); *In the Outer Skerries* (1890); *A Blue Book* (1907–8).

TAGORE, RABINDRANATH, *pages 64–65*
Hindu philosopher, poet, and artist from Calcutta, Tagore was awarded the Nobel Prize for Literature in 1913. Founder of the Santiniketan University in 1901, he traveled extensively, exhibited his artworks in Moscow and Paris, and lived for a while in London. Major works Plays: *The Genius of Valmiki* (1877); *Raja O Rani* (*The King of the Dark Chamber*, 1909); *The Post Office* (1910); *Sacrifice and Other Plays* (1917); *Chitrangada*, dance, music, drama (1937). Novels: *Broken Nest* (1901); *Yogayog* (1927). Books of poems: *Gitanjali* (1912); *Lipika* (1919). Autobiographical writings: *Fruit-Gathering* (1916); *My Reminiscences* (1917); *Glimpses of Bengal* (1923). *The Religion of Man*, philosophy (1931).

THACKERAY, WILLIAM MAKEPEACE, *pages 34–35*
Thackeray criticized society's materialism in novels of social comedy. He studied art in Paris before beginning his literary career as a humorist. Major works Humorous fiction in serialized episodes: *The Yellowplush Correspondence* (1840); *The Paris Sketch-Book, by Mr. Titmarsh* (1840); *The Irish Sketch-Book* (1843); *The Book of Snobs* (1847). Novels: *Barry Lyndon* (1844); *Vanity Fair* (1848); *Pendennis* (1850); *Henry Esmond* (1852); *The Newcomes* (1853–55); *The Virginians* (1857–59). *The Christmas Books*, short tales (1857).

THOMAS, DYLAN, *pages 138–39*
The popularity of the young Welshman's poetry was boosted by the power of his dramatic readings, commercially recorded. In the public mind, his tempestuous and excessive personality became as important as, and inseparable from, his poetry, which used powerful visual images and strong rhythms to express metaphysical ideas. He died suddenly during his second visit to New York City. Major works Books of poems: *25 Poems* (1936); *The Map of Love* (1939); *New Poems* (1943); *Deaths and Entrances* (1946); *Quite Early One Morning* (1954). Prose: *Portrait of the Artist as a Young Dog*, autobiographical (1940); *Adventures in the Skin Trade* (1955). Plays: *Under Milk Wood* (1954).

THURBER, JAMES, *pages 112–13*
James Thurber left college to become a code clerk in Washington, D.C., then worked in the American Embassy in Paris. In 1927 he joined the staff of *The New Yorker*, where his humorous prose and cartoons set the style for the next two decades. Major works Essays and stories, illustrated: *The Seal in the Bedroom* (1932); *My Life and Hard Times* (1933); *My World—and Welcome to It* (1942); *Thurber's Men, Women, and Dogs* (1943); *The Thurber Carnival* (1945).

UPDIKE, JOHN, *pages 148–49*
Updike's novels explore the world of the ordinary man in extraordinarily rich language. Editor of the *Lampoon* while at Harvard, he was awarded the Knox Fellowship and used it to attend, for one year, the Ruskin School of Drawing and Fine Arts at Oxford. He won the Pulitzer Prize in 1982. Major works Novels: *Rabbit, Run* (1960); *The Centaur* (1963); *Couples* (1968); *Rabbit Redux* (1971); *The Witches of Eastwick* (1984). Poetry: *The Carpentered Hen, and Other Tame Creatures* (1958); *Telephone*

Poles, and Other Poems (1963); *Facing Nature* (1985). *Pigeon Feathers*, short stories (1962).

VERLAINE, PAUL, *pages 58–59*
As a poet, Verlaine took part in the Symbolist, Decadent, and Parnassian movements. He deserted his family and roamed Europe with the young poet Arthur Rimbaud. After wounding Rimbaud, Verlaine served a prison term, repented, and joined the Catholic Church. Major works Books of poems: *Poèmes saturniens* (1866); *Fêtes galantes* (1869); *La Bonne Chanson* (1870); *Romances sans paroles* (1874); *Sagesse* (1881); *Bonheur* (1891); *Liturgies intimes* (1892). *Les Poètes maudits*, essays (1884); *Confessions*, autobiography (1895).

WAUGH, EVELYN, *pages 128–29*
Educated at Oxford, but not wealthy, Evelyn Waugh viewed the behavior of the upper classes with admiration as well as disdain. Major works Novels: *Decline and Fall* (1928); *Vile Bodies* (1930); *Brideshead Revisited* (1945); *The Loved One* (1948); a war trilogy—*Men at Arms* (1952); *Officers and Gentlemen* (1955); *Unconditional Surrender* (1961). *Rossetti: His Life and Works*, critical biography (1928); *Edmund Campion*, biography (1935); *A Little Learning*, autobiography (1964).

WHITE, T. H., *pages 130–31*
White humanized the legendary King Arthur and his court with his characterizations. Like Merlyn, he lived a solitary life with his falcons and other pets, first in Ireland, then on the island of Alderney. Major works *England Have My Bones*, autobiographical prose (1938); *The Biography of Brownie*, White's dog (1943); *The Age of Scandal*, essays (1950). Novels: the Arthurian quartet—*The Sword and the Stone*; *The Queen of Air and Darkness*; *The Ill-Made Knight*; *Candle in the Wind* (1938–41), published together under the title *The Once and Future King* (1958).

WILDE, OSCAR, *page 50*
Poet, dramatist, and novelist, Wilde founded his own aesthetic movement while still at Cambridge, spearheaded by his outrageous motto, "Art for Art's sake." His personal eccentricities became as trend-setting as his writings. Major works Plays: *Lady Windermere's Fan* (1892); *A Woman of No Importance* (1893); *Salomé* (1893); *The Importance of Being Earnest* (1895). *The Picture of Dorian Gray*, a novel (1891); *The Soul of Man Under Socialism*, a political essay (1895); *The Ballad of Reading Gaol*, a poem (1898); *De Profundis*, autobiographical philosophy, published posthumously (1905).

WILLIAMS, TENNESSEE, *pages 140–41*
The pathos Thomas Williams felt for the decaying Southern aristocracy stemmed partially from his grief over the insanity of his own sister. His gripping plays, which dealt with the displaced, the inability of illusion to withstand brutal reality, and the fear of death, were equally absorbing in adaptation to films. Major works Plays: *The Glass Menagerie* (1945); *A Streetcar Named Desire* (1947); *Summer and Smoke* (1948); *Camino Real* (1953); *Cat on a Hot Tin Roof* (1955); *The Night of the Iguana* (1962). Memoirs (1972).

ACKNOWLEDGMENTS

I gratefully acknowledge the assistance of these individuals and institution staff members: Mr. A. V. Griffiths, The British Museum; David Schoonover and Al Cupo, Yale University; Kenneth A. Lohf, Columbia University; Betty Coley, Baylor University; Anita Persson, Strindbergsmuseet, Stockholm; Lucille Wehner, The Newberry Library, Chicago; Ulf Abel, National Gallery, Stockholm; Sally Stonehouse and Dr. Juliet R. V. Barker of the Brontë Parsonage; Cynthia Draney, Nelson-Atkins Museum of Art; Antoinette Rezé Hure, Centre Pompidou; Patricia C. Willis, Rosenbach Library, Philadelphia; Kathleen Catalano, The Longfellow House, Cambridge; James A. Bear, Monticello, Charlottesville; Dimitrios Papostamos, Pinthotèque Nationale, Athens; Murphy D. Smith, The American Philosophic Society, Philadelphia; Françoise Foliot, Paris; Roberta Bradford and Thomas F. Harkins, Stowe-Day Foundation; Frederic Wilson, The Pierpont Morgan Library, New York; Mr. William Koshland, Alfred A. Knopf. A special commendation goes to Mr. Gregory Johnson of Alderman Library, The University of Virginia at Charlottesville, for his excellent research.

Special thanks go to my colleagues at the Harry Ransom Humanities Research Center: to Mr. Decherd Turner, the Director, John Payne, Roberta Cox, Patrick Keeley, Nancy Hughes, Eric Beggs, May Ellen MacNamara, Don Etherington, and to the members of the Academic Center staff, past and present. In New York, special thanks to Donn Teal, who made this book possible, and to Janice Byrne. My appreciation to Edwina Sandys and Jennifer Beeby of the Royal Oaks Trust, Fred Mason, Bradford Morrow, Pamela Walters, Carol Zoref, and Carmen del Rio de Piniés.

My appreciation extends to personal friends for many favors: Hazel Ransom, Catherine Wrather, Violet and Theron Palmer, Raymond Daum, Nancy Bauerle Campbell, Carol Gikas, Trudy Hanson, Mary Alice Valentine, Carol Chamberlain, Emily Ferris, Wilson Gathings, John Kirkpatrick, Nicholas Covich and Marilyn Haws, Cynthia Murray, Denis Ribiero, and all members of the Austin Girls Book Club.

At Harry N. Abrams, I wish to thank Paul Gottlieb and Leta Bostelman for their strong and continuing support. For a good editor, possessing patience and flair, my special gratitude to Lory Frankel, and an accolade to the designer, Judith Michael.

REPRODUCTION AND TEXT CREDITS

The author and the publishers gratefully acknowledge all of the publishers, agencies, and individuals who kindly gave us permission to reprint text excerpts and reproduce artworks. Page 6: Copyright 1938 by E. E. Cummings; renewed 1966 by Marion Moorehouse Cummings. Reprinted from *Complete Poems 1913–1962* by E. E. Cummings by permission of Harcourt Brace Jovanovich, Inc.; 6 (below): Excerpt from "Artists and Psychoanalysis" from *My Belief* by Hermann Hesse, translated by Denver Lindley with Ralph Manheim. Copyright © 1974 by Farrar, Straus and Giroux, Inc. Reprinted by permission of Farrar, Straus and Giroux, Inc.; 9: Erwin Panofsky, *Life and Art of Albrecht Dürer*. Copyright 1943, 1955 by Princeton University Press, © 1973 renewed by Princeton University Press; 24: Excerpts from *Prosper Mérimée: A Mask and a Face* by G. H. Johnstone reprinted by permission of Haskell House, New York; 26: Excerpt from *George Sand: A Biography* by Curtis Cate. Copyright © 1975 by Curtis Cate; 37: Excerpt from *Ruskin: The Great Victorian* by Derrick Leon reprinted by permission of the Estate of Derrick Leon; 44: *Baudelaire: A Study of His Poetry* by Martin Turnell. All rights reserved. Reprinted by permission of New Directions Publishing Corporation; 46: From *Ibsen: Letters and Speeches* edited by Evert Sprinchorn. Copyright © 1964 by Evert Sprinchorn. Reprinted by permission of Farrar, Straus and Giroux, Inc.; 48: Excerpt from *Ruskin: The Great Victorian* by Derrick Leon reprinted by permission of the Estate of Derrick Leon; 51: Excerpt from *The Journal of Arnold Bennett 1896–1910* reprinted by permission of the Executors of the Estate of the Late Arnold Bennett; 51–53: Artworks reprinted by kind permission of Madame V M Eldin; 54: Excerpt from *Life and Art* by Thomas Hardy reprinted by permission of Haskell House, New York; 54: "A Sign Seeker" and "She, to Him" from *The Complete Poems of Thomas Hardy*, edited by James Gibson (New York: Macmillan, 1978); 60: From *Strindberg as Dramatist* by Evert Sprinchorn. Copyright © 1982 by Yale University. All rights reserved. Reprinted by permission of Yale University Press; 62: Robert Louis Stevenson, excerpted from "Will O' the Mill," in *The Merry Men and Other Tales and Fables*, Volume 7 of *The Biographical Edition of Stevenson's Works*. Copyright 1927 Charles Scribner's Sons; copyright renewed. Reprinted with the permission of Charles Scribner's Sons; 64–65: It has come to our attention that the artworks attributed to Rabindranath Tagore may be the work of his nephew Abindranath Tagore; 65: *My Reminiscences* by Rabindranath Tagore, Copyright 1916, 1917 by Macmillan Publishing Co., Inc., renewed 1944,

1945 by Rabindranath Tagore; 68–69: Rudyard Kipling, "The Conundrum of the Workshops," *Barrack-Room Ballads and Other Verses*, reprinted by permission of The National Trust and Methuen and Company Ltd. Excerpt from *Something of Myself: For My Friends Known and Unknown* and artworks reprinted by permission of The National Trust; 69: Excerpt from *Something of Myself* by Rudyard Kipling. Copyright 1937 by Caroline Kipling. Reprinted by permission of Doubleday & Company, Inc.; 74–75: Artworks and text excerpts by Max Beerbohm reprinted by permission of Mrs. Eva G. Reichmann; 76–77: Artwork and text excerpts by G. K. Chesterton reprinted by permission of Miss D. E. Collins; 80–81: Artworks reprinted by kind permission of Curtis Brown Ltd. on behalf of the Estate of Winston Churchill. Copyright the Executors of Baroness Spencer Churchill; 81: Winston Churchill, *Maxims and Reflections of the Honorable Winston S. Churchill*. Reprinted by kind permission of Curtis Brown Ltd. on behalf of C. & T. Publications. Copyright C. & T. Publications; 82–83: Picture reproduction rights reserved by S.P.A.D.E.M. and A.D.A.G.P., Paris; 84: "Passing Strange" reprinted with permission of Macmillan Publishing Company from *Poems* by John Masefield. Copyright 1920, and renewed 1948, by John Masefield; 84–85: Artworks and text excerpts by John Masefield reprinted by permission of The Society of Authors as the literary representative of the Estate of John Masefield; 87: A selection from *Apollinaire on Art, Essays and Reviews 1902–1918* by Guillaume Apollinaire, edited by LeRoy C. Breunig, The Documents of 20th Century Art Series. Copyright © 1960 by Librairie Gallimard. English language translation copyright © 1972 by The Viking Press, Inc. Reprinted by permission of Viking Penguin, Inc.; 91: Illustrations reprinted by permission of Mrs. Valerie Eliot and Faber & Faber Ltd, London. Words reprinted by permission of Faber & Faber Ltd from *Selected Essays* by T. S. Eliot; 91: From "Tradition and the Individual Talent" in *Selected Essays* by T. S. Eliot, copyright 1950 by Harcourt Brace Jovanovich, Inc.; renewed 1978 by Esme Valerie Eliot. Reprinted by permission of the publisher; 92: Excerpts from *Seven Pillars of Wisdom* by T. E. Lawrence. Copyright 1926, 1935 by Doubleday & Company, Inc. Reprinted by permission of the publisher; 94–97: Artwork and text excerpts by D. H. Lawrence reprinted by permission of Laurence Pollinger Ltd and the Estate of Mrs. Frieda Lawrence Ravagli; 95: From "Making Pictures," by D. H. Lawrence in *Phoenix II, More Uncollected Writings* (1967), by D. H. Lawrence. Edited and with an Introduction by Warren Roberts and Harry T. Moore. Copyright © 1959, 1963, 1968 by the Estate of Frieda Lawrence Ravagli. Reprinted by permission of Viking Penguin, Inc.; 95: From *The Collected Letters of D. H. Lawrence*, vol. II, by D. H. Lawrence, ed. by Harry T. Moore. Copyright © 1962 by Angelo Ravagli and C. M. Weekley, Executors of the Estate of Frieda Lawrence Ravagli. Copyright 1932 by the Estate of D. H. Lawrence and 1934 by Frieda Lawrence; copyright 1933, 1948, 1953, 1954 and each year 1956–1962 by Angelo Ravagli and C. M. Weekley, Executors of the Estate of Frieda Lawrence Ravagli. Reprinted by permission of Viking Penguin, Inc.; 98–99: Artwork copyright © Estate of Mrs. G. A. Wyndham Lewis. By permission; 99: Excerpt from *Blasting & Bombardiering* by Wyndham Lewis courtesy of John Calder Ltd., London, 1967; 100: Excerpt from "Orphee" from *Five Plays* by Jean Cocteau. Copyright © 1961 by Hill and Wang, Inc. Reprinted by permission of Hill and Wang, a division of Farrar, Straus and Giroux, Inc.; 104: *Untitled* and *Vignette* copyright © 1928 by Djuna Barnes. Reproduced by arrangement with The Authors League Fund and The Historic Churches Preservation Trust, beneficiaries of the literary properties of Djuna Barnes; 104: From *The Antiphon* by Djuna Barnes. Copyright © 1958, 1962 by Djuna Barnes. Reprinted by permission of Farrar, Straus and Giroux, Inc.; 108–11: Artwork © 1986 by the E. E. Cummings Trust; 6: Excerpt from 'Introduction' to Collected Poems in *Complete Poems 1910–1962* (London: Granada, 1981) © 1938 by E. E. Cummings, 1966 by Marion Moorehouse Cummings, 1981 by G.J. Firmage; 109: From the catalogue of a onemanshow at the Memorial Gallery, Rochester, N.Y., in 'Foreword to an Exhibit: II,' *A Miscellany* (New York, 1958) © 1958 by E. E. Cummings, 1986 by the E. E. Cummings Trust; 109: From 'Post Impressions V' in *Tulips & Chimneys* (New York: Liveright Publishing Corporation, 1976) © 1976 by the E. E. Cummings Trust and G.J. Firmage; 111: From 'Videlicet' in *A Miscellany* (New York, 1958) © 1954 by E. E. Cummings, 1982 by the E. E. Cummings Trust; 112–13: These drawings are used by special permission of Helen W. Thurber; 114: Excerpts from *André Breton and the Basic Concepts of Surrealism*, Michael Carrouges, Maura Prendergast, trans., English translation © 1974 The University of Alabama Press. Translated into English from *André Breton et les Données Fondamentales du Surréalisme* © Editions Gallimard 1950; 122: From *The Little Prince* by Antoine de Saint-Exupéry, copyright 1943, 1971 by Harcourt Brace Jovanovich, Inc. Reprinted by permission of the publisher; 122: Excerpts from *The Little Prince* reprinted by permission of William Heinemann Limited; 127: From *Letters*

of James Agee to Father Flye. Copyright © 1971 by James Harold Flye. Copyright © 1962 by James Harold Flye and the James Agee Trust. Reprinted by permission of Houghton Mifflin Company; 128–29: Artwork by Evelyn Waugh reprinted by permission of A. D. Peters & Co Ltd; 130, 131: Extracts from *T. H. White: A Biography* by Sylvia Townsend Warner reprinted by permission of Chatto & Windus and Sylvia Townsend Warner; 134–35: Artwork © Heiner Hesse 1986. All rights reserved; 134–35: Excerpt from "At Year's End" and "Language" from *My Belief* by Hermann Hesse, translated by Denver Lindley with Ralph Manheim. Copyright © 1974 by Farrar, Straus and Giroux, Inc. Reprinted by permission of Farrar, Straus and Giroux, Inc.; 135: Excerpt from "On Moving to a New House" and "Life Story Briefly Told" from *Autobiographical Writings* by Hermann Hesse. Translated by Denver Lindley. Copyright © 1971, 1972 by Farrar, Straus and Giroux, Inc. Reprinted by permission of Farrar, Straus and Giroux, Inc.; 141: *Theatre of Tennessee Williams*, by Tennessee Williams. Copyright © 1972 by Tennessee Williams. Reprinted by permission of New Directions Publishing Corporation; 141: Excerpt from *Tennessee Williams: Memoirs* by Tennessee Williams. Copyright © 1972, 1975 by Tennessee Williams. Reprinted by permission of Doubleday & Company, Inc.; 142–43: Artwork Copyright © Allen Ginsberg 1985, reproduced by permission of Andrew Wylie Agency; 142: "Lysergic Acid" from *Collected Poems 1947–1980* by Allen Ginsberg. Copyright © 1959 by Allen Ginsberg. "Aether" from *Collected Poems 1947–1980* by Allen Ginsberg. Copyright © 1960 by Allen Ginsberg. Reprinted by permission of Harper & Row, Publishers, Inc.; 142: Excerpts from "Lysergic Acid" and "Aether" from Allen Ginsberg: *Collected Poems 1947–1980* (Viking Books, 1985), pp. 232–33, 242, copyright © Allen Ginsberg, 1985; 144: From *From the Diary of a Snail* by Günter Grass, translated by Ralph Manheim, copyright © 1972 by Hermann Luchterhand Verlag; English translation copyright © 1973 by Harcourt Brace Jovanovich, Inc. Reprinted by permission of Harcourt Brace Jovanovich, Inc.; 146, 147: "The Breast" and "The Break" from *Love Poems* by Anne Sexton. Copyright © 1967, 1968, 1969 by Anne Sexton. Reprinted by permission of Houghton Mifflin Company; 146: "Her Kind" from *To Bedlam and Part Way Back* by Anne Sexton. Copyright © 1960 by Anne Sexton. Reprinted by permission of Houghton Mifflin Company; 151: Excerpts from *The Thorn Birds*, Copyright © 1977 by Colleen McCullough, and *An Indecent Obsession*, Copyright © 1981 by Colleen McCullough. All rights reserved. Reprinted by permission of Harper & Row, Publishers, Inc.; 152: *Palinuro de México* by Fernando del Paso, copyright 1977 by Fernando del Paso. Extract in English, translated by W. H. Corral, in *Review*, no. 28.

PHOTOCREDITS: Figures refer to page numbers. W. C. Baker, Doylestown, Pa.: 132–33; Enrique Bostelmann: 152–53; Reproduced by Courtesy of the Trustees of the British Museum, London: 36–37; The Brontë Society, Haworth, Eng./ N. K. Howarth, Keighley: 40 below, 41; Bulloz, Paris: 24 above; City Museums and Art Gallery, Birmingham, Eng.: 55; Columbia University, New York, Rare Book and Manuscript Library: 38–39, 120–21, 142–43; Ernst Barlach Haus, Hamburg: 72–73; Fogg Art Museum, Harvard University, Cambridge, Mass.: 91; foto-studio-rama, Berlin: 14, 145; Françoise Foliot, Paris: 26, 28–29; Goethe-Museums, Düsseldorf/foto Walter Klein, Düsseldorf: 16–17; S. and M. K. Grundy, London: 80; Harry Ransom Humanities Research Center, The University of Texas at Austin/Eric Beggs and Patrick Keeley, Austin, Texas: dustjacket, front and back, endpapers, 1, 3, 6, 15, 18–21, 24 below, 25, 34–35, 40 above, 43, 45, 48–53, 56–57, 58 above, 59 above, 64–71, 74–75, 76 above, 77, 82–87, 90 left, 92–97, 99–101, 103, 108, 110, 111 above, 112–13, 118–19, 123, 126–31, 136 below, 137, 138 above, 139–41, 146–47; Ibsenhuset, Grimstad, Norway/Dannevig Foto, Arendal, Denmark: 46–47; Courtesy Alfred A. Knopf, New York, from *The Prophet*, frontispiece, 1928: 90 right; Lilly Library, Indiana University, Bloomington, Ind.: 30–31, 76 below; The Pierpont Morgan Library, New York: 124; Cliché Musée National d'Art Moderne, Paris: 114–15; Lee Naiman Gallery, New York/Eeva Inkeri, New York: 144; Nationalmuseum, Stockholm: 61; Otto E. Nelson, New York: 4, 98, 102, 104–5, 109, 111 below, 136 above; Nelson-Atkins Museum of Art, Kansas City, Mo.: 23 above; The Newberry Library, Chicago/Gamma, Chicago: 78–79; The New York Public Library: 22; The Pearl Buck Foundation, Perkasie, Pa./Photo Journalism W. C. Baker, Doylestown, Pa.: 106; Service Culturels de l'Ambassade de France, New York: 27; Smithsonian Institution, Washington, D.C.: 59 below, 122 left, 138 below; Picture reproduction rights reserved by S.P.A.D.E.M. and A.D.A.G.P., Paris: 114 below; Staatliche Landesbildstelle Hamburg: 73 above; Stowe-Day Foundation, Hartford, Conn.: 32–33; University of Virginia Library, Charlottesville: 88–89, 116–17; Yale University Library, New Haven, Conn.: 23 below, 62–63, 134–35.